FRY PLAYS THREE

D1388236

CHRISTOPHER FRY was born Arthur Hammond Harris in 1907. After a short stint as a teacher, he renamed himself Christopher Fry – taking his new, Quaker-inflected surname from his mother's side of the family – and during the 1930s worked in a variety of theatrical jobs, including playwright, producer, lyricist, composer, designer, draughtsman and actor. Plays from this time include *Siege* (1936) and *The Boy with a Cart* (1939). After the Second World War he began to make a name for himself as a verse dramatist with the one-act *A Phoenix Too Frequent* and the full-length drama *The Firstborn* (both 1946). However, the major success of his career came with *The Lady's Not for Burning* in 1948, which ran for nine months in the West End and is still frequently revived. Fry followed this up with *Thor, with Angels* (1948), *Venus Observed* (1950), *A Sleep of Prisoners* (1951) and *The Dark is Light Enough* (1954). During this period he also produced much-loved translations of Jean Anouilh's *L'Invitation au château* (*Ring Round the Moon*) and *The Lark*, and went on to translate three plays by Jean Giraudoux: *La Guerre de Troie n'aura pas lieu* (*Tiger at the Gates*), *Pour Lucrèce* (*Duel of Angels*) and *Judith*. From the mid-1950s he began to work on screenplays for Hollywood, most famously *Ben Hur* and *The Bible*. His last two full-length stage plays were *Curtmantle* (1962) and *A Yard of Sun* (1970), still in verse but employing a leaner language than in his earlier work. In the 1970s he produced verse translations of both *Peer Gynt* and *Cyrano de Bergerac*, as well as writing drama for television, including *The Brontës of Haworth*, and essays and autobiographical writings such as *Can You Find Me?* He would go on to write two more one-act plays: *Caedmon Construed* (1986) – also known as *One Thing More* – and *A Ringing of Bells* (2000), written in his nineties for his old school, Bedford Modern. He died in 2005.

Christopher Fry

PLAYS THREE

The Firstborn

The Boy with a Cart

A Phoenix Too Frequent

Thor, With Angels

A Sleep of Prisoners

Caedmon Construed

A Ringing of Bells

OBERON BOOKS
LONDON

First published in this collection in 2007 by Oberon Books Ltd
521 Caledonian Road, London N7 9RH
Tel: 020 7607 3637 / Fax: 020 7607 3629
e-mail: info@oberonbooks.com
www.oberonbooks.com

The Firstborn first published by Cambridge University Press, 1946;
third edition by Oxford University Press, 1958. *The Boy with a Cart*
first published by Oxford University Press, 1939; second edition by
Frederick Muller Ltd, 1945; reissued by Oxford University Press,
1970. *A Phoenix Too Frequent* first published by Hollis & Carter, 1946;
reissued by Oxford University Press, 1949. *Thor, with Angels* first
published by H J Goulden Ltd, 1948; reissued by Oxford University
Press, 1949. *A Sleep of Prisoners* first published by Oxford University
Press, 1951. *Caedmon Construed* first published (as *One Thing More*)
by King's College London, 1986. *A Ringing of Bells* first published by
Samuel French Ltd, 2000

A catalogue record for this book is available from the British Library.

ISBN: 1 84002 773 8 / 978 1 84002 773 0

Printed in Great Britain by Antony Rowe Ltd, Chippenham

Contents

THE FIRSTBORN

To my mother and my brother

Characters

ANATH BITHIAH, Pharaoh's sister

TEUSRET, Pharaoh's daughter

SETI THE SECOND, the Pharaoh

RAMESES, his son

MOSES

AARON, his brother

MIRIAM, his sister

SHENDI, Miriam's son

Two OVERSEERS, a Minister (KEF)

A GUARD and a SERVANT

The action of the play takes place in the summer of 1200 BC, alternating between Pharaoh's palace and Miriam's tent.

The Firstborn was first performed at the Gateway Theatre, Edinburgh, on 6 September 1948, with the following cast:

ANATH BITHIAH, Athene Seyler
TEUSRET, Deidre Doone
SETI THE SECOND, Robert Speaight
RAMESES, Paul Hansard
MOSES, Ivan Brandt
AARON, Robert Sansom
MIRIAM, Henzie Raeburn
SHENDI, Robert Rietty

Director E Martin Browne

Winter Garden Theatre, London, 29 January 1952:

ANATH BITHIAH, Barbara Everest
TEUSRET, Ruth Trouncer
SETI THE SECOND, Mark Dignam
RAMESES, Tony Britton
MOSES, Alec Clunes
AARON, Cyril Luckham
MIRIAM, Dorothy Reynolds
SHENDI, Robert Rietty

Director John Fernald

Coronet Theatre, New York, 30 April 1958:

ANATH BITHIAH, Katharine Cornell
TEUSRET, Kathleen Widdoes
SETI THE SECOND, Torin Thatcher
RAMESES, Robert Drivas
MOSES, Anthony Quayle
AARON, Michael Strong
MIRIAM, Mildred Natwick
SHENDI, Michael Wager

Director Anthony Quayle

ACT ONE

Scene One

(*The terrace of the palace of SETI THE SECOND, at Tanis. A morning in the summer of 1200 BC. A flight of steps (unseen) leads down through a gate to open ground. The terrace looks out upon an incompleted pyramid. A scream. Enter from the palace ANATH BITHIAH, a woman of fifty, sister to the Pharaoh, and TEUSRET, a girl of fifteen, the Pharaoh's daughter.*)

ANATH: What was it, Teusret?

TEUSRET: Did you hear it too?

ANATH: Some man is dead. That scream was password to a grave.
Look there: up go the birds!

TEUSRET: The heat on this terrace!
You could bake on these stones, Aunt Anath.

ANATH: Ask who it was.

TEUSRET: They're working steadily at father's tomb.
There's no sign of trouble.

ANATH: We're too far off to see.
We should know more if we could see their faces.

TEUSRET: (*Calling down the steps.*) Guard! Come up here.

ANATH: I should like to be certain.
Oh, that pyramid! Every day, watching it build,
Will make an old woman of me early.
It will cast a pretty shadow when it's done.
Two hundred more men were taken on today,
Did you know that, Teusret? Your father's in a hurry.
Their sweat would be invaluable to the farmers in this drought.
What pains they take to house a family of dust.

TEUSRET: It's a lovely tomb.

ANATH: Yes, so it may be.
But what shall we do with all that air to breathe
And no more breath? I could as happily lie
And wait for eternal life in something smaller.

(*Enter a GUARD.*)

TEUSRET: What was that scream we heard?

GUARD: It's nothing, madam.

ANATH: You are right. Nothing. It was something once
But now it is only a scare of birds in the air
And a pair of women with their nerves uncovered;
Nothing.

TEUSRET: Who was it screamed?

GUARD: One of the builders
Missed his footing, madam; merely an Israelite.
They're digging him into the sand. No, over to the left.

TEUSRET: Oh, yes, I see them now. – That was all I wanted.

(*Exit the GUARD.*)

So that's all right.

ANATH: Can you remember your cousin?

TEUSRET: Why, which cousin?

ANATH: My foster son. You knew him
When you were little. He lived with us in the palace.

TEUSRET: The birds are back on the roof now.

ANATH: Moses, Teusret.

TEUSRET: What, Aunt? Yes, I think I remember. I remember
A tall uncle. Was he only a cousin?
He used to drum his helmet with a dagger
While he sang us regimental marches to get us to sleep.
It never did. Why?

ANATH: No reason. I thought of him.
Well, they've buried the man in the sand. We'd better
Find our morning again and use what's left.

TEUSRET: Why did you think of him? Why *then* particularly?

ANATH: Why not then? Sometimes he blows about my brain
Like litter at the end of a public holiday.
I have obstinate affections. Ask your father.
He would tell you, if it wasn't impolitic
To mention Moses, what a girl of fire
I was, before I made these embers.

He could tell you how I crossed your grandfather,
And your grandfather was a dynasty in himself.
Oh, Teusret, what a day of legend that was!
I held forbidden Israel in my arms
And growled on my stubborn doorstep, till I had my way.

TEUSRET: What do you mean?

ANATH: Well, never mind.

TEUSRET: You've told me so far.

ANATH: Keep it to yourself then.
The summer of '24 had brilliant days
And unprecedented storms. The striped linen
You once cut up for a doll's dress was the dress
Made for me that summer. It was the summer
When my father, your grandfather, published the pronouncement.

TEUSRET: What pronouncement?

ANATH: That all the boys of Jewdom
Should be killed. Not out of spite, Teusret; necessity.
Your grandfather ordered that Defence of the Realm be painted
At the head of the document, in azure and silver.
It made it easier for him.

TEUSRET: Were they killed?

ANATH: Yes, they all died of a signature. Or we thought so,
Until the thirtieth of August. I went bathing on that day.
I was a girl then, Teusret, and played with the Nile
As though with a sister. And afterwards as I waded
To land again, pushing the river with my knees,
The wash rocked a little ark out
Into the daylight: and in the ark I found
A tiny weeping Israel who had failed
To be exterminated. When I stooped
With my hair dripping onto his face
He stopped in a screwed-up wail and looked.
And when I found my hands and crowded him
Into my breast, he buried like a burr.
And when I spoke I laughed, and when I laughed
I cried, he was so enchanting. I was ready

To raise a hornet's nest to keep him; in fact
I raised one. All the court flew up and buzzed.
But what could they do? Not even my Pharaoh-father
Could sting him out of my arms. So he grew up
Into your tall cousin, Egyptian
From beard to boots and, what was almost better,
A soldier of genius. You don't remember
How I held you on this terrace, to see him come home from war?
It was ten years ago. Do you remember
The shrieking music, and half Egypt shouting
Conqueror! Peacemaker!

TEUSRET: No.

ANATH: They have all tried to forget.
They have blotted him out of the records, but not out
Of my memory.

TEUSRET: Why did they blot him out?

ANATH: I might have known that I should say too much.

TEUSRET: Aunt, you must tell me.

ANATH: Well, no doubt I meant to.
The day I held you here, he came as the conqueror
Of Abyssinia. In all the windows and doors
Women elbowed and cracked their voices; and men
Hung on the gates and the trees; and children sang
The usual songs, conducted by their teachers.

TEUSRET: Yes, but what happened to make him –

ANATH: All right, I'm coming to it, Teusret. The day after,
For the countryside also to be able to see the hero,
He went to inspect the city being built at Pithom. –
My book was closed from that day forward.
He went round with an officer who unfortunately
Was zealous but unintelligent. Silly man:
Silly, silly man. He found a labourer
Idling or resting, and he thought, I suppose,
'I'll show this prince that I'm worth my position'
And beat the workman. A Jewish bricklayer.
He beat him senseless.

TEUSRET: And then?

ANATH: Moses turned – turned to what was going on –
 Turned himself and his world turtle. It was
 As though an inward knife scraped his eyes clean.
 The General of Egypt, the Lion and the Prince
 Recognised his mother's face in the battered body
 Of a bricklayer; saw it was not the face above
 His nursery, not my face after all.
 He knew his seed. And where my voice had hung till then
 Now voices descending from ancestral Abraham
 Congregated on him. And he killed
 His Egyptian self in the self of that Egyptian
 And buried that self in the sand.

TEUSRET: Aunt –

(Enter a GUARD.)

GUARD: The Pharaoh.
 Madam, the Pharaoh is here.

ANATH: Can we look innocent?

(Enter SETI. Exit the GUARD.)

TEUSRET: Good morning, father.

SETI: Go indoors, my Teusret.

(Exit TEUSRET.)
 Where is Moses?

ANATH: Seti!

SETI: Where is Moses? You will know.
 In what country? Doing what?

ANATH: Why Moses?

SETI: I need him.

ANATH: I've no reason to remember.
 I'm without him.

SETI: But you know.

ANATH: Why should I know?
 Why should I? When the sun goes down do I have to know
 Where and how it grovels under the world?
 I thought he was a dust-storm we had shut outside.

Even now I sometimes bite on the grit.

SETI: I have found him necessary.
Libya is armed along the length of her frontier,
And the South's like sand, shifting and uncertain.
I need Moses. – We have discarded in him
A general of excellent perception.

ANATH: He's discarded, rightly or wrongly. We've let him go.

SETI: Deeds lie down at last, and so did his.
Out in the wilderness, after two days' flight,
His deed lay down, knowing what it had lost him.
Under the boredom of thorn-trees he cried out
For Egypt and his deed died. Ten years long
He has lugged this dead thing after him.
His loyalty needn't be questioned.

ANATH: We're coming to something strange when a normal day
Opens and lets in the past. He may remember
Egypt. He's in Midian.

SETI: In what part of Midian?

ANATH: Wherever buckets are fetched up out of wells
Or in his grave.

SETI: We'll find him. If we have to comb
Midian to its shadows we'll find him.

ANATH: He's better where he is.

SETI: He is essential to my plans.

ANATH: I tell you
He is better where he is. For you or me
He's better where he is.
We have seen different days without him
And I have done my hair a different way.
Leave him alone to bite his lips.

(*SETI's eye is caught by something below and beyond the
terrace.*)

SETI: What's this,
What is this crowd?

ANATH: It's Rameses! No qualms
For the dynasty, with a son as popular as he is.

SETI: There's half the city round him. Where are his guards?

ANATH: There: a little behind.

SETI: The boy's too careless.
 I'm not altogether at rest in the way he's growing,
 His good graces for no-matter-whom.
 He must learn to let the needs of Egypt rule him.

ANATH: He will learn. He is learning.

SETI: Egypt should pray so.

ANATH: I would hazard a guess that Egypt's women
 Have prayed for him often enough. Ra, raising
 An eyebrow stiff with the concentration of creation
 Probably says: That boy again? We'd better
 Make something of him early and have them satisfied.
 O, Rameses will be all right.

SETI: I hope,
 I hope.

 (Enter RAMESES, a boy of eighteen.)

RAMESES: Did you see the excitement? I think it's the drought.
 Like the air, we're all quivering with heat.
 Do you find that, Aunt? Either you must sleep like the dead
 Or something violent must happen.

ANATH: Look: your father.

RAMESES: I didn't see you, father. I'm sorry, sir.
 Did I interrupt state matters?

SETI: What morning have you had?

RAMESES: Holiday – books rolled up, military exercises
 Over, and no social engagements. I've been fowling
 Down at the marshes.

ANATH: Any luck?

RAMESES: Not much flesh
 But a paradise of feathers. I was out before daybreak.

ANATH: It's a good marksman who hunts by batlight.

RAMESES: But I
 Waited for daylight. Until then the marsh was a torpor.
 I clucked and clapped as the sun rose

And up shot so much whistle and whirr
I could only hold my spear and laugh.
All the indignant wings of the marshes
Flocking to the banner of Tuesday
To avoid the Prince of Egypt!
Off they flapped into the mist
Looking about for Monday
The day they had lived in peace: and finding nothing
Back they wheeled to Tuesday.
I had recovered myself by then and killed
One that had the breast of a chestnut.
At last he could feel the uninterrupted darkness
Of an addled egg. I watched his nerves flinching
As they felt how dark that darkness was.
I found myself trying to peer into his death.
It seemed a long way down. The morning and it
Were oddly separate,
Though the bird lay in the sun: separate somehow
Even from contemplation.

ANATH: Excellent spirits
 To make a success of a holiday.

RAMESES: Only for a moment.

SETI: This afternoon I have business for you. (*He turns to go in.*)

RAMESES: Very well.

SETI: Was that thunder?

ANATH: They're dumping new stone for the pyramid.

RAMESES: Two men came through the marshes before I left;
 Jews, but not our Jews: or one of them
 Was not; he seemed a man of authority
 Although some miles of sun and dust were on him.

SETI: Aliens?

RAMESES: Yes; but one of them I felt
 I should have known. How could I?
 I passed them again as I came home. They stood
 To watch the crowd. I looked across and smiled
 But got no smiles from them. And one, the tall one –

ANATH: Very tall?

RAMESES: Yes, he was tall. It was he
Who is somehow in my memory.

ANATH: Seti —

SETI: Well?

ANATH: Is it possible that someone hasn't waited to be recalled?
Is it possible?

SETI: It is not possible.

ANATH: Your thoughts are leaning that way too.
Sometimes the unaccountable stalks in.

SETI: Which way were they travelling, Rameses?

RAMESES: This way. If I had only thought of them sooner
We could have seen them go by. — Sir!
They are standing here at the foot of the stairway. How long
Can they have been there? Shall I speak to them?

ANATH: He has stood all day under my brain's stairway.
Seti, who is there? Which foremost, Rameses?
The tall one?

RAMESES: Yes. Who's in your mind?

ANATH: The tall one.
The tall one.

(*RAMESES goes down the steps.*)

 So he is back; and small-talk
Has to block a draught up ten years old.

SETI: Why has he come?

ANATH: You said he longed for Egypt.

SETI: I think so.

ANATH: But what am I in Egypt?
A dead king's daughter.

(*Re-enter RAMESES, followed by MOSES and AARON.*)

SETI: What words can I find to fit
So ghostly a homecoming? Understand you are welcome.
Whatever uncertainty you have can go.
We welcome you. Look who is here.

ANATH: He has seen me. We have looked at one another.

SETI: We'll absolve ourselves of the ten years. Who is this?

MOSES: My brother.

SETI: I had not heard you had a brother.

ANATH: A brother, a sister – and a mother. All the three.

SETI: I told my sister we must have you back.
> And so we must, and so Egypt must; and it seems
> That we have. You are come promptly at the word, Moses.

MOSES: This is not why I came.

SETI: You would scarcely foresee it.

MOSES: I am not who you think. I am a stranger.

SETI: Not by a vein or a hair. The past is forgotten.
> You are a prince of Egypt.

MOSES: The prince of Egypt
> Died the day he fled.

SETI: What do you mean?

MOSES: That prince of Egypt died. I am the Hebrew
> Smitten out of the shadow of that prince,
> Vomited out of his dry lips, the cry
> Whipped off the sanded tongue of that prince of Egypt.

SETI: What has this long discomfort done for you,
> My friend? It has made you bitter.

MOSES: Why was it you decided to ask me to come back?

SETI: Isn't it time we laid the crippling ghost
> That haunts us? You evidently thought so too
> To come so far.

MOSES: You've a better reason than that.

SETI: Why should you want reasons when you have come
> On your own initiative? Why are you here?
> I am asking you candidly. Why did you come?

MOSES: My blood heard my blood weeping
> Far off like the swimming of fear under the sea,
> The sobbing at night below the garden. I heard
> My blood weeping. It is here it wept and weeps.
> It was from here I heard coming this drum of despair,

Under your shoes, under your smile, and under
The foundations of your tomb. From Egypt.

ANATH: What was it, Seti, that lay down and died?

SETI: Why are you here?

MOSES: To be close to this that up to now
Has been a pain in the mind, not yet
Possessing the mind, but so increasing
It has driven me here, to be in myself the pain,
To be the pain's own life.

SETI: Still you haven't
Answered my question. Come, what do you want?

MOSES: First, that you should know what you are doing.

SETI: Take care, Moses.

ANATH: And secondly?

MOSES: What can I hope
From that until he has understood the first?

SETI: What is this mood you have come in which is so ready
To abuse a decent welcome? There is something shipwreck
About you that will not do for peaceful places.
Steady yourself if we're to understand one another.
I am the Pharaoh, Moses, not the young uncle
Of the Heliopolis classroom, nor your messroom brother.

MOSES: A man has more to be than a Pharaoh.
He must dare to outgrow the security
Of partial blindness. I'm not speaking now
To your crown; I'm speaking to your merciless mischief.

SETI: You have coarsened during your exile. What you say
Hasn't even the virtue of clarity. If you wish
To consider my offer of reinstatement, go
And consider. I can be patient. Egypt can do
Her work on you like a generous woman, given
Her time.

(He glances at ANATH.)

Midian will wash off in the Nile.
Go on, go on, I shall not remember this morning.

21

MOSES: I think you will. My brother has lived these days
 In amongst Israel, while I was sleeping.
 He knows both the truth and the injury better than I can.
 Let him speak what he knows.

AARON: Twelve hundred thousand Israelites are under
 Your dominion. Of these two hundred and twenty thousand
 Only, are men. The rest are in the proportion
 Of four hundred and fifty thousand women
 And five hundred and thirty thousand children.

SETI: I have my census-takers.

AARON: So perhaps
 Has Death got his; but I think he has not referred
 His undertakings to your dynastic understanding.
 Here I have his estimate: between April and July
 Six hundred and one deaths suffered in old age
 But an old age of forced labour, their backs bent twice,
 Under the weight of years and under the mule-whip.
 Also thirty-eight deaths of healthy men
 Who made some show of reluctance or momentary
 Impatience.

MOSES: That was a good cure. They are now
 Patient for all eternity.

AARON: Also the deaths
 Of a hundred pregnant women, forced to dig
 Until they had become their own gravediggers.
 Also the deaths of eighty-four children, twelve
 Unofficial crucifixions...

SETI: This is intolerable
 Singsong! Am I to compose the epitaphs
 For every individual grave of this trying summer?
 I have my figures. I do not need yours.
 I have put men to a purpose who otherwise
 Would have had not the least meaning.

MOSES: Not the least meaning, except the meaning
 Of the breath in your lungs, the mystery of existing
 At all. What have we approached or conceived

When we have conquered and built a world? Even
Though civilisation became perfect? What then?
We have only put a crown on the skeleton.
It is the individual man
In his individual freedom who can mature
With his warm spirit the unripe world.
They are your likeness, these men, even to nightmares.
I have business with Egypt, one more victory for her,
A better one than Ethiopia:
That she should come to see her own shame
And discover justice for my people.

SETI: You have fermented in your Midian bottle.
But lately I have learnt an obstinate patience.
We should have done better to have met
Out of the sun. We can do better than this
And so we shall yet, later, at a cooler time.
Where will you sleep? We will see you have food.
Do you remember, I wonder, the palace nectarine?
I said, where will you lodge?

MOSES: With my sister, Miriam.

SETI: (*To ANATH.*) Do you know where that is?

ANATH: Perfectly.

SETI: (*Going in.*) Very well.

ANATH: Now he will not sleep again tonight.

MOSES: I hope that none of us will sleep again
Until we all can sleep.

ANATH: And so once more
We see each other. You have chosen a fine day.
(*MOSES waits. ANATH says no more. He goes with AARON.*)
I taught him to walk, Rameses. I also taught him
To speak and say his alphabet. I taught you your
Alphabet also; and also Teusret hers.
I have been a really useful woman.

RAMESES: Where
Does his sister live?

ANATH: Why do you want to know?

RAMESES: I wondered where it might be.

ANATH: She has a tent
By the brick-kiln.

RAMESES: I liked that man.

ANATH: So have others before you. Like him, Rameses,
Forget him, and let us live in peace.

RAMESES: I shall go and find him.

ANATH: Rameses, I ask you to forget him.

RAMESES: How?

ANATH: What would make it difficult?

RAMESES: Can you forget him?

ANATH: He has gone.

RAMESES: And something of us, I think, went with him.

ANATH: Well, you will let him go. I have asked you.

RAMESES: No.
I love you, you know that. But trust me a little.
I shall be discreet.

(*Exit RAMESES.*)

ANATH: Rameses! – No,
What should I be doing, turning his feet
Towards my fears?

(*She goes to the parapet. Enter TEUSRET.*)

TEUSRET: Aunt Anath, where is Rameses going?
Aunt Anath –

ANATH: Do you remember, Teusret?
A man fell from the pyramid – only this morning.

(*Curtain.*)

Scene Two

(*MIRIAM's tent. MOSES in the entrance. MIRIAM.*)

MOSES: Miriam! Miriam!

MIRIAM: Is it my brother? Yes;
You have his immovable look. Aaron told me
To expect you.

MOSES: Can you be Miriam?

MIRIAM: A kind
 Of residue. Sit down, if you don't mind.
 I dislike answering questions. Ask me nothing.
 I am very well; I have nothing to offer you
 To drink.

MOSES: I'm glad to be with you after so long.

MIRIAM: You will find it very tiresome after five or six minutes.
 I repeat myself unendurably, like the Creation.
 Your only hope is to deaden yourself to me
 And it.

AARON: (*In the entrance.*) Your name runs like fire, like an ostrich!
 You didn't wait to hear, but the sergeant at the gate
 Was full of it. He said the whole city
 Is pulsing with talk and argument about you:
 As soon as this; before you've even been seen!

MOSES: And what will this do for us?

AARON: Surely it suggests
 They're taking sides? Down in the square, it seems, a
 minister's wife
 Was wearing an M in small lilies; her daughter snatched them off
 And threw them among the pigeons. How can Seti
 Assure himself what size your faction is?
 Egypt loves and hates you inextricably.

MOSES: Egypt is afraid. Love me? No;
 They're afraid to be without me.

AARON: That will pass for love.

MOSES: They love me from the bottom of their greed.
 Give me the bad news. What men have we lost?

MIRIAM: So you're not only here on a visit to your sister.

AARON: Here is a list. It's not complete.

MIRIAM: I've had
 Enough of trouble.

MOSES: Rahnor, Janeth, Pathrusim –
 Is he lost? Pathrusim? The sand of Egypt

Is abominably the richer. – Hadoram, Seth,
Havilah, Dodanim…

MIRIAM: Why do you read
Dead men's names? There are some of us still breathing.
Your sister, for example, is still alive,
Figuratively speaking. I imagined
You would have plenty to tell me. Have you not?
Am I always to know nothing of you?

MOSES: These names are what I am.

MIRIAM: They are yesterday's life. I liked many of them very well;
But we no longer have anything in common.

AARON: Are we to forget them because we have lost them?

MIRIAM: To wish
To be with them comes too easily.

MOSES: This tent
Is stifling.

MIRIAM: I keep it closed. I have no liking
For what goes on outside.

MOSES: When do they say
The mountains last had rain?

MIRIAM: Nine months ago.

MOSES: It's time for parturition.
Look: what you shut out is a withering city.
City of Egypt. This land once I worshipped,
And now I cannot be sure what I bring against her
In my heart. This noon, like every other noon,
Still groans with the laborious wheels which drew
The Nile water. There is little difference
Between ourselves and those blindfolded oxen.
We also do the thing we cannot see,
Hearing the creaking pivot and only knowing
That we labour.

MIRIAM: Why did you bring him? Take yourselves off!
This is my tent, and it's not for restless hands.
He's a dangermaker still.

AARON: What has he said, Miriam?

MIRIAM: I have a son
 And that is all I rest on. There's a man
 Who should have been my brother. A king's daughter
 Swallowed him and spat out this outlaw. I'll
 Not have any more in the family.

AARON: What should make them?

MIRIAM: You and he. I know. Two years ago
 I had it all: the surly men coming in here,
 One at a time by signal, hardly nodding
 Towards me, covering the table with their knife-cuts
 To show how revolution must come, and freedom,
 And idiocy; till a beetle striking the lamp.
 Or the coal settling, would shiver through us all
 As though a dagger had sung into the pole.
 And Espah and Zoad are dead from it. And you
 In a night of loud hyenas went over the border.
 Not again. I'll keep my nights of sleep, and I'll keep
 My son.

AARON: In this country of murder?

MIRIAM: I'll keep my son
 In whatever country.

MOSES: Happily?

MIRIAM: We have
 A way of living. We have the habit. Well?
 It becomes a kind of pleasantness.

MOSES: You have gone
 With the dead after all, but you pretend not to see them.
 Miriam, we have to speak to them with our lives.
 Death was their question to us, and our lives
 Become their understanding or perplexity.
 And by living to answer them, we also answer
 Our own impermanence. But this rule of Egypt
 Denies us life, Miriam, and gives us nothing
 With which we can outspeak our graves.

MIRIAM: I am angry;
 The pity is I am angry. I must pretend

You have said nothing.

AARON: But do you understand him?
In fact, do I understand him?

MOSES: When I was a child,
Miriam, and you would come to me in the huge
Nursery of the Pharaohs, we'd go hand
In hand along your stories, Hebrew stories
Which like contraband you put quietly in
To become my nature. Do you remember?

MIRIAM: How she disliked me then! But what a talent
For condescension she had. I never saw you
After you were a child except by waiting
Among the crowd in the streets. There was no need
To come from Midian to tell me what my life is;
I have a bowing acquaintance with it. I knew it
When I hid you to save you from the knives.
Before I could talk it talked to me
In most difficult words.

MOSES: What words, Miriam?

MIRIAM: Pogrom, for one. And the curses of Egyptian children
When I ran towards them expecting to play;
The shout of command kicking at the ribs,
All human words torn to a scream.
We have a wildfowl quality of blood,
Moses, temptation for sportsmen.

MOSES: Go on.

MIRIAM: With what,
If you please? Do you know the secret which will change
Our spoor? Our grandfather was stoned. I imagine
Creation tried our blood, and brought it in guilty.

MOSES: It was the verdict of Chaos.

MIRIAM: Let us alone
To serve the sentence. One grows accustomed.
We have to be as we are.

MOSES: We have
To be Israel; as we are.

MIRIAM: Where do you see Israel now?

MOSES: Where
Do I see God? Be certain, Israel is.
I am here to be a stone in her sling, out of her gall.

MIRIAM: Israel! Israel's the legend I told you in the nursery.
We've no more spirit to support a God.

MOSES: We have a God who will support the spirit,
And both shall be found. But still I need to know how good
Can be strong enough to break out of the possessing
Arms of evil. I am there, beyond myself,
If I could reach to where I am.

AARON: You will find the approach
And the means you want, I'm confident. Something
Will soon open a way to action.

RAMESES: (*In the tent-opening.*) Uncle.
I knew you as that. When I have thought of you
It has been as my uncle. You may not like it.
You may not want to see me, even.

MOSES: Welcome and unwelcome.

RAMESES: I haven't come
From my father. I used schoolboy's worship, like myrrh
And cassia, to perpetuate you:
The immense and affable god in general's uniform,
Who came and went between wars, who filled the schoolroom;
And I could call him uncle. So when the memory
Broke its wrappings, and stood speaking like a man
On a noonday terrace, I decided to come nearer.

MOSES: Come on, then, and send the god to vanish finally
Into the lie that he always was.

RAMESES: You spoke
To my father too suddenly.

MOSES: Yes, we're precipitous,
We gods. We threw off the world, vegetable
And animal too, on the impulse of an imaginative
Moment. But we lost interest.

RAMESES: You mean
 I'm a boy to you still.

MOSES: You came by your boyhood honestly.
 Mine I stole. I had no right to it.

AARON: Why
 Do you turn him away, Moses? Why not talk to him?

MOSES: What would we talk of, Aaron? What quiet subject?
 They tell me centuries of horror brood
 In this vivid kingdom of fertile mud. Do you think
 If we swung the rattle of conversation
 Those centuries would fly off like so many crows?
 They would wheel above us and come to feed again.

AARON: But where shall we find a better
 Opportunity?

RAMESES: I have my father mapped
 So that I know which way to travel. Listen,
 Uncle – he says he would have recalled you, which means
 He needs you here. He'll be friendly if you let him.
 I kept a buckle of your uniform – this one, the lion-head.
 Take it again, take our army and be our general.
 You'll become inseparable from Egypt's safety;
 Then he will listen. Then you can direct
 His goodwill past yourself to these Israelites.

AARON: It's true. You have the buckle, and we're agreed, then.
 My dreams were less; not a third as felicitous.

MOSES: Egypt and Israel both in me together!
 How would that be managed? I should wolf
 Myself to keep myself nourished. I could play
 With wars, oh God, very pleasantly. You know
 I prosper in a cloud of dust – you're wise
 To offer me that. And Egypt would still be,
 In spite of my fathers, a sufficient cause.

AARON: Yes, it would be sufficient.

MOSES: Splendid, then.
 What armour shall I wear? What ancestral metal
 Above my heart? Rib, thighbone and skull:

Bones from the mines of Egypt. I will clank
To Egypt's victory in Israel's bones.
Does this please you? Does it not? Admire
How when preparing a campaign I become
Oblivious to day and night, and in
The action, obsessed. How will that do? I make
My future, put glory into Egypt, enjoy myself
Into your father's confidence – yes, that,
I know; and being there, perhaps I coax
Little concessions for the Hebrew cause
To justify me. – Idiot, idiot!
I should have lost them, Aaron, and be lost,
More than when in Midian I sat
Over my food and let them trudge in my bowels.

AARON: I have faith in your judgement. Nevertheless, this is
Something to be thought of, a reality of a kind.

MOSES: Like adultery.

MIRIAM: Offer of a generalship?
Of course I don't understand. But like adultery?
To be a general? Do you mean us to think
You would refuse –

MOSES: You both would like to see
Your brother fat, but your brother has a fancy
To be as lean as Israel.

RAMESES: Will you promise to be patient?
There will be difficulties to be got over;
I have a father. But at some future time
When I am Pharaoh –

MOSES: By then I may be free
To let my bones talk of their disinterest
In the world's affairs: and whether it is Hebrew
Or Egyptian, man will cry for me no longer.

MIRIAM: Listen!

AARON: What is it?

MIRIAM: Nothing, nothing – I imagined –
Why should he be back at this time? What

Could bring him now? Listen!

MOSES: What do you hear?

MIRIAM: It's the call he gives when he's reaching home.

AARON: Her son.

It's Shendi.

MIRIAM: Something has happened.

Why is the palace here? What are you doing here

In my home? He cannot even come home.

RAMESES: Is this

Egypt?

MIRIAM: Do you hear him again? No nearer, no nearer.

He is being prevented. Can I get to him

Without being seen? Stay where you are. No one

Must see me, no one.

(She goes out. In a moment AARON follows her.)

RAMESES: You all think of me

As an enemy.

MOSES: We're not enemies so much

As creatures of division. You and I,

Rameses, like money in a purse,

Ring together only to be spent

For different reasons.

There will be summers to come

Which need the throne and lotus: a world

Richer for an Egypt prosperous in wisdom

Which you will govern.

RAMESES: Am I never to see you?

MOSES: No, it would be better, never. Stay with your own:

A people without blame which still

Faces the good future. My own purpose

Would only bring you confusion. Forget me, Rameses.

RAMESES: That anyway is impossible. I know

I bear your mark, and how will you obliterate

That? Do you forget the feel of the year

When you were as I am? They count me as a man,

Just. But the boy is still in my head and mouth.

I feel him there. I speak him. I should burn
Throne and lotus gladly if I could break
Myself of boyhood, if burning would do it. But you
Are clear and risen roundly over the hazes.
You have the formula. I need it.

MOSES: Clear?
Evidence of that! Where in this drouthy
Overwatered world can you find me clarity?
What spirit made the hawk? – a bird obedient
To grace, a bright lash on the cheek of the wind
And drawn and ringed with feathered earth and sun,
An achievement of eternity's birdsmith. But did he
Also bleak the glittering charcoal of the eyes
And sharpen beak and claws on his hone of lust?
What language is life? Not one I know.
A quarrel in God's nature. But you, at least,
Are pronounceable: heir of Egypt, heir of Egypt.
That is yourself.

RAMESES: You mean I'm of no value
Except to be Egypt's ornament.

MOSES: Of much
Value; infinite.

RAMESES: But we stay unfriendly?

MOSES: Because I taste your boyhood and remember mine
And like them both.

RAMESES: But even so –

MOSES: You shall stay as you are.

RAMESES: Exactly as I am, a friend of Moses.

MOSES: They're coming with Shendi. Keep with me in the shadow.
(*Enter MIRIAM and AARON, supporting SHENDI.*)

MIRIAM: He has been so strong. Are you ill? How are you ill?
You can speak, surely you can speak? We don't know them;
That's what is worst – our own – even in childhood
They say so little.

AARON: Lie here, Shendi.

33

MIRIAM: Still
 And quiet. What shall I do for him?

AARON: Give him this water.

MIRIAM: A sip, and then you shall have more.

SHENDI: They'll come.

MIRIAM: Keep yourself quiet.

SHENDI: Yes, they will come,
 They'll come for me, they'll find me!

AARON: What have you done?

MIRIAM: Done?

SHENDI: What are you holding me for? Must I always
 Be held? It was the sun! Don't you know that?
 They make madmen in the sun. Thousands of madmen
 Have been made in the sun. They say nothing, nothing at all,
 But suddenly they're running – no, not they,
 It's only their bodies that are running: the madmen
 Are still standing in the sun, watching their bodies
 Run away. Can they kill me for that? Or what, or what?
 It was the strike that made it happen!

AARON: What have you said?
 What strike?

MIRIAM: He's ill!

SHENDI: No, it was the sun; not the strike,
 The sun. The noise of the strike, the whips.

AARON: The strike?
 What was it? What has happened?

SHENDI: The spermy bastards!
 They make us hit the earth like spit.

MIRIAM: What are you saying?
 Don't ask him any more!

AARON: I'll make him tell me. What strike?
 What are you saying?

SHENDI: I don't know what has happened.
 The brickmakers began it. A youngster was with me,
 Twelve years old, and he left me to watch the trouble.

I saw them take him away, they dragged him off
To the captain at the gate, because he was watching.
It has nothing to do with it. It's the sun. Have you heard
The order? They'll not give us straw to make the bricks;
We must gather the straw ourselves; but the tale of bricks
Must be more, more! What does it matter? Who says
It matters? They're coming for me.

MIRIAM: It cannot happen,
 Shendi, it cannot.

MOSES: Cannot happen, cannot be.
 Cannot. Earth, life, ourselves are impossibility;
 What is this Pharaoh who answers me with this?

SHENDI: Who's that?
 My uncle, is it? The great fellow that was.
 The man who thought he was Egypt. Have you come
 To try again, murderer? Look at your crop of relations
 And how they do in the land you dunged for us.
 Do you hear that? They're whipping the side of the tent.
 You know I can't stand up, they've come for me,
 You know it was the sun – uncle, uncle!

MIRIAM: It was neighbours talking, it was only the neighbours.

 – Aaron,
 It was neighbours talking. Wasn't it, wasn't it?
 (*Enter two* OVERSEERS.)

 No, no!

1ST OVERSEER: Nice family. Here's the man we want.

2ND OVERSEER: Get up,
 Little rat. So you'd strike? We'll teach you striking.
 Striking's our specialty. Eh? Not bad! We'll strike him!

MIRIAM: He's sick – can't you see?

1ST OVERSEER: That's enough of that.

RAMESES: What is this?
 Weren't you told I had sent for him?

2ND OVERSEER: My crimes!

RAMESES: Well, weren't you told?

1ST OVERSEER: No, sir; no, your holiness; not told.
I beg pardon, sir. I didn't see you, my lord, didn't see you.

RAMESES: I tell you now. I sent for him. Go away.

1ST OVERSEER: Yes, lord.

2ND OVERSEER: Yes, almighty.

(*They back away out of sight.*)

MIRIAM: You're here, Shendi, you're here. The prince has kept you.
He spoke for you.

SHENDI: No one warned – What are you doing with me?
Is it a trick? What did I say before they came?
My lord forgive me, I was ill.

RAMESES: Nothing will hurt you. You can rest.
You have seen enough of Egypt in this tent.

(*Exit RAMESES.*)

AARON: I begin to have hope.
Eh, Moses? This is the boy who will be our man,
The palace key. In the belly of our misfortune
We find our hope.

MOSES: We're not concerned with hope,
Or with despair; our need is something different:
To confront ourselves, to create within ourselves
Existence which cannot fail to be fulfilled.
It will not be through this boy, or through
Thankless palace manoeuvring and compromise.

AARON: Where will you turn, then?

MOSES: Where shall I look for triumph?
Somewhere, not beyond our scope, is a power
Participating but unharnessed, waiting
To be led towards us. Good has a singular strength
Not known to evil; and I, an ambitious heart
Needing interpretation. But not through Rameses,
Never through Rameses. I will not use him!

(*Curtain.*)

Scene Three

(*A room in the Palace, giving onto the terrace of Scene One. ANATH is standing on the terrace. TEUSRET's voice is heard calling 'Rameses! Rameses!' It draws nearer. ANATH comes into the room and listens for TEUSRET's voice which now comes from farther away. She turns to go back to the terrace. Enter RAMESES.*)

ANATH: Have you seen your father?

RAMESES: He has made me a present of my future
 With the royal seal attached. I'm to marry
 The King of Syria's daughter. Did you know?

ANATH: He told me he would ask this of you.

RAMESES: When I woke this morning I thought nothing of
 the future,
 Only of today, and what I remembered of the past.
 And yet in these twelve hours the future
 Has suddenly come up, two-legged, huge, as though to say
 'See nothing but me'. First Moses, with his fixed purpose
 Walking ahead of us, as absolute
 As a man's death. And now this other future,
 A stranger from Syria to be the focus
 Of my life, my senses and devotion, if it may be.

ANATH: I wish you happiness.

RAMESES: Where is Teusret?

ANATH: Everywhere.
 Put your hand in one place, she is already
 Beating her wings in another.

RAMESES: Listen – look –
 What is this 'now', the moment we're now crossing?
 Can this truth vanish?
 Look, your shadow thrown over the chair,
 That dog's jerking bark, the distance of whistling,
 A gate clanging-to, the water thrown into the yard,
 Your fingers travelling your bracelet, my voice – listen,
 My voice – your breathing –
 (*TEUSRET is heard calling RAMESES.*)
 And Teusret running through the empty rooms.

It is true for us now, but not till now, and never
To be again. I want it for myself.
This is my life.

(*Enter TEUSRET.*)

 It has gone.

TEUSRET: I've found you at last.
Where have you been hidden? Where were you?

RAMESES: With father.

TEUSRET: For an hour!
No one could tell me. The rooms were all deserted.
Just as it happens in my sleep sometimes; but then
The door on the other side of the room is always
Closing behind you, and the room is empty – I never
Come to you.

RAMESES: But, awake, it's different. You find me.

TEUSRET: Why did he talk for so long?

RAMESES: I'm to be married
He says.

TEUSRET: I had a riddle to ask you. Fareti
Taught it to me.

RAMESES: What is it?

TEUSRET: Rameses,
When will you be married?

RAMESES: Soon, he says.

TEUSRET: Why? Why? You can't! What does he mean?
Then – if you did – Why have you said so? Oh,
Why did you say it?

RAMESES: Teusret –

TEUSRET: Who is it?

RAMESES: The Syrian.
Her name is Phipa.

TEUSRET: Do you think that's pretty?
Phipa, Phipa, Phipa! The noise a flute makes
When the mouth's too full of saliva. You won't do it.

RAMESES: What can I say?

ANATH: Teusret, we all, you will find,
 Belong to Egypt: our lives go on the loom
 And our land weaves. And the gods know we need
 Some such alliance. If the dynasty is safe
 We can at least be partly ourselves. He will need
 Both of us still.

TEUSRET: He won't. He will be changed.
 The days will be different and I shall be the same.
 How shall I be happy then?
 (*Enter SETI.*)

 Will *you* be?

 Are you glad?

SETI: Can you imagine, Teusret,
 The frantic compulsion which first fetched man forming
 And breathing out of the earth's dust? Such
 A compulsion of beauty has this Phipa of Syria,
 With the addition of wit and a good head for business.
 She's immensely rich. Homegoing sailors,
 When there are no stars, steer perfectly for Syria
 Merely by thinking of her. So they say.
 A figure of her, hung under the stern
 And kissing the wake, ensures a harvest of fish.

TEUSRET: What a tale!

SETI: Well, yes, but she has beauty.

TEUSRET: Flowers for Rameses
 Then! We must make it an occasion. I'll fetch my lute
 And celebrate. Garlands! I'll make you into
 A nice little afternoon god. Don't go away.

RAMESES: Here, Teusret –

TEUSRET: You have earned a ceremony.
 Would you rather have me in tears? This isn't silliness
 But a proper formality. I need to do it.
 Wait, all of you.
 (*Exit TEUSRET.*)

ANATH: Let her do what she must.

RAMESES: Father,
I have something to ask you. It has to do with Moses.

SETI: He needn't trouble you.

RAMESES: Nor any of us. But haven't you
Overlooked his nephew?

SETI: This is nothing to you.
Nothing to you at all.

RAMESES: Nothing at all.
Moses has a sister and a nephew.
The nephew's a labourer. Might there not here be a way
By which you could come at Moses?

SETI: Statesmanship,
My son, is the god's gift to restrain their own
Infidelities to man. As for Moses,
I'll comprehend him when he's comprehensible.

RAMESES: Such as a commission for this nephew; or a place in
the palace.
What do you say? Can you talk of honours
To a man whose family is unhonoured? I don't know,
But you will know.

SETI: Who told you to speak of him?
What do you know of this name that you're bandying? Anath?
Is this your influence?

ANATH: Am I a planet,
To be so influential? No, Seti; it is not.
I would rather infect him with something less dubious
Than the blood of Moses.

(Enter TEUSRET with a lute and flowers.)

TEUSRET: Look, I have them. I got them
Out of my room. They were round my bronze Isis.
Shall I have offended her?

SETI: Do you know this nephew?

ANATH: I've seen him.

SETI: How did he promise?

ANATH: He promised to be male,

As though he might have the ability for a beard
I thought.

TEUSRET: Are you all ready for the ceremony?
Rameses, you must be in a chair; this chair.

RAMESES: Can it be tried?

SETI: What is it now?

RAMESES: To mark
My coming of age. May I commission the nephew?

SETI: That is still to be known. I must have precise
Information of him. Now forget the question.

TEUSRET: Why must you go
Before you see Rameses in flowers? And when
Have you ever heard me play on my lute?
(*Exit SETI.*)

 Has no one
Told him he has a daughter?

ANATH: The flowers were schooled
With salamanders, to be so enduring
In this furnace.

RAMESES: Will he really do it?

ANATH: The land
Is rocking, remember. He'll take hold even of grass.

TEUSRET: Let me begin. Neither of you has any sense
Of occasion. These on your shoulders. What *are* flowers?
What is the bridge to be crossed, I wonder,
From a petal to being a wing or a hand? These
For your brows. Does the scent of them sicken you?
My pollen fingers.

RAMESES: They're shattering already.

TEUSRET: Some of them are too full.

RAMESES: You've brought me the garden.
Here's an earwig on my hand.

TEUSRET: Tread on it. Now
You're ripe to receive a god. Isn't he, Aunt?
Does he look noble? My brother in bloom.

RAMESES: (*Treading on the earwig.*)
Out goes he. Let's get your singing over.

TEUSRET: (*Staring.*) I have to remember you. Sing with me.

ANATH: I?
Sing? With the crack in my voice? Not songs for bridegrooms.
Only songs in the minor, where a false note
Can be taken to be excessive sensibility.

TEUSRET: Nothing, nothing will go on in the old way.
I wonder, can I remember which is the key?

(*She touches the lute.*)

RAMESES: Did you know my father had ordered the Israelites
To gather their own straw?

ANATH: Yes, I knew.

RAMESES: Why did he?

ANATH: A little show of invulnerability.

RAMESES: Is Moses safe here?

TEUSRET: I wish there were echoes in this room,
A choir of them, to be company for my voice.
You will have to help me when I lose myself.

(*Sings.*)
> Why should there be two
> Where one will do,
> Step over this shadow and tell me
> And my heart will make a ring
> Sighing in a circle
> And my hands will beckon and bring
> The maiden fortune who befell me
> O fortune, fortune.

(*Enter SETI.*)

You see, father – doesn't he look married already?

(*Sings.*)
> Why do we breathe and wait
> So separate?
> The whirl in the shell and the sand
> Is time going home to time
> Kissing to a darkness.

So shall we go, so shall we seem
In the gardens, hand in hand.
O fortune, fortune.
So changed against the sun –

(*She is interrupted by MOSES, who enters bearing in his arms a dead Israelite boy.*)

ANATH: What are we to have now?

SETI: What is this? Isn't it enough that you broke
Into Egypt unasked but you must –

MOSES: This is your property.
Of little value. Shall I bury it in your garden?
You need have no anxiety. It will not grow.

ANATH: Oh, in the name of the gods –

SETI: Is your reason gone?

MOSES: (*Laying the body at SETI's feet.*)
Look: worthless, worthless. The music needn't stop.
You killed him.

SETI: As I thought; you've let your brain
Suffer in this heat. I saw, in the first few words
You spoke this morning, it would end in this.

TEUSRET: Rameses! That boy!

RAMESES: That isn't death
Lying on the ground.

TEUSRET: It is! It is! It is!

SETI: Well? Tell me: is it an act of sanity
To carry this child here? I'm sorry to see it.
Take him and have him buried. You know it wasn't
Done by me.

MOSES: It was done of you. You'll not
Escape from yourself through the narrows between By and Of.
Your captain killed him on the metal of your gates, as with
A score of others. If it wasn't done of you
Fetch the captain, condemn him to death, and watch
How he'll stare.

SETI: I'll see the man. It's understood.

MOSES: Who understands? And what is understood?
 If you move your foot only a little forward
 Your toe will be against your power. Is this
 How you imagined your strength to be – ungrowing,
 Unbreathing, a child, and dead? Out of him
 Comes your army, your fleet, the cliff of gold
 You move on, pride, place, adulation
 And name. Fetch in your captain,
 Fetch in your thousand captains, and condemn them
 For the murder of your power.

SETI: Nature is lavish,
 And in return for being understood,
 Not hoarded, gives us civilisation.
 Would you have the earth never see purple
 Because the murex dies? Blame, dear Moses,
 The gods for their creative plan which is
 Not to count the cost but enormously
 To bring about.

MOSES: And so they bring about
 The enormity of Egypt. Is that the full
 Ambition of your gods? Egypt is only
 One golden eruption of time, one flying spark
 Attempting the ultimate fire. But who can say
 What secrets my race has, what unworked seams
 Of consciousness in mind and soul? Deny
 Life to itself and life will harness and ride you
 To its purpose. My people shall become themselves,
 By reason of their own god who speaks within them.
 What I ask is that I may lead them peaceably
 Into the wilderness for a space, to find
 Their god and so become living men at last.

SETI: More favours, something new. What god is this?

MOSES: The inimitable patience who doesn't yet
 Strike you down.

SETI: He and I have something in common
 If he has patience. My trust is Egypt

And the maturity of the world.

MOSES: You know well enough invasion is probable,
 Unrest is in and out of doors, your southern half
 Splits from the north, the lords at your table
 Are looking down at their hands. And flowing through all
 Is the misery of my blood. Let that be clean
 First, and then your flesh may heal.

SETI: Enough,
 I have nursed you enough. Now dungeons can nurse you.
 Your god can find you behind the walls
 And return your reason when he will.

ANATH: Seti! Are you sure? Will the surly half
 Of Egypt believe he was mad?

SETI: Do you still play
 At being his mother?

ANATH: Do you think I do?

RAMESES: There could have been some other way than this.
 Is only Israel present to you,
 As once it was only Egypt?
 Are you still Moses? Or who? Who are you?

ANATH: Does he know?

SETI: A man without laws.

MOSES: What are the laws? Tell me, you taker of lives!
 I am here by fury and the heart. Is that not
 A law? I am here to appease the unconsummated
 Resourceless dead, to join life to the living.
 Is that not underwritten by nature? Is that
 Not a law? Do not ask me why I do it!
 I live. I do this thing. I was born this action.
 Despite you, through you, upon you,
 I am compelled.

(*A distant long cracking sound of thunder. MOSES jerks back his head to listen.*)

 Are we overheard? Behind
The door that shuts us into life, there is
An ear. Am I given the power

To do what I am?
What says the infinite eavesdropper?
(From horizon to horizon the sky is beaten into thunder.
Curtain on Act One.)

ACT TWO

Scene One

(*MIRIAM's tent, the evening of the same day. MOSES. AARON.*)

MOSES: Look: I shall divide them
Into groups a hundred or a hundred and fifty strong,
Each with a man to lead them, one they can trust,
Such as this man you mention, Morshad –
And the man I spoke with this evening. Put them down.

AARON: Morshad and Zedeth. Yes, I have them.

MOSES: And then
This morning's rioting, the man who started that,
Whatever his name is. Will they listen to him again?

(*AARON goes to the tent-opening and looks out.*)

He made his move too early, some few days
Too soon.

AARON: I thought I felt the earth quiver.

MOSES: What is he called?

AARON: The earth has moved. It stirred
Like an animal. Moses!

MOSES: The man has a name. Put him down.

AARON: Something unnatural has come awake
Which should have slept until time was finished.
Listen! Did you hear a roar? A building
Has collapsed. The dust is like a cloud, higher
Than the city. Will you see?

MOSES: We have something more to do
Than to listen to falling cities. The dust will settle
While we Hebrews die. Come on; give me the names.

AARON: Why does this mean nothing to you?
Why won't you come and see it?

MOSES: The names, the names.

(*MIRIAM stands in the opening, with a pitcher.*)

MIRIAM: All the water is blood.

AARON: Miriam! What is happening to the city?

MIRIAM: There's no water, no water. Nothing but blood.

AARON: Then my fear has foundation. The sun has set
On truth altogether. The evening's a perjury!
Let none of us be duped by it.

MIRIAM: The water
Is blood. The river floods it over the fields.
The wells stink of it.

AARON: What are you saying?

MIRIAM: Go out then
And see it yourself. The men who were thirsty enough
To drink what came, are lying at the well-heads
Vomiting.

MOSES: What men? Ours?

MIRIAM: Egyptians.

MOSES: Miriam,
What have you there?

MIRIAM: I filled my pitcher. We all
Filled our pitchers, everyone, in spite of –
Do you think it could happen to us? To them
Perhaps, something might happen; to the others but not
To ourselves.

MOSES: (*Bringing his hand out of the pitcher.*)
Not to ourselves. To the others.

MIRIAM: Your hand
Has water on it! It is water!

MOSES: From which well
Was this drawn?

MIRIAM: Our own. Are we likely to use the Egyptians'?
But I saw it, we all saw it.

MOSES: The sun this last hour
Has been that colour. Doesn't it at evening
Fall directly on our well?

MIRIAM: The sun? Are we
 Talking about the sun? Tell me I'm lying
 And look at my feet. We slopped in blood flooding
 From the Nile. I saw the Egyptians who drank it.

MOSES: The Nile.
 The Egyptians! But this water came from our well
 Not theirs. – Was I waiting, Aaron? I was waiting
 Without expectation. But surely, I already knew?
 We with our five bare fingers
 Have caused the strings of God to sound.
 Creation's mutehead is dissolving, Aaron.
 Our lives are being lived into our lives.
 We are known!

MIRIAM: Do you think it was you who made the Egyptians
 Vomit? We may as well all be mad.
 Where is Shendi?

AARON: What's this?
 Isn't there confusion enough? Confusion I call it!
 A contradiction of what we have always known
 To be conclusive: an ugly and impossible
 Mistake in nature. And you, you of all men
 Accept it, identify yourself with it. It must be
 Denied. What has become of you since yesterday?
 Is it not possible still to be plain men
 Dealing with a plain situation? Must we see
 Visions? You were an unchallengeable leader once.
 That is the man I follow. A plain soldier.

MIRIAM: Where can Shendi be?

MOSES: The plainest soldier is sworn to the service of riddles.
 Our strategy is written on strange eternal paper.
 We may decide to advance this way or that way
 But we are lifted forward by a wind
 And when it drops we see no more of the world.
 Shall we live in mystery and yet
 Conduct ourselves as though everything were known?
 If, in battle upon the sea, we fought

As though on land, we should be more embroiled
With water than the enemy. Are we on sea
Or land, would you say?

AARON: Sea? Land? For pity's sake
Stay with reality.

MOSES: If I can penetrate
So far.

MIRIAM: Why hasn't Shendi come home yet? It's past his time.
He should have stayed here the rest of the day.
Will you let me out of this intolerable night?
Are we going to stand here forever?

SHENDI: (*In the tent-opening.*) Mother!

MIRIAM: Shendi,
Has nothing happened to you? Let me see you and be
Reasssured. Were you harmed by what I saw?

SHENDI: What have you seen? Nothing happened? Everything!
We've stepped across to a new life. Where were we living?
It was the appearance, of course, the appearance of hell.
Nothing like it at all, except in our minds, our poor
Minds. I was going to make you try to guess,
But such an idea could never come at a guess.
They've made me an officer!

MIRIAM: I don't – understand what you mean.

SHENDI: Your son! You see?
They've made him an officer. Like an Egyptian officer.
Like? I am one. We didn't know, that was all,
The world is perfectly fair, something to laugh at.
The ridiculous difference between me this morning
And now! They found I was better with head than hands.

MIRIAM: Shendi, did you come by way of the wells? Did you
see them?

SHENDI: I expect so. They say they're diseased. Can you imagine
How I felt when they took me by the arm and led me
Apart from the other men? I almost fought them.
I knew I was going to be beaten –

MIRIAM: Shendi, stop!
What are you saying?

SHENDI: Hell is done, done,
Done with, over!

MOSES: For you.

MIRIAM: They would never do it.
But then tonight everything is to be believed.
Nothing has any truth and anything is true.

SHENDI: I report at the officers' quarters
In half an hour. I'll take some of my things
Along with me now. Has the world always been known
To spring such wonders, do you think? You're to live with me,
Mother, do you understand? Follow on later
And ask for the new officer. At the officers' quarters.
Have you something you can give me to wrap this linen in?
The Libyans have broken across the border and massacred
Two companies of the border regiment.

AARON: What?
A massacre? When was this?

SHENDI: I don't know when.
Where have you put my razor? Four hundred Egyptians
Killed, they say. They talked as though
I were already one of themselves. They say
There's also a rumor of revolution in the south.

AARON: Moses, do you hear?

SHENDI: Where is my razor?

MIRIAM: There.
Did you see the wells? I don't know what life's doing.
I don't know how we're to think.

AARON: Ambitiously.
These incidents all march our way. The Libyans
Over the border – revolution – Time
Is preparing for us with a timely unrest.
We came to Egypt at the perfect hour as it happens.

SHENDI: That's enough of talk like that!

MIRIAM: As it happens;
 If we knew what happens. Shendi an officer!
 Will this be what we want, at last? As the Nile
 Happens into blood. Shendi an officer.

SHENDI: And the officers' quarters, remember: comfort.

MIRIAM: As massacre
 And revolution happens. As tomorrow
 Happens, whatever happens tomorrow.

SHENDI: Come on,
 I must go.

MOSES: Refuse this commission.

SHENDI: What did you say?

MOSES: Refuse this commission.

MIRIAM: Refuse it?

SHENDI: Listen to that!
 As my uncle happens, this is no surprise.
 Only one of the family must rise
 And glow in Egypt. The rest of us can keep
 Against the ground, and lose the whole damned world
 Because Moses prefers it. But in spite of that,
 In spite of that, generous brother of my mother,
 We hope to live a little.

AARON: As who does not?
 The Pharaoh, I quite see, will have his motives.
 But we can outmove motives to our advantage;
 And here surely is a kind of proferred hand.

MIRIAM: Why should he refuse? How could he refuse?

SHENDI: It's clear
 Why he says it. It was he who came back for recognition
 And I have got it.

MOSES: Make yourself live, then, Shendi;
 But be sure it is life. The golden bear Success
 Hugs a man close to its heart; and breaks his bones.
 What have they said, these Egyptians?
 Come with us and we'll treat you well.

Not, come with us and we will treat
You and your people well.

AARON: They will come in time
Even to say that.

SHENDI: (*To MOSES.*) This sounds well
Indeed, from you!

MIRIAM: Shendi is to be all
That he can become – all; and I say so,
I who made him. Am I to go on holding
The guilt for his unhappiness when opportunity
Offers to deliver me from it? Guilt it was,
And damnation, for giving him birth. This will let me loose!

SHENDI: Why do we listen to him? I know how to value
The first fairness I've known. If you think so little
Of being alive, uncle, you will find they're assembling
Spears to flash on Libya. Why not make something
Of that? The tradition is that, once upon a time,
You didn't know the meaning of apprehension
Or fear – back in those days when it was you
They treated well.

ANATH: (*In the tent-opening.*) Does he still not apprehend
Or fear?

SHENDI: Madam, madam –

ANATH: What are you doing
To Egypt, Moses?

MOSES: What have you come for?

ANATH: You.
What are you doing to Egypt, Moses?

MOSES: What
Is Egypt doing to Egypt?

ANATH: Or Egypt to you.
Come with me. I came by the old walks.
What have I seen? You shall come with me
And see it and tell me, and see the men and women
Bewildered in the doorways, for the name of their world
Has changed from home to horror. And is this

What you have in your heart for Egypt? Then favour me
And also have it in your eyes.

MOSES: But why
Do you come to me? To whose blood has the Nile
Turned? It isn't mine. Can it be the spilt blood
Of Israelites that is flowing back on Egypt?
Why come to me?

ANATH: He wants reason! Rationalise
The full moon and the howling dog. I have less
Inclination to be here than the dog has to howl.
If you come with me to Seti, he's ready to talk to you.

MOSES: We've talked already.

ANATH: He'll let you take your Hebrews
To make their worship, or whatever you want of them,
On some conditions which he'll tell you.

AARON: Good.
Events are moving.

MOSES: If Seti is so ready,
Why did you make the walk through the ominous evening
To remind me that I'm in Egypt?

ANATH: Because he is sitting
Pressing his thumbs together, wedged inactive
In between his decision and pride. What it is
To have to do with men! They live too large.
I'm ready to take you.

MOSES: I'll go.

AARON: This will be a great day for Israel.

MIRIAM: My son has been made an officer.

ANATH: I shall be glad
Not to be alone this time, with the earth
Wavering to a hint of doom. I suppose
There have to be powers of darkness, but they should keep
To the rules. The sky is lighter. The worst may be over.

MOSES: Aaron, you will come too.

AARON: It has been easier
Than I should have thought possible this morning.

(*Exeunt ANATH, MOSES and AARON.*)

SHENDI: What is this business the Pharaoh has with my uncle?

MIRIAM: I mustn't think of Moses. Many things
 I must be sure to keep my thoughts quite away from.
 What is it we have to do? A dark mind
 And he has followed that woman.

SHENDI: Will he try to stop my commission going through?

MIRIAM: No, no, he's forgotten it.

SHENDI: What does he matter, then?
 I'm an officer!

MIRIAM: How could the water be blood, Shendi?

SHENDI: What?

MIRIAM: I'll put your things together for you.
 How grand we shall be!

 (*Curtain.*)

Scene Two

(*A room in the Palace. SETI. ANATH.*)

ANATH: Keep the window covered, Seti. The terrace
 Crackles with dying locusts. I looked out.
 I seemed to look within, onto myself,
 When I stood there and looked out over Egypt.
 The face of all this land is turned to the wall.
 I looked out, and when I looked to the north I saw
 Instead of quiet cattle, glutted jackals,
 Not trees and pasture but vulture-bearing boughs
 And fields which had been sown with hail. And looking
 To the south I saw, like falling ashes after fire,
 Death after thirst, death after hunger, death
 After disease. And when I looked to the east
 I saw an old woman ridding herself of lice;
 And to the west, a man who had no meaning
 Pushing thigh-deep through drifts of locusts.

SETI: Well; these things are finished.

ANATH: And what happens
 Now? What will you do when the mourners have done
 Wailing, and men look across the havoc of their fields
 And the bones of their cattle and say: You did this,
 What happens now?

SETI: Why am I to be blamed
 For all the elemental poisons that come up fungoid
 Out of the damps and shadows which our existence
 Moves in? Can I put peace into the furious
 God-epilepsy of earthquake and eruption?
 What am I but one of those you pity?

ANATH: You tricked him, you tricked Moses, and not once
 But seven times. First when I, against
 All my self-warning, approached the unapproachable
 And brought him to you. Didn't you make him promises
 Then, and break them? And that night your promises
 Plagued our ears with a croaking mockery,
 With an unceasing frog-echo of those words
 Which had meant nothing; with a plague of frogs!
 A second time you made promises, and a third time
 And a fourth: seven times you've broken them
 While the stews of creation had their way with Egypt.

SETI: You say this, concoct this legend; you have become
 Infected with the venom that's against me.

ANATH: No, I've no venom. I've no more efficacy
 Than a fishwife who has been made to breed against
 Her will; and so I'm shrill and desperate.
 No power against misery! That's what our lives add up to.
 Our spacious affability, our subtle intelligence,
 Our delicate consciousness of worlds beyond the world,
 Our persuasive dignity when sacrificing to the gods,
 Our bodies and our brains can all become
 Slutted with lice between afternoon and evening.
 You tricked him a second time, and that is what
 You saw: sweet made foul. And then the third time
 And we became the dungheap, the lusted of flies,
 The desirable excretion. Our pleasantness was flyblown.

SETI: I've suffered this once with Egypt —
ANATH: You tricked Moses.
 And what has come of it I would bring back to you
 Until pity came out of you like blood to the knife,
 Remembering how disease swept all the cattle,
 How we could not sleep for intolerable lowing
 Till daylight rounded up the herds of wolftorn
 Death. You tricked him, and that feculent moment
 Filthied our blood and made of us a nation
 Loathsome with boils. You had stirred up the muck
 Which the sweet gods thought fit to make us of
 When they first formed man, the primal putrescence
 We keep hidden under our thin dress of health.
 What a pretty world, this world of filthmade kings!
 When, after the sixth time, the hail came down,
 I laughed. The hail was hard, metallic, cold
 And clean, beating on us with the ferocity
 Of brainbright anger. As cut diamonds, clean,
 Clean, and fit to be beaten down by. When
 It stamped out the gardens and cracked the skulls of birds
 It bruised away the memory of vermin
 And struck our faces fairly. If then, if only
 Then our consciousness had gone clean out,
 Or if then you had let these Israelites go with Moses,
 We should not now so vainly
 Shuffle our fingers in the dust to find
 The name we once were known by. But you tricked
 For the seventh time, and then the curse of the locusts
 Strangled the whole air, the whole earth,
 Devoured the last leaf of the old life
 That we had sometime lived. The land is naked
 To the bone, and men are naked beyond the bone,
 Down to the barest nakedness which until now
 Hope kept covered up. Now climb and sit
 On the throne of this reality, and be
 A king.

SETI: Anath! These plagues were not my doing
 And you know they were not. No man would say I caused them.
 Only a woman with her mind hung
 With a curtain of superstition would say so.

ANATH: I admit it.
 I am superstitious. I have my terrors.
 We are born too inexplicably out
 Of one night's pleasure, and have too little security:
 No more than a beating heart to keep us probable.
 There must be other probabilities.
 You tricked Moses after I had gone myself
 To bring him to you, and what followed followed.

SETI: It is true I made certain concessions to Moses
 And reconsidered them. I was prepared
 To let him have his way, if in return
 He would use his great abilities to our advantage.
 But am I to have no kind of surety
 That he'll return, after this godhunt of his?
 I said to him, Take the men but their wives and children
 Must remain. And then I went further: I told him to take
 Both men and women, but the children must stay. And at last
 I only insisted on their cattle, since our cattle
 Were dead. I'll not be panicked by this chain
 Of black coincidence, which he with his genius
 For generalship has taken advantage of.
 He presumes upon the eternal because he has
 No power to strike his bargain. I have not done
 These things to Egypt. I'll not hear it be said.

ANATH: Well, they're done. Blame has no value anyway.
 There's not one of us whose life doesn't make mischief
 Somewhere. Now after all you've had to give in.
 At last, this morning, he has carried the day.
 We must calculate again, calculate without Moses.
 I picked unhappy days in those girlhood rushes.
 But at least we can sweep away the locusts.

SETI: How carried the day? It is he
 Who must calculate again. You understand

There will be no postponement of Rameses' marriage.
We can look forward to that, and the change of policy
Which I shall force presently.

ANATH: What do you mean?
Moses by now has called the assembly of the Hebrews.
By now Egypt has heard the news. Moses
Has taken policy out of your hands.

SETI: I sent
Word after him.

ANATH: Seti! What word did you send?
What have you done?

SETI: I have only been careful
To protect your future. Even before Moses
Had gone three steps from the palace there came the news
Of another defeat. Fate has taken a hammer
To chip and chip at our confidence.
But while I still have Moses to come at my call
I have not lost him. And while he needs my help
He will continue to come. And when he is tired –
We'll make a bargain.

ANATH: All this, then, over again.
You're mad. It isn't we who make the bargains
In this life, but chance and time. I tell you it's madness!

(*Enter RAMESES.*)

RAMESES: Father,
Is it true you've withdrawn your latest promise to Moses?

SETI: Whatever I have done or not done isn't to be said
In a sentence.

RAMESES: They say it's true. Wherever I have gone
Dank rumour has been rising off the pavements, chilling
Into the heart of the people: 'Pharaoh has refused
Moses again. What new disastrous day
Is coming?' I tell you I've been out walking
Under the burning window of the people's eyes.
You've stood fast long enough. Let Moses take
The Hebrews.

SETI: So you also are afraid of magic
 And believe that this tall Moses can make a business
 Out of curses? Do you suppose if I surrendered to him
 There would be any less roaring in the wind
 Or less infection in disease? Why
 Aren't you beside me like another man,
 Instead of so fretting me with nursery behaviour
 That I could strike you? I made life in your mother
 To hand me strength when I should need it. That life
 Was you. I made you exactly for this time
 And I find you screeching to escape it.

RAMESES: I have been
 Through streets that no men should have to walk in.
 You must let the Hebrews go. Father, you must!

SETI: You know nothing, you little fool, nothing! Govern
 By your idiocy when I am dead.

RAMESES: What
 Will you leave me to govern, or what by then
 Shall I have become, what figure of faded purple
 Who clears his throat on an unimportant throne?
 I am to you only the boy who comes
 To the door to say goodnight on his way to bed.
 It's you who invite the future but it's I
 Who have to entertain it, remember that.
 What is expedience for you may become
 Dark experience for me. And these last weeks
 I've heard the future's loping footfall, as plague
 Came after plague, and I knew the steps
 Were not passing but approaching. You
 Were persuading them. They came each time a little
 Nearer, and each time closer to me.
 Keep your word to Moses. Let him take them.

SETI: I tell you it isn't possible.

RAMESES: Then get
 Yourself another heir, and make him eat

Your black bread of policy. Marry yourself
To this girl from Syria. My plans are different.

SETI: Your plans are different! You insolent cub, you spoiled
Insolent cub! And so your plans are different?
You've already made your plans!

RAMESES: Wait. What
Was that noise?

ANATH: The old familiar. A man crying out.
What difference is one man's groaning more or less?

RAMESES: (*Looking from the terrace.*)
Oh, horrible! What is it that makes men
And makes them like this man? Abortions of nature.
It is true what they said.

ANATH: What is true?

RAMESES: What the other officers said, what I thought they spread
About out of malice: that Shendi outstruts them all,
Drives the Hebrews harder than any Egyptian
Drives them, hits them down with a readier fist,
And smiles and thrives under the admiration
Of the overseers. Go out on the terrace if you doubt me
And see him, Shendi, the son of Miriam, a Jew
Beating a Jew.

SETI: So perhaps at last,
So perhaps at last you will have seen
That what you thought was child's play, black and white,
Is a problem of many sides. And you will kindly
Wait and learn. This fellow does the work
Which you yourself suggested he should do
And does it conscientiously, without sentiment.

RAMESES: I suggested he should do it. Yes.
I put the whip in his hand. I raised that arm.
I struck that Jew. I did it. I did not know
How the things we do, take their own life after
They are done, how they can twist themselves
Into foul shapes. I can now see better
The deathly ground we live on. Yes, all right,

61

I have surrendered. Whatever happens will happen
Without me. I've finished meddling.

ANATH: Rameses!
Of all the Jews one Jew has done this.

RAMESES: It might be
A thousand instead of one.

ANATH: Rameses, only
One Jew!

SETI: Would you even encourage the traitor
In my son, because of your fear of this Moses?

ANATH: Yes,
I would make him rebellious, and if I could I would make
Every limb of your body rebellious;
I'd paralyse that pride which sends us packing
Into a daily purgatory of apprehension.

SETI: Turn yourselves all against me.
I stand now living and breathing only to protect
This country from disintegration.

ANATH: Oh
The gods, how we fumble between right and wrong,
Between our salvation and our overthrow,
Like drunk men with a key in the dark who stand
At the right door but cannot get out of the cold.
May the moment of accident bless us.

RAMESES: I shall not
Rebel again. That will be one trouble less.

SETI: Stand beside me. We're almost of equal height
And may yet come to be of equal mind;
And if that is so, one of us will find
The way of escape out of this distress
Of ours, either you or I.

(*Enter KEF, a Minister to the Pharoah.*)

KEF: My lord Pharaoh.

SETI: News; come on.

KEF: Better to hear it alone.

SETI: Bad news. Well, let's have it. Catastrophe
Is no longer my secret. Let us have it all.

KEF: My lord –

SETI: Go on, go on.

KEF: A report that the Libyans
Have annihilated the reinforcing fifth
Division.

SETI: It is impossible.

KEF: They were surrounded
And surprised. Only six men got through.

SETI: Six men.

RAMESES: Six men.

SETI: They load me to the last inch.

(*Enter TEUSRET.*)

TEUSRET: Moses has come
Again. I saw him walking like a lion
Behind bars, up and down in your battered garden,
Rameses. The sentries had tried to hold him
But he broke through their spears as though he didn't see them.
He looked at me, his eyes the color of anger;
He looked at me and gripped a mulberry-bough
And broke it, and said Go to your father, fetch me
Your father.

SETI: He can walk longer and break more boughs.
He shall wait, and find that Egypt is hard ground
Under his lion's walk. (*To KEF.*) Go out to the overseers
And tell them to tighten discipline, to give
No rest to those Hebrews, not to let man, woman
Or child straighten their backs while they still stand.
I shall not see him until I choose; and, when
I choose, for his people's sake, he'll do what I need.
See this done.

ANATH: Seti, take care; take care
What you do.

SETI: Let Moses think again what behaviour
Is best, best to save his people. (*Exit.*)

TEUSRET: Rameses,
What is it? Why are you so silent? Are you afraid
As well? Are you afraid? Are you, Rameses?

RAMESES: Why should I be? The sweet part of the world's
All over, but that's nothing. It had to go.
My mind had lutes and harps and nodding musicians
Who drowned my days with their casual tunes. They have been
Paid off by this honest hour. And now I hear
My voice raised in deathly quiet. It's insufferable
That my voice, without the accompaniment of good fortune,
Should be so out of key, so faltering,
So cracking with puberty. – Aunt Anath,
What's the meaning of my manhood, to be found
So helpless, to be so helpless: what is there to do
Which I could do and haven't yet seen?

ANATH: We're no longer alone.

(*MOSES stands in the doorway.*)

TEUSRET: Look, Rameses.

MOSES: Where is Seti?

ANATH: He will not see you.

MOSES: When will he learn? When,
When, when will he learn? We have agonised
This land with anger for too many days.

ANATH: You
And he together. No birth is worth this labour.

MOSES: For three hundred years the pangs of this coming
deliverance
Have been suffered by my people, while Egypt played.
But now Egypt suffers, and she says
This is a new hell. But hell is old;
And you yourself sitting in sunlight
Embroidered on it with your needle. Hell
Is old, but until now
It fed on other women, that is all.

ANATH: And all is the innocent as well as the guilty;
All is the small farmer and the singing fisherman

And the wife who sweeps; tomorrow's boy as well
As yesterday's. All these, while Seti twists
To have his way, must go to your fire like sticks.

RAMESES: (*Looking from the terrace.*)
The gods help them now! The gods help those Hebrews!

MOSES: It must be one people or another, your people
Or mine. You appeal to Moses,
But Moses is now only a name and an obedience.
It is the God of the Hebrews, a vigour moving
In a great shadow, who draws the bow
Of his mystery, to loose this punishing arrow
Feathered with my fate; he who in his hour
Broke the irreparable dam which kept his thought,
Released the cataract birth and death
To storm across time and the world;
He who in his morning
Drew open the furious petals of the sun;
He who through his iron fingers
Lets all go, lets all waste and go,
Except, dearly retained in his palm, the soul:
He, the God of my living, the God of the Hebrews,
Has stooped beside Israel
And wept my life like a tear of passion
Onto the iniquity of Egypt.

ANATH: So the great general steps down to captaincy.
I wonder. Does this god use you
Or do you use this god? What is this divinity
Which with no more dexterity than a man
Rips up good things to make a different kind
Of good? For any god's sake, if you came here
To get justice, also give justice.
In this mood the lot goes headlong.

MOSES: Headlong!
And our memories too. And our hands which once
Knew how to come together, must now forever
Hide themselves in our dress. We are utterly separate.

RAMESES: Look at the sky! A sea of cloud, blind-black,
 Is pouring onto the beaches of the sun!

TEUSRET: Oh, it will swamp the sailing of the air!
 The sky will be gone from us, it's taking the sky!
 What shall we do?

ANATH:　　　　　　　Hush, Teusret.

 (*The stage grows dark.*)

MOSES:　　　　　　　　　Seti
 May see better without the light of day.
 The hand of God has gone across his eyes
 And closed all life upon itself. Egypt
 Goes inward, by a gate which shuts more heavily than sunset,
 Leaving man alone with his baffled brain.
 Only Seti can let the sun free again.

ANATH: It is here! The darkness!

MOSES:　　　　　　　　Tell him, tell Seti
 That I wait for his answer.

 (*Curtain on Act Two.*)

ACT THREE

Scene One

(Miriam's tent at night. AARON. Enter MIRIAM.)

AARON: Everything has been done, I think. I have daubed
 The lamb's blood three times over the entry
 And all that remained of the meat has been burned. –
 Miriam! You; not Moses! What do you want
 Here at close on midnight?

MIRIAM: Must I want something
 To come into my own tent?

AARON: Tell me; what is it?
 There's no time left. Has the news got past our silence?
 Do they know? That's why you've come in the night. The
 Egyptians
 Are one ahead of us!

MIRIAM: News? I've got no news.
 Is there any news at midnight? I've come to sleep.

AARON: Why not sleep, as you did, in the city with Shendi?

MIRIAM: Do I have to be catechised in my own tent?
 If you want to ferret in unlighted places
 Penetrate into the mind of Moses, and let me
 Sleep.

AARON: His mind will be our history
 Before the morning. Whatever is about to happen –
 I cannot doubt that something is about to happen –
 Will divulge him to us at last. I have become
 Almost docile to his darkness. By what providence
 I wonder, did you come back? There was no way
 Of getting word to you, but you came, thank God.
 Whatever is wrong for you, to make you walk
 So far to sleep, this midnight of Moses
 (I call it to myself his midnight) will clarify
 Into right.

MIRIAM: Wrong things and right things!
 Still you talk of those, those things that are catches
 To make us lose heart. Take evil by the tail
 And you find you are holding head-downwards.
 Let me go to sleep.
AARON: Something that Shendi has done
 Has brought you back.
MIRIAM: Shendi, Shendi to blame!
 To you Shendi is always blameable.
 Because at last he can have ambitions,
 Because he's ripping up the bare boards
 His boyhood lay on, to make himself a fire
 Which will warm his manhood, we turn on him – yes,
 I also, as much as you – I stormed so.
 I? The right to blame him? The wrong to have borne him
 To that childhood. Why shouldn't he be finished with the lot
 of us?
AARON: So he turned you out: he sent you away.
MIRIAM: I left him.
 I came away from him. I couldn't watch him
 Live what is now his life.
AARON: I won't think of him.
MIRIAM: He'll succeed without your thoughts.
AARON: Look at me, Miriam.
MIRIAM: You're going away.
AARON: And so is all Israel.
 We all have staves in our hands and our feet shod
 For travelling; Moses' orders. He also gave
 Other orders; they were very curious.
 We have all had to eat lambs' flesh, seasoned
 With bitter herbs. As I see it, Miriam,
 That is his characteristic way of achieving
 Unity among us, before the event,
 That we should all fill this waiting time by doing
 The same thing, however trivial. And then
 We have splashed the blood three times over the doorways.

That is quite inexplicable. It is drying in the night air,
At this moment, while I speak. What happens, I ask myself,
When it is dry? It means our freedom. He has told me so.
Tonight we're to go free. And when I look at him
I have to permit myself a wonderful hope.

MIRIAM: He came back from Midian a madman.

AARON: His madness seems to be a kind of extended sanity.
But he tells me nothing, nothing is discussed or planned
Even with me, his lieutenant. And this closeness
Has hurt me, I won't try to deny it. And yet
He has me by the scruff of the heart and I ask
No questions. I've begun to believe that the reasonable
Is an invention of man, altogether in opposition
To the facts of creation, though I wish it hadn't
Occurred to me. I've been with Moses, watching
How in tent after tent he manipulated
Man upon man into consciousness. Though perhaps
They don't know of what they're conscious, any more than I do.
Except of the night; of the night, Miriam! I would swear
The night is dedicated to our cause.
You must have seen it: there's such a brightness,
Such a swingeing stillness, the sky has transfixed itself;
As though it hung with every vigorous star
On some action to be done before daybreak.

(*Enter SHENDI.*)

SHENDI: Why must he be here?
I have something to say to you, mother.

MIRIAM: Not any more
Tonight; nothing more said tonight. Go back
To your bed.

SHENDI: Yes, you must listen!

AARON: Listen to your tongue
Or your brotherly whip?

MIRIAM: He knows already what we feel.
Now let him alone.

SHENDI: Let him think what he likes. I have come
 To you, not to him. We've taken so long to get
 What at last we have: why must you spoil it? I know;
 It was the spate of our tempers, gone again now.
 If you go away from me, more than half the triumph
 Is lost. You haven't been my mother for nothing.
 I mean to see you happy.

MIRIAM: I shall stay alone.

SHENDI: Oh, it's fantastic. What did you expect
 My work to be? And how can we be scrupulous
 In a life which, from birth onwards, is so determined
 To wring us dry of any serenity at all?

MIRIAM: You must do as you must.

AARON: But in the morning
 He may wish he had chosen otherwise.

SHENDI: What do you mean?
 Let me hear what you mean by that. Have you
 And your brother done some dirtiness against me
 To put me wrong with the Pharaoh? I know you'd founder me
 If you had the chance –

 (Enter MOSES.)

MOSES: Get ready, Miriam. And you,
 Shendi. Get together all that you value.
 You won't come to this tent again.

MIRIAM: Get ready?
 All that I value? What would that be, I wonder?
 Tell your delirium to be precise.

AARON: This midnight is his. For pity's sake believe it,
 Miriam. Then all our wills resolved into
 One Will –

SHENDI: His, of course! The stupendous mischief
 Of the man! I beg your pardon if he no longer
 Rates himself as a man after living through
 The pestilences as though he owned them.
 You can blame him, not me, for the punishment
 I give the labourers. He makes them undisciplined

70

With his raving of freedom which they'll never get.
It's he, not I, who knits the darker and darker
Frowns for Pharaoh – it's he who's the one for you
To abominate, if anybody.

MOSES: Be ready for journey.
The time is prepared for us. What we were is sinking
Under the disposition of what will be.
Let it so dispose; let us not fondle our wrongs
Because they're familiar. Now, as the night turns,
A different life, pitched above our experience
Or imagining, is moving about its business.
Tonight – Aaron, Miriam, Shendi – our slavery
Will be gone.

AARON: Do you hear what he says?

MIRIAM: What is he hiding?
There's something he knows.

AARON: Something known by the night;
That was how it felt to me.

MIRIAM: What is it you know?

MOSES: The sound
Of God. It comes; after all, it comes. It made
The crucial interchange of earth with everlasting;
Found and parted the stone lips of this
Egyptian twilight in the speech of souls,
Moulding the air of all the world, and desiring
Into that shell of shadow, a man's mind –
Into my own.

AARON: What was told? What was said?

SHENDI: Oh, leave them
To excite each other. I'm going if you're not.

MOSES: Stay where you are. Do you deny voice
To that power, the whirler of suns and moons, when even
Dust can speak, as it does in Moses now?
It comes.
And by the welding of what loved me and what harmed me,
I have been brought to that stature which has heard.

Tonight, at midnight,
God will unfasten the hawk of death from his
Grave wrist, to let it rake our world,
Descend and obliterate the firstborn of Egypt,
All the firstborn, cattle, flocks, and men:
Mortality lunging in the midnight fields
And briding in the beds: a sombre visit
Such as no nation has known before. Upon
All Egypt! Only we who have the darkness
Here in our blood, under the symbol of blood
Over our doors, only we of Israel
Standing ready for the morning will be unvisited.

AARON: So this is what you know.

SHENDI: What he wants, what he fondly
Imagines. Why did I follow you here
To get drawn into this? That fox has his tail on fire
And someone should know about it. For the last time,
Are you coming?

MIRIAM: Don't go back – not just
Within a pace of this midnight.

SHENDI: I can see
What's been thought out between you. Now that you have me,
You think you'll keep me: here, dropped back in the pit.
What a chance of it! Must I tell you that I'm an Egyptian?
An Egyptian! I'm an Egyptian!

AARON: Mind what you say, Shendi!
Remember the midnight promised to us,
Which is almost here! No doubt the timing of God
Will be extremely exact. And does nothing, no presentiment,
Creep on the heart of Pharaoh at this moment?

MOSES: Aaron!

AARON: I wonder, does nothing make him fetch his firstborn
Beside him –

MOSES: Aaron!
Do you see the ambush I have blundered into?
I heard God, as though hearing were understanding.

But he kept his hands hidden from me. He spoke,
But while he spoke he pointed. Aaron, he pointed
At Rameses, and I couldn't see!

AARON: The boy
Pays for the father.

MOSES: Why had I not thought of him? —
When other boys were slaughtered I was spared for Israel.
Surely I who have been the go-between for God
Can keep one firstborn living now for Egypt?

AARON: Is this how you fought your other wars?
There were boys then who put
Eager toes into fatal stirrups, who were young
And out of life altogether in the same
Almighty and unthinkable moment. You learnt
Then to grieve and advance, uninterrupted.
And so it has to be now.

MOSES: Look what it is.
God is putting me back with the assassins.
Is that how he sees me? I killed an Egyptian
And buried him in the sand. Does one deed
Become our immortal shape? And Egypt! Egypt!
He was meant for Egypt. Aaron,
You are here in my place until I come again.
Keep Shendi with you.

AARON: Where are you going?

MOSES: Keep Shendi with you. (*He goes.*)

AARON: He is in a space somewhere between
The human and inhuman. That's a terrible
Neighbourhood.

SHENDI: Did you see how he looked? He believes
What he said.

MIRIAM: Shut us in. He has gone.
Can't we forget the man?

SHENDI: I won't stay here!
Thank goodness I can go where things are healthier.

AARON: It's midnight.
　　Wasn't that the winding of the city's horn,
　　The sound of twelve? I think so. I have to delay you,
　　Shendi.

SHENDI: (*At the tent-opening.*) Nobody will delay me.

MIRIAM: 　　　　　　　　　　　　　　Stay in the tent!

AARON: The hour may go past and leave us knowing
　　It was unremarkable. But wait till the light,
　　Wait, Shendi, keep yourself unseen
　　By that inquisition of stars out there.
　　Wait for Moses to return.

SHENDI: 　　　　　　Who?

MIRIAM: What is it? What have you seen?

SHENDI: 　　　　　　　　　　　I've lost the city,
　　I can't reach it! You trapped me!

MIRIAM: 　　　　　　　　What do you see?

SHENDI: The sand is rising and living!
　　Is an invisible nation going through to the north?
　　Or what is it the sand can feel? I can't go back,
　　God, God, I can't go!

MIRIAM: 　　　　　　Come inside,
　　Shendi, come into the tent.

AARON: 　　　　　　　　Happening,
　　You see, happening. Why try to go back?

SHENDI: Some of the men will still be awake. We could light
　　The lights in the barrack-room. If only some of them
　　Would come out to look for me! Can you hear it, the noise,
　　The rending apart and shuddering-to of wings?
　　Where can I get away from this? Nowhere
　　Except into the ground.

MIRIAM: 　　　　　　Shendi, here, in the tent,
　　In the tent: it will pass the tent.

AARON: (*Dragging him in.*) 　　　Are you trying to die?

SHENDI: Let me go, death; death, let me go!

AARON: It is I

Not death.

SHENDI: It isn't only you.

The wings were right over me and I was wrenched by a hand
That came spinning out of them. I'll not be sent into a grave.
I'll be what I was. I am Shendi, a Jew.
How can my blood alter and make me Egyptian?
I only wanted to be free! (*He tears off the Egyptian insignia.*)
Look: Egypt comes away – it's no part of me,
It's easily off. This body is all I am –
It is Shendi, the Jew, Shendi, Shendi, a Jew,
A Jew! Isn't it so? Then why am I dying?

MIRIAM: You are not, Shendi; it's gone past us. There's nothing
 more.

AARON: Look, you're with us.

SHENDI: Only free to die?

This wasn't a world. It was death from the beginning.
Here's my name, without a man to it. My name!
Let me go. It's a chance! I'll make them see me. Wings,

(*He breaks away into the dark.*)

Shadows, eagles! I am Shendi, Shendi, the Jew!
I am Shendi the Jew! Shendi the Jew!

MIRIAM: Shendi!

He has gone behind the sand. Son!

(*She runs into the dark.*)

AARON: The night

Of deliverance. Tonight we all go free.
And Miriam too. He said she would go free.

(*The voice of MIRIAM is heard crying out her last desperate
'Shendi!'*)

(*Curtain.*)

Scene Two

(The Palace. ANATH, TEUSRET.)

ANATH: How the stars have taken possession of the sky tonight.

TEUSRET: Occasion, dear Aunt. Phipa is coming,
 The magnitude out of Syria.

ANATH: Tomorrow.

TEUSRET: No; now they say tonight, very soon,
 For Rameses. Messengers were here
 Half an hour ago, sweating in the cool yard.
 She's already at Hahiroth, with her romantic nature
 Plying the spurs, and waking all the villages
 With the interminable jingle-jangle of what father calls
 Her considerable means. We shall see her tonight.

ANATH: How do we welcome her? Nothing has been said
 To me.

TEUSRET: Who says anything in this palace now
 Except good morning or good night? Father
 Waits for each moment to come and touch him
 And then it has gone before he can use it.

ANATH: And you
 Have a hard welcome for this girl from Syria.

TEUSRET: No; I'm praying her here, for all our sakes.
 She will bring solid and gay Syria
 To chase away the fiends.
 (Enter SETI.)

 Who is that?

SETI: I. Is there something to be seen?

ANATH: We're watching the dark for bridles.

TEUSRET: And the dark
 Watches us. I know you dislike me to be afraid of it.
 Are we all to meet her in the jumping shadows,
 Aunts, owls, flame, sisters and all?
 Or will she go quietly to bed and wait for tomorrow?

SETI: Tonight. She must dismount into a light
 Of welcome. Where's your brother?... Turn this way;

Are you handsome? Well, the years of my life
Conveyed in a woman, perhaps safely. Remember to love me
For everything you become, particularly
For the worship of the male sunrise which will stand
Over your maturity.

TEUSRET: What is it, father?
 What is it?

SETI: How many thousand thousand years
 Are being nursed in your body, my young daughter?
 And under a secure lock, away from the eyes.

TEUSRET: What eyes?

SETI: The envy; confusion.
 Where's Rameses?

TEUSRET: In bed.

SETI: He can go to bed tomorrow.

ANATH: Precious heart,
 That was a wild cry that ripped the darkness
 From somewhere down in the city.

SETI: He will have dreams in plenty after tonight;
 I'm giving them to him with both my hands. Where is he?
 Fetch him.

RAMESES: (*In the doorway.*) I am here, sir.

SETI: You're the Pharaoh.

ANATH: Seti!

SETI: You have slept into a throne and an empire
 While time has begun to heap age over me
 With a bony spade, to make me like the rest,
 Rameses, like the poor rest.

RAMESES: Has Syria come?

ANATH: Tell the boy what,you mean: and me.
 What are you pulling down now?

SETI: Myself.
 It seems that I have grown too tall
 And keep out the sun. I overbranch the light.
 I am giving you the throne, Rameses.

It gives itself. The wind has hurled it under you,
A biting wind, the hatred that has turned me
Into decay and grub in my own garden.
You may have luckier hands. You have at least
Hands less calloused with enemies. You will be able
To hold the sceptre perhaps without such pain.

ANATH: Abdication!

RAMESES: Is that what you mean? The throne?

SETI: This is how we distract them: under my seal
 Affixed in the morning, Moses shall have the permission
 He has raged for: and then, with the sun somewhat higher,
 Under my final seal you shall take Egypt.
 I drown myself in my own wave: I am not,
 But I am always. And when they come, the factions,
 The whorers and devourers, roaring over
 The rocks of the dynasty, they'll only find
 Perpetual Egypt.

RAMESES: I'm to inherit the kingdom
 Of desperate measures, to be not a self
 But a glove disguising your hand. Is there nowhere
 Where I can come upon my own shape
 Between these overbearing ends of Egypt?
 Where am I to look for life?

SETI: What else
 Am I shaking over you but a wealth of life?
 Do you comprehend, this land, the bright wrists
 Of the world on which the centuries are bracelets,
 Is yours? And the heart of beauty out of Syria.
 Teusret, watch: is there anything to be seen?
 Any sound yet? – Stupidity, what would you have?
 Love is the dominant of life, to which all our changes
 Of key are subdued in the end. You will be able
 To wander the winding and coitous passages
 Of the heart, and be more than you could have prophesied
 For yourself.

TEUSRET: Listen, listen!

SETI: Is it the girl?

TEUSRET: No, listen!

ANATH: A tortured gale, a gale
 Of crying moving through the streets.

TEUSRET: Listen!
 It's the noise of breaking lives.

SETI: What is it now?

RAMESES: What is it, Darkness? Why are you coming now?
 For whom this time?

ANATH: Oh, make the city silent!

TEUSRET: Someone's coming: a shadow, a man,
 Leaping for the terrace.

RAMESES: Let it come to me.
 If I'm to have Egypt I'll have its treachery, too.
 Keep away from the window. Who goes there? Stand.
 Who goes there? Who is it?

 (*MOSES comes breathlessly onto the terrace.*)

MOSES: Shut all your doors! Nothing will wait for us,
 We are at war with this moment. Draw yourselves
 Like swords. It is for Rameses.

RAMESES: For me?

MOSES: Put your lives round him.

SETI: Have you come
 Out of the city? What's there? What's on its way?

MOSES: Death, death, deliberately
 Aimed, falling on all your firstborn sons,
 All Egypt's firstborn, Seti, cattle and men;
 Death particular and infallible, mounting
 With an increasing terrible wake of cries
 To your window, to come to Rameses. I know –
 It was I that loosed it. Can I deflect it now?
 Can we so rope our lives together that we
 Can be a miracle against death?

SETI: Go back
 Into your night. I'll not believe in you.

ANATH: What do you want from us?

MOSES: Power of life
 To beat death out of this house.
 The vigour of our lives must be
 The miracle to save him.

ANATH: What is my life?
 It went to be your shadow. For fifteen years
 It has been nothing but a level of darkness
 Cast on the world by you. I made myself
 Your mother, and then loved you and desired you
 Till you became the best and worst of the world,
 The water that kept me alive to thirst.

MOSES: Anath –

ANATH: I loved you until I longed to hear
 That you were dead.

MOSES: Not this, not now!
 Give me greater life for the boy's sake.

SETI: There is no more life to be demanded of me
 Than I've already given: care,
 Effort, devotion, sacrifice of all inclination,
 Even to the sacrifice of my own person.
 I have changed the channel that evil was running in.
 This boy's the Pharaoh now.

RAMESES: And yet,
 And yet, if I'm to live, shall I know how?

MOSES: We'll hold you with our lives, if our lives will hold.
 More life! The dark is already beside us.
 In life's name, what are we?
 Five worlds of separation? Or can we be
 Five fingers to close into a hand
 To strike this death clean away from us?
 Has none of us the life to keep him living?

SETI: A great power, a great people,
 A living Egypt.

MOSES: Pain of man,
 Affirm my strength, and make me

Equal to this wrestler come against me.

TEUSRET: Look, look – the torches in the gateway;
 She is here!

SETI: Anath, all of you,
 We meet her as though Egypt were in high health;
 No anxiety on your faces as though you were ambassadors
 Of some haunted country.

TEUSRET: We shall be alive again.
 Phipa has come to us, and the horns have begun
 To wind their welcome in the towers. Come on,
 Rameses, come to meet her. The dark's not dangerous
 Now.

RAMESES: But still dark. And we have to enact
 A daylight for this unsuspecting beauty.
 Well, we'll meet her.

ANATH: No, don't go, don't look!
 The men who were opening the gates to let her in
 Have fallen to the ground. An owl in mid-air
 Has wrenched itself upward screaming, and smashed
 Down to the yard – there falls another! Oh,
 Are these the flowers we throw at her feet?
 You asked us for life, Moses; what life have you
 Against this death which pushes through the gate
 Shoulder to shoulder with the bride? Moses,
 It is now that you must break through to your power,
 Now! It's here.

MOSES: The shadows are too many.
 All was right, except this, all, the reason,
 The purpose, the justice, except this culmination.
 Good has turned against itself and become
 Its own enemy. Have we to say that truth
 Is only punishment? What must we say
 To be free of the bewildering mesh of God?
 Where is my hand to go to? Rameses,
 There's no more of me than this. This is all:
 I followed a light into a blindness.

TEUSRET: Come
 Away, Rameses, Rameses, come now.
 You must meet her and love her.
 Isn't it in love that life is strongest?
 I want you to love her. Already we're latc.

RAMESES: Why is she sighing, Teusret? Such great sighs.
 They have taken all the air. Now there will be
 Nowhere to breathe. Come with me.
 (*He crumples and falls.*)

TEUSRET: Rameses,
 I don't know the way!

RAMESES: I am finding it for you.
 Stoop, Teusret. You see? You cannot lose me.
 Here I am. (*He dies.*)

TEUSRET: Where? Where? Rameses!
 I'll meet her alone, then. When she comes she'll reach you.
 She must, she must. She came so far.
 (*She runs to the courtyard.*)

ANATH: Rameses, pharaoh of sleep, you have
 The one sure possession of the world.

SETI: (*To MOSES.*) You have done what you returned for.
 You found us in the morning.
 Leave us with what remains of the night.
 The day you found us in is over.
 (*Enter AARON.*)

AARON: We are standing ready. The sound of the wings is quiet
 And the stars are fading in silence.
 All ears wait for your command to march.
 Egypt is throwing away its gold to have us gone.
 Is it now?

MOSES: Now! At last the crying of our past
 Is over.

ANATH: You have the freedom of the darkness, Moses,
 Why do you wait? Haven't you recognised
 The triumph of your purpose? Your twelve hundred
 Thousand souls, out here in the dungeon of the night

Are waiting to hear the long bolts grate back.
Rameses has died,
And the air stands ready in the wilderness to take you in.
Rameses has died. Tomorrow the lizards
Will be sparkling on the rocks. Why aren't you dancing
With such liberty for such starving souls?

MOSES: Anath – Egypt,
Why was it I that had to be disaster to you?
I do not know why the necessity of God
Should feed on grief; but it seems to. And to know it
Is not to grieve less, but to see grief grow big
With what has died, and in some spirit differently
Bear it back to life. The blame could impale me
Forever; I could be so sick of heart
That who asked for my life should have it; or I could see
Man's life go forward only by guilt and guilt.
Then we should always be watching Rameses die.
Whereas he had such life his death can only
Take him for a moment, to undo his mortality,
And he is here pursuing the ends of the world.

ANATH: You have nothing now except the wilderness.

MOSES: The wilderness has wisdom.
And what does eternity bear witness to
If not at last to hope?
(Re-enter TEUSRET.)

TEUSRET: I have seen her. O Rameses,
She has come so gifted for you,
With pearls like seeds of the moon,
With metal and strange horns, ebon and ivory,
Spilling chalcedonyx and male sapphires.
Doesn't their brightness come to you? Do they glimmer
Nowhere into the cupboards of your sleep?

SETI: She need bring nothing, except the hour that has gone.

MOSES: Death and life are moving to a call.
I turn from Egypt.

ANATH: What is left
 To call to me?

MOSES: The morning, which still comes
 To Egypt as to Israel, the round of light
 Which will not wheel in vain.
 We must each find our separate meaning
 In the persuasion of our days
 Until we meet in the meaning of the world.
 Until that time.

 (*He goes. The early light reaches RAMESES.*
 The curtain falls.)

THE BOY WITH A CART

To Barry Mann
the first Cuthman

Characters

CUTHMAN

Cornish neighbours:
BESS and MILDRED

MATT and TIBB

Cuthman's MOTHER

Villagers of Steyning:
TAWM

His DAUGHTER

His SON-IN-LAW

A FARMER

ALFRED and DEMIWULF, the sons of MRS FIPPS

CORNISH NEIGHBOURS, MOWERS,
VILLAGERS OF STEYNING and
THE PEOPLE OF SOUTH ENGLAND

The Boy with a Cart was first performed at the Coleman's Hatch, Sussex, in 1938. It was subsequently revived at the Lyric Theatre, Hammersmith, on 16 January 1950, with the following cast:

CUTHMAN, Richard Burton

BESS, Hazel Terry

MILDRED / MRS FIPPS, Diana Graves

MATT, Lee Fox

TIBB, John Kidd

CUTHMAN'S MOTHER, Mary Jerrold

TAWM, Noël Willman

HIS DAUGHTER, Harriette Johns

HIS SON-IN-LAW, Adrian Cairns

A FARMER, Olaf Pooley

ALFRED, David Oxley

DEMIWULF, Robert Marsden

Director John Gielgud

THE PEOPLE OF SOUTH ENGLAND:
In our fields, fallow and burdened, in grass and furrow,
In barn and stable, with scythe, flail, or harrow,
Sheepshearing, milking or mowing, on labour that's older
Than knowledge, with God we work shoulder to shoulder;
God providing, we dividing, sowing, and pruning;
Not knowing yet and yet sometimes discerning:
Discerning a little at spring when the bud and shoot
With pointing finger show the hand at the root,
With stretching finger point the mood in the sky:
Sky and root in joint action; and the cry
Of the unsteady lamb allying with the brief
Sunlight, with the curled and cautious leaf.

 Coming out from our doorways on April evenings
 When tomorrow's sky is written on the slates
 We have discerned a little, we have learned
 More than the gossip that comes to us over our gates.
 We have seen old men cracking their memories for dry milk.
 We have seen old women dandling shadows;
 But coming out from our doorways, we have felt
 Heaven ride with Spring into the meadows.

We have felt the joint action of root and sky, of man
And God, when day first risks the hills, and when
The darkness hangs the hatchet in the barn
And scrapes the heavy boot against the iron:
In first and last twilight, before wheels have turned
Or after they are still, we have discerned:
Guessed at divinity working above the wind,
Working under our feet; or at the end
Of a furrow, watching the lark dissolve in sun,
We have almost known, a little have known
The work that is with our work, as we have seen
The blackthorn hang where the Milky Way has been:
Flower and star spattering the sky
And the root touched by some divinity.

 Coming out from our doorways on October nights
 We have seen the sky unfreeze and a star drip
 Into the south; experienced alteration

Beyond experience. We have felt the grip
Of the hand on earth and sky in careful coupling
Despite the jibbing, man destroying, denying,
Disputing, or the late frost looting the land
Of green. Despite flood and the lightning's rifle
In root and sky we can discern the hand.

It is there in the story of Cuthman, the working together
Of man and God like root and sky; the son
Of a Cornish shepherd, Cuthman, the boy with a cart,
The boy we saw trudging the sheep-tracks with his mother
Mile upon mile over five counties; one
Fixed purpose biting his heels and lifting his heart.
We saw him; we saw him with a grass in his mouth, chewing
And travelling. We saw him building at last
A church among whortleberries. And you shall see
Now, in this place, the story of his going
And his building. — A thousand years in the past
There was a shepherd, and his son had three
Sorrows come together on him. Shadow
The boy. Follow him now as he runs in the meadow.

(*Enter CUTHMAN, running. He stops short as he sees two
NEIGHBOURS approaching.*)

CUTHMAN: Now, my legs, look what a bad place
You've brought me into: Bess and Mildred coming:
Two nice neighbours with long noses. Now
I should like the sun to go down, and I could close
As the daisy closes: put up my shutters, slap,
Here in the long grass. Whip the world away
In one collapsing gesture. And you can't
Waken a sleeping daisy with a shaking. —
Well, green is green and flesh is a different matter.
Green is under their feet, but my lot's better.
I can say to them, Neighbours, believe it or not.
God is looking after my father's sheep.
But the simple truth is harder to tell than a lie.
The trouble I'll have, and the trouble they'll have to believe it!
And I wasn't looking for trouble this bright morning.

(As the NEIGHBOURS come up to him.)

Good morning, good morning!

BESS: Good morning, Cuthman.

CUTHMAN: This is the morning to take the air, flute-clear
 And, like a lutenist, with a hand of wind
 Playing the responsive hills, till a long vibration
 Spills across the fields, and the chancelled larches
 Sing like Lenten choirboys, a green treble;
 Playing at last the skylark into rising,
 The wintered cuckoo to a bashful stutter.
 It is the first day of the year that I've king'd
 Myself on the rock, sat myself in the wind:
 It was laying my face on gold. And when I stood
 I felt the webs of winter all blow by
 And in the bone-dry runnel of the earth
 Spring restart her flood.

MILDRED: We came to find you,
 Cuthman, expecting to find you with the sheep.

CUTHMAN: Dinner-time is passed, and my father
 Has forgotten where his son chews on a grass
 And thinks of meat.

BESS: Cuthman-chick, your father –

CUTHMAN: I know what you will say to me: My father
 Has my promise to be shepherd till he send
 Another boy to take my place and tend them.
 And, promise-bound, what do I do careering
 Like a stone down a hill, like a holidaymaker
 With only his own will? But they're safe,
 Those little sheep, more than with me beside them,
 More than with twenty Cuthmans now God minds them.

BESS: Cuthman-boy –

CUTHMAN: It is so! Not today
 Only, but other days God took the crook
 And watched them in the wind. One other day
 My father let the time go by, forgetting
 To send away the herd boy to relieve me.
 However often I stood up on the rock

Shouting 'Here's Cuthman! Here's a hungry shepherd!'
My only relief came from the clouds that closed
With the sun and dodged again: the sun that tacked
From dinner-time into the afternoon.
I was as empty as a vacant barn.
It might have been because my stomach was empty
That I was suddenly filled with faith –
Suddenly parcelled with faith like a little wain
In a good hay-season and, all round, the hills
Lay at my feet like collies. So I took
My crook, and round the sheep I drew a circle
Saying 'God guard them here, if God will guard them';
Drew it, though as a fence I knew it was less
Good than a bubble. Then to yearling and ewe
And lamb I said 'Give no trouble'; laid
My crook against the rock and went to dinner.
When I came back no lamb or yearling or ewe
Had broken through. They gently lay together
Cropping the crook's limited pasture, though
The unhedged green said 'Trespass'. – This is true.
Come, and I'll show you. I have waited again
To go to dinner and father has forgotten –

BESS: Cuthman, your father is dead.

MILDRED: We came to tell you.

CUTHMAN: You can't say that to me. I was speaking the truth.

MILDRED: We were speaking the truth.

CUTHMAN: You came to make me sorry,
 But you're breaking the sun over your knees to say
 My father's dead. My father is strong and well.
 Each morning my father buckles himself to,
 Like a leather strap, and at night comes to the fire
 His hands bare with well-water to tell
 The story of Jesus. So he will talk tonight,
 Clenching his hands against Gethsemane,
 Opening his hands to feel the Ascension
 As though after dry weeks he were feeling
 The first rain. Every evening I have watched,

And his face was like a live coal under the smoking
Shadows on the ceiling.

BESS: What can we do,
Cuthman, if you're unbelieving?

MILDRED: Come
Down with us and see him.

CUTHMAN: Let me alone.
No; if I come you'll take me to a place
Where truth will laugh and scatter like a magpie.
Up here, my father waits for me at home
And God sits with the sheep.

BESS: Cuthman, you make it
Hard for us to tell you.

MILDRED: The trouble we have
To tell him, and the trouble he has to believe.

BESS: How can we help you, Cuthman, in your trouble
If our words go by like water in a sieve?

CUTHMAN: Let me alone.

MILDRED: It's funny the way it takes him.
I don't even know if he really understands.
I don't even know if he really thinks we're lying.

BESS: Well, I don't know. Perhaps he feels like crying
And that's why he wants us to go.

MILDRED: It may be so.

BESS (*To CUTHMAN.*) If we can be any help –

MILDRED: If there's anything we can do –

BESS: We'd better go to his mother again, poor soul,
And get her a bite or two. She's certain not
To eat a thing unless somebody's by.

MILDRED: It's a merciful thing she had the sense to cry.

(*They go away down the hill.*)

CUTHMAN: What have I done? Did I steal God away
From my father to guard my sheep? How can I keep
Pace with a pain that comes in my head so fast?
How did I make the day brittle to break?
What sin brought in the strain, the ominous knock,

The gaping seam? Was it a boast on the rock,
The garrulous game? What have I done to him?
Father, if you are standing by to help me –
Help me to cry.

(*He falls on the ground.*)

THE PEOPLE OF SOUTH ENGLAND:
The day is pulled up by the root and dries,
And the sun drains to the hollow sea.
Heaven is quarried with cries.
Song dies on the tree.

The thongs of the daylight are drawn and slack.
The dew crawls down to earth like tears.
Root and sky break
And will not mend with prayers.

Only the minutes fall and stack
Like a rising drum
Where, thin as a draught through the crack,
Death has whistled home.

CUTHMAN: (*Rising to his knees.*) I have ears stopped with earth
Not to have heard the door-catch as he went,
The raven guling dew, the crow on the stack,
Nor grasped the warning of the howling dog
To bring me to my feet, to have me home;
Heard soon enough to run and still to find him;
For me to say 'You have been a father
Not to lie down so soon, not to forget
Till I forget the last hand that shall hold me'.
Still to be able to find him, and to see
How he put down his cup and dried his mouth
And turned as heaven shut behind him.

THE PEOPLE OF SOUTH ENGLAND:
How is your faith now, Cuthman?
Your faith that the warm world hatched,
That spread its unaccustomed colour
Up on the rock, game and detached?

You see how sorrow rises, Cuthman,
How sorrow rises like the heat

Even up to the plumed hills
And the quickest feet.

Pain is low against the ground
And grows like a weed.
Is God still in the air
And in the seed?

Is God still in the air
Now that the sun is down?
They are afraid in the city,
Sleepless in the town.

Cold on the roads,
Desperate by the river.
Can faith for long elude
Prevailing fever?

CUTHMAN: I have stayed too long with the children, a boy sliding
On the easy ice, skating the foolish silver
Over the entangling weed and the eddying water.
If I have only ventured the reflection
And not the substance, and accepted only
A brushwork sun skidding ahead of me
And not the dealer of days and docker of time;
Only the blueprint of a star and not
The star; accepted only the light's boundary
To the shadow and not the shadow, only the gloss
And burnish of the leaf and not the leaf –
Let me see now with truer sight, O God
Of root and sky; let me at last be faithful
In perception, and in action that is born
Of perception, even as I have been faithful
In the green recklessness of little knowledge.
Grant this, O God, that I may grow to my father
As he grew to Thy Son, and be his son
Now and for always.

NEIGHBOURS: (*Off.*) Cuthman! Cuthman! Cuthman!

CUTHMAN: Here's the valley breaking against the hill.

PEOPLE OF ENGLAND: Sorrow rises like the heat.

CUTHMAN: No longer dryshod can I keep my will.

PEOPLE OF ENGLAND: Nor the plumed feet.

CUTHMAN: The circle is broken and the sheep wander.
They pull the branches of the myrtle under:
Nibble the shadow of the cypress, trample
The yew, and break the willow of its tears.
This is no grief of theirs.

(*Two NEIGHBOURS, MATT and TIB, come up to him.*)

MATT: Cuthman, your father
Is dead.

CUTHMAN: They told me.

TIB: Your mother is sick.

CUTHMAN: She is grieving.

MATT: She is calling for you. We heard her voice through the
window.

CUTHMAN: I shall come soon. But the sheep are foot-loose and
green-
Hungry. They will be lost in sundown, and no
Bell-wether. Where would my mother tell me to go,
To her or bring them home?

TIB: You have no home, Cuthman.

CUTHMAN: I have no father, but my mother
Is at home.

MATT: Your home is sold over your head.
There's no roof over your sorrow: nor a patch
Of ground to know your name in; nothing, son,
Nothing in the valley.

CUTHMAN: My mother's at home.

TIB: Your mother is sick. What will you do, Cuthman?

CUTHMAN: I will drive my father's sheep home to my mother.

(*Exit CUTHMAN.*)

MATT: Could we have told him the rest of it: the last
Of the rotten business?

TIB: I had said enough.
I had done more damage with words than downpour
Did the crops. Look how his wing is dragging.

MATT: Look what he still has to know. His father dead,

The house sold over his head, and still the blow,
The final straw: no money in the house,
Not a flip of silver he can toss,
And double in his hand.

TIB: But still we said
Enough. And what we said he scarcely knows.
He carries the first trouble, and the rest
Only dog at his heels.

MATT: Make your way down.
None of us knows the way a neighbour feels.

(*Exeunt.*)

THE PEOPLE OF SOUTH ENGLAND:
Out of this, out of the first incision
Of mortality on mortality, there comes
The genuflexion, and the partition of pain
Between man and God; there grows the mutual action,
The perspective to the vision.
Out of this, out of the dereliction
Of a mild morning, comes the morning's motive,
The first conception, the fusion of root and sky;
Grows the achievement of the falling shadow,
Pain's patient benediction.

NEIGHBOURS: (*Entering.*)
One after the other we have gone to the boy,
Offering him advice, condolences and recommendations
To relations in more well-to-do places.
We have offered him two good meals a day. –
My wife is a bad cook but she gives large helpings. –
We have done what we could; we can't do more.
But he goes his own way. All that we say
He seems to ignore. He keeps himself apart,
Speaking only out of politeness,
Eating out his heart, and of all things on earth
He is making a cart!

One after the other we have gone to him and said,
'Cuthman, what use will a cart be to you?'
He scarcely so much as raised his head, only

Shook it, saying, 'I will tell you some other time;
I am in a hurry.'

One after the other we have gone also
To his mother, offering advice, condolences,
Recommendations to our distant relations.
His poor mother, she suffers a great deal in her legs.
And we have said to her, 'We hope you will excuse
Our asking, we hope you will not think us
Inquisitive, but what is your boy Cuthman
So busy on?' – And she replied each time:
'It is something after his own heart.'

We are none the wiser: and after all
It is none of our business, though it's only natural
We should take a certain amount of interest.

One after the other we have gone indoors
Turning it over in our minds as we went
About our chores. What will the old woman do,
Dear heart, with no roof over her head, no man,
No money, and her boy doing nothing
But make a cart?

'I will tell you some other time,' he said.
'I am in a hurry.' Well, that's his look-out.
It's not for us to worry.

(They go back to the village. Enter CUTHMAN with a cart, and his MOTHER.)

CUTHMAN: If you turn round, Mother, you can see the village almost under your feet. You won't get another view. It's sinking like a ship. We're looking at the last of it.

MOTHER: My legs, my legs! That hill's finished them. I should have stopped at the bottom. Your grandmother used to say to me when I was a girl: 'Daughter,' she would say, 'never get above yourself. It will be your downfall.' Little did she guess what things would happen to me, and it's just as well, I was her favourite daughter.

CUTHMAN: We shall never see it again; we shall never look again at the sun on the white walls, my swaddling-clothes put out to dry. I am out of them once and for all.

MOTHER: What on earth are you doing talking about your swaddling clothes? I wish I knew what was the matter with you. You were shortened at five months. You were walking at a year... Dear heart, I don't know however I got up as far as I have.

CUTHMAN: I have never known anything except the village and these few hills. I have two eyes, but how can I know if I have a memory for faces? I have two legs, but they've only carried me backwards and forwards like an old flight of steps. All my life I have been on a tether, but now I have slipped it and the world is green from side to side.

MOTHER: You know nothing of the world, Cuthman, and I'm thankful to say it. I am an old woman and I know too much. I have seen it. I've seen too much of it. Before I married your father I worked as a laundress at Letherwithel. That's fourteen miles away. And after we were married he brought me here, fourteen miles sitting behind him on a horse.

CUTHMAN: But now you're going to travel in style; we've got a cart for you to ride in.

MOTHER: (*Looking at the cart and back at CUTHMAN.*) Sometimes I think you can't be very well, Cuthman... Your father and I first met one October. He had ridden over to the fair and it came on to rain.

CUTHMAN: We have more than fourteen miles to go. Last night I looked up and saw the full moon standing behind a tree. It was like a strange man walking into the room at night without knocking. It made my heart jump... I don't know how many miles we'll have to go.

MOTHER: Cuthman! Look your mother in the face. What are you going to do with her?

CUTHMAN: We're going to travel.

MOTHER: I wish I knew what to do with you. The trouble is, you don't give me time to speak. You rush me up a hill so that I lose all my breath. You won't listen to reason. Where are you taking me? I insist upon knowing – don't think you can get away with those mysterious wags of your head. I shan't take another step until I know.

CUTHMAN: We're going to see the world, Mother.

MOTHER: I'm an old woman and I won't be joked to. Who gave you this man's address?

CUTHMAN: I haven't got an address, Mother.

MOTHER: I'm going to be very ill. (*She sits on the cart.*)

CUTHMAN: We shall find our way in the world, Mother, and I've made you a cart. You can rest as you go.

MOTHER: I've always stood up for you to the neighbours. They have come to me often enough and said: 'Cuthman isn't practical; he's going to find life very difficult.' And I have always said to them: 'Never you mind. Cuthman's my son, and when I was a girl his grandmother used to say to me, "Daughter, whatever else you may be, you have your wits."' – And in the end, after all the trouble I've had to bring you up, you want to use me like a barrowful of turnips.

CUTHMAN: Mother, can you remember the neighbours' faces when you came into the village riding on the back of my father's horse?

MOTHER: The neighbours' faces? I should think so indeed, like yesterday. They were all stuck out of the windows and they were shouting out to each other, 'What do you think of that? He's gone out of his way to find something!' They liked the look of me at once, they told me afterwards. We have always been very respected in the village.

CUTHMAN: That's just it; so it wouldn't do at all to end your days as a beggar in the place where you've always been respected; it wouldn't do to end them in a little hovel that someone would let us have, in a corner of one of their sheds, living on their left-overs and perhaps a good meal at Christmas.

MOTHER: This is the finish of me, I can't survive it. There wasn't a day in the week that I didn't have a clean apron. And now there's no one to look after me except a fool of a son, and he wants to trundle me all over the world like a load of fish.

CUTHMAN: What do you think I have been doing, Mother, while I sat all day on the doorstep, working at the cart? You

couldn't get a whistle or a word out of me. But I've been thinking and praying; and wherever we go, if we go wisely and faithfully, God will look after us. Calamity is the forking of the roads, and when we have gone a little way up the turn we shall find it equally green. We have nibbled the old pasture bare, and now we must look for longer grass.

MOTHER: I'm too old for it, too old for it. The world's no greener than a crab in the sea, and I don't like its nip... Oh, what a disaster! What a wealth of affliction! Nothing between me and the weather except my second-best bombasine!

CUTHMAN: You'll see; after a bit, and after a bit of worry perhaps, we shall come into our own again. You'll find yourself saying, 'This is just the place for us; just what we wanted.' And there'll be work for me to do. I shall buckle myself to every morning, and you shall have a white apron. These last days, while I sat on the step, I prayed. I was praying while I worked at the cart.

MOTHER: That's the best thing; it's always the best thing. I have been praying too. But I'm an old woman and I know the dangers. The world's a bothering place, that's what I can't make you see: the world isn't Heaven and I know it well.

CUTHMAN: But the world has more than one hill and valley and that's the comfort of it. Get easy, Mother; we're leaving.

MOTHER: I'm sick at the thought of it. Your grandmother would cry herself into her grave if she were alive to see us.

CUTHMAN: But as it is nobody is crying.

(He turns and looks for the last time at the village.)

MOTHER: (As they go.) It is just as well that we went away respected; that will be something to remember at any rate. I told the villagers, 'We are going away; Cuthman has found work to do.'

CUTHMAN: And hard work, too, Mother, if there are many hills. You're no feather.

(They set off on their journey, the MOTHER in the cart, and a rope round CUTHMAN's neck attached to the handles. As they go CUTHMAN begins to whistle. They are heard going away into the distance.)

THE PEOPLE OF SOUTH ENGLAND:
 Stone over stone, over the shaking track,
 They start their journey: jarring muscle and aching
 Back crunch the fading county into
 Dust. Stone over stone, over the trundling
 Mile, they stumble and trudge: where the thirsty bramble
 Begs at the sleeve, the pot-hole tugs the foot.
 Stone over stone, over the trampled sunlight,
 Over the flagging day, over the burn
 And blister of the dry boot, they flog their way
 To where the journeyless and roofless trees
 Muster against the plunging of the dark:
 Where the shut door and the ministering fire
 Have shrunk across the fields to a dog's bark,
 To a charred circle in the grass.
 No floorboard mouse, no tattling friend; only
 The flickering bat dodging the night air,
 Only the stoat clapping the fern as it runs.

 Stone over stone, Cuthman has spoken out
 His faith to his mother. She has been comforted
 A little; begins to believe in her son.
 He has made her clumsy rhymes to laugh at.
 She has tried to tell him stories of his grandmother,
 But it is hard to talk buffeted by a cart.

 After these miles, at last when the day leans
 On the wall, at last when the vagrant hour flops
 In the shade, they found a protected place, a ground
 Where limbs and prayers could stretch between root and
 Root, between root and sky; and they slept under curfew
 Or Cuthman slept. His mother was chasing fears
 Until daylight. 'What is rustling in the grass?
 What shakes in the tree? What is hiding in
 The shadow?' And Cuthman said, 'God is there.
 God is waiting with us.'

 Stone over stone, in the thin morning, they plod
 Again, until they come to a field where mowers
 Sweep their scythes under the dry sun.

(*The MOWERS at work in the field. They sing.*)

MOWERS: The muscle and the meadow
 Make men sing,
 And the grass grows high
 Like lashes to a lady's eye.
 Sickle-blades go sliding by
 And so does everything,
 Grass, the year, and a merry friend
 All at last come to an end.

(*Enter CUTHMAN wheeling his MOTHER. The MOWERS stop work and nudge each other.*)

MOTHER: I have gone up and down stairs fifty times a day when you were a baby and your aunt lived with us. She was an invalid but you wouldn't remember her. I have dug in the garden for your father, and had all the housework to do into the bargain. You don't know the work there is to do in a house. Your father's brother came to see us (you were only two months old at the time) and he said: 'Sister, you must be made of rope. My wife has help in the house, but nevertheless when she takes a broom in her hand she bursts into tears.' And I wasn't young, you must remember. I was nearly forty years old when I married your father. But never mind that. The point is that we've come a long way, so far that it's a wonder we've still kept the sun in sight; and I've been so jogged and jerked that I think your uncle must have been right. I begin to think that I'm really made of rope.

(*At this moment the rope round CUTHMAN's shoulders breaks, and his mother is rolled on to the ground. The MOWERS burst out laughing.*)

CUTHMAN: Are you hurt, Mother? The rope broke. How are you, Mother, are you all right?

MOTHER: Oh! Oh! If your mother ever walks again you'll be luckier than you deserve. This is what it has come to. You bring me all these miles to throw me on the ground.

CUTHMAN: The rope broke, Mother. Are you hurt?

MOTHER: Of course I'm hurt. I'm more than hurt, I'm injured.

CUTHMAN: Let me help you up; see if you can walk.

MOTHER: Walk? I might as well try to fly. What are all those people laughing at?

CUTHMAN: Try to stand on your legs.

MOTHER: They're laughing at me; that's what's the matter with them. They're laughing at an old woman who has had a misfortune. I told you what kind of place the world was, Cuthman, and I shall put a stop to it. I tell you, I've a sense of humour, but I won't be laughed at.

(*She gets to her feet and rounds on the MOWERS.*)

I don't know who you are, but I'm glad I wasn't born in your part of the country. Where I was born we knew how to behave; we knew better than to laugh at an old woman who had come to grief. We were very respected in the village where we come from, I may tell you; but as it happens we decided to travel.

(*The MOWERS give an even louder roar of laughter.*)

All right, all right! One of these days you'll laugh for too long, you'll laugh yourselves into trouble, take my word for it.

CUTHMAN: I must make a new rope for the cart; I shall have to make it out of withies. We shall find some at the stream we just passed over, remember, Mother? Fifty yards back or so. What will you do? Would you rather stay here, or come with me?

1ST MOWER: Did you hear what the boy said? A rope of withies! What a joke!

2ND MOWER: Don't you go and make the rope too strong, baby boy – You needn't go further than the end of the earth to find a fortune!

(*They go off again into a roar of laughter.*)

MOTHER: I should like to box the ears of the whole lot, but there are too many of them; it would take too long.

CUTHMAN: Let's go, Mother; let's find the withies.

MOTHER: I may be lame, but I'd walk away from this place if it was the last thing I did.

(*They go off, CUTHMAN wheeling the cart.*)

3RD MOWER: (*Singing after them.*)
>Don't fall into the stream, Mother.
>The water's very high.
>We might not hear you scream, Mother
>And we'd hate to see you die!

(*They laugh again, and sing it all together.*)

4TH MOWER: Here, did you feel that? A drop of rain!

1ST MOWER: Never; never on your life.

4TH MOWER: I swear it was. I felt a drop of rain. Look at the clouds coming up.

2ND MOWER: He's right. I felt a drop on my hand, and another, and another!

3RD MOWER: Don't stand about then. For the crop's sake, get at the hay!

(*They feverishly set to work.*)

1ST MOWER: It's no good. We can do nothing at all – the whole sky is opening.

THE PEOPLE OF SOUTH ENGLAND:
>That is rain on dry ground. We heard it:
>We saw the little tempest in the grass,
>The panic of anticipation: heard
>The uneasy leaves flutter, the air pass
>In a wave, the fluster of the vegetation;

>Heard the first spatter of drops, the outriders
>Larruping on the road, hitting against
>The gate of the drought, and shattering
>On to the lances of the tottering meadow
>It is rain; it is rain on dry ground.

>Rain riding suddenly out of the air,
>Battering the bare walls of the sun.
>It is falling onto the tongue of the blackbird,
>Into the heart of the thrush; the dazed valley
>Sings it down. Rain, rain on dry ground!

>This is the urgent decision of the day,
>The urgent drubbing of earth, the urgent raid
>On the dust; downpour over the flaring poppy,

Deluge on the face of noon, the flagellant
Rain drenching across the air. – The day

Flows in the ditch; bubble and twisting twig
And the sodden morning swirl along together
Under the crying hedge. And where the sun
Ran on the scythes, the rain runs down
The obliterated field, the blunted crop.

(*The MOWERS have fled from the rain, leaving the hay to disaster.*)

THE PEOPLE OF SOUTH ENGLAND:

The rain stops.
The air is sprung with green.
The intercepted drops
Fall at their leisure; and between
The threading runnels on the slopes
The snail drags his caution into the sun.

(*Re-enter CUTHMAN and his MOTHER, his rope of withies fastened from the cart to his shoulder.*)

CUTHMAN: All the mowers are gone.

MOTHER: If I'd been the ground under their feet I should have swallowed the lot.

CUTHMAN: But look at the field! You might think the sky had crashed onto it.

MOTHER: Rain! I never!

CUTHMAN: Down by the stream there wasn't even a shower; we had a hard job keeping the sun out of our eyes. But here the crop is ruined and everywhere is running with water. Only a field away, and we felt nothing of it!

MOTHER: They were laughing at an old woman come to grief. I told them how it would be. You'll go on laughing too long, I said. And look what a plight they're in now. – Poor souls.

CUTHMAN: Mother –

MOTHER: What is it, son?

CUTHMAN: When the withies break –

MOTHER: What! When the withies break! Do you think I'll get back into that cart when I shall be expecting every bump

to be my last? You don't know your mother, Cuthman. She
doesn't walk up to misfortune like a horse to sugar.

CUTHMAN: I shall be ready for it this time, Mother.

MOTHER: So you will, and so shall I. My eyes will be round
your neck every minute of the day.

CUTHMAN: I shall look out and keep a good hold on the
handles. And when the withies break –

MOTHER: If you can tell me what happens then it will be a
relief to me.

CUTHMAN: We won't go any further.

MOTHER: That's just what I was afraid of. All my bones will be
broken to smithereens.

CUTHMAN: When we had gone down to the banks of the stream
And were cutting willow-shoots (listen, Mother,
This is something I must tell you: how
From today for all my days life has to be,
How life is proving) while the rain was falling
Behind us in the field though we still wore
The sun like a coat, I felt the mood
Of the meadow change, as though a tide
Had turned in the sap, or heaven from the balance
Of creation had shifted a degree.
The skirling water crept into a flow,
The sapling flickered in my hand, timber
And flesh seemed of equal and old significance.
At that place, and then, I tell you, Mother,
God rode up my spirit and drew in
Beside me. His breath met on my breath, moved
And mingled. I was taller then than death.
Under the willows I was taller than death.

MOTHER: I saw you standing quiet. I said to myself
He has something in his heart, he has something
That occupies him.

CUTHMAN: We shall go as far
As the withies take us. There, where they break,
Where God breaks them, you shall set up
House again and put clean paper on

Larder shelves. And there where God breaks them
And scoops our peace out of a strange field
I shall build my answer in plank and brick,
Labour out my thanks in plaster and beam
And stone. You, Mother, and I, when God
Brings our settled days again, will build
A church where the withies are broken, a church to pray in
When you have put your broom away, and untied
Your apron.

MOTHER: Build a church, with our own hands?

CUTHMAN: With our own hands, Mother, and with our own
Love of God and with nothing else; for I have
Nothing else; I have no craft or knowledge of joint
Or strain, more than will make a cart, and even
The cart you scarcely would call handsome. What
Did I learn to do after I found my feet
And found my tongue? Only to seem as intelligent
As the neighbours' children whatever happened; to be
Always a little less than myself in order
To avoid being conspicuous. But now
I am less than I would be, less
Than I must be; my buzzing life is less
Than my birth was or my death will be. The church
And I shall be built together; and together
Find our significance. Breaking and building
In the progression of this world go hand in hand.
And where the withies break I shall build.

MOTHER: I am always lagging a little behind your thoughts,
I am always put out of breath by them. No doubt
I shall arrive one of these days.

CUTHMAN: In, Mother.
We shall arrive together if the cart holds good.

MOTHER: It always seems to me I take my life
In my hands, every time I get into this
Contraption.

CUTHMAN: Listen to that! A hard week's work
And she calls it a contraption!

(They set out again.)

THE PEOPLE OF SOUTH ENGLAND:

> For the lifetime of a sapling-rope
> Plaited in the eye of God,
> Among the unfamiliar twine
> Of England, he still must strain
> And plug the uneasy slope,
> And struggle in heavy sun, and plod
> Out his vision; still must haunt
> Along the evening battlement
> Of hills and creep in the long valleys
> In the insect's trail, the small, the dogged
> Pinhead of dust, by whose desire
> A church shall struggle into the air.
> No flattering builder of follies
> Would lay foundations so deep and rugged
> A church, a church will branch at last
> Above a country pentecost,
> And the vision at last will find its people
> And the prayers at last be said.
> This is how he mutters and how
> Weariness runs off his brow.
> Already the bell climbs in the steeple,
> The belfry of his shaggy head,
> And the choir over and over again
> Sings in the chancel of his brain.
> Across the shorn downs, to the foot,
> To Steyning, the last laborious track
> Is traipsed and the withies at his neck
> Untwist and break.
> So he tips the stone from his boot,
> Laughs at the smoking stack,
> At the carthorse shaking its brass,
> And knows the evening will turn a friendly face.

(Enter TAWM, an old man. He keeps a look-out over his shoulder.)

TAWM: They'll be after me again, not a corner of Steyning
> but they'll ferret me out; my daughter and my daughter's
> husband and my daughter's daughter; my nephew and my

nephew's nephews: they'll be after me. 'There's a cold wind, Father (or uncle or grandfather or whatever it is); take care of yourself, wrap yourself up; it's going to rain, it's likely to snow, there's a heavy dew.' What do they think I was born into this world for if it wasn't to die of it?

VOICES: (*Off.*) Father! Father!

TAWM: The ferrets, the ferrets! If I climbed up onto a cloud they'd find me out and bring me my hat.

(*Enter his DAUGHTER and his SON-IN-LAW.*)

DAUGHTER: Father, whatever are you thinking about? Why ever do you want to go walking about the fields with a cold wind blowing? I've got your supper waiting for you.

SON-IN-LAW: Here's your hat.

TAWM: (*With bitterness.*) Daughter, your husband's a most obliging man. He brings me my hat when the wind's in my hair. Thank you, son; you're an invaluable fellow.

(*Enter CUTHMAN wheeling his MOTHER.*)

DAUGHTER: Whoever have we got here? (*She giggles.*)

SON-IN-LAW: They're nobody I know. I've seen everybody twenty miles around and this is none of them.

TAWM: They're strangers, likely as not. If I was challenged I shouldn't be afraid to say that these are strangers.

DAUGHTER: What does he think he's doing going around like that with the old woman? I've never seen anything like it. (*She giggles again.*)

TAWM: You've got no understanding of geography, daughter. All the places in the world have their own ways and this young man is doing so because it's his way.

MOTHER: Cuthman, this is a very pretty place, quite a picture. The beauties of nature always make me feel honest with myself.

CUTHMAN: Mother, the withies have broken!

MOTHER: I remember when I was a girl I went up to my mother with a bunch of cornflowers in my hand –

CUTHMAN: Mother, the withies! The withies have broken!

MOTHER: Nothing has happened to me; I'm still where I was; I'm still in the cart.

CUTHMAN: I was holding it firm; but look at them, they've chafed in two. You can get out of it now, Mother; we're not going any further.

MOTHER: If ever I sit in a chair again I shan't recognise myself. What a very pretty place! Are we really stopping here, Cuthman?

CUTHMAN: Yes, Mother; we've arrived.

MOTHER: It's too much to believe all in a minute. But one thing's quite certain: it'll be a good many nights before I stop bumping about in my dreams.

(A crowd of VILLAGERS has collected. They stare at CUTHMAN and his MOTHER.)

CUTHMAN: Why do you think all these people are staring, Mother?

MOTHER: They're welcoming us. It's like old times. It was just like this when your father brought me home on the back of his horse.

CUTHMAN: (Calling out to them.) Could you tell me the name of this place, please?

(The VILLAGERS continue to stare.)

I say! Would you mind telling us where we are? – They're dumb, Mother.

MOTHER: They like us and respect us. One of these days they'll tell us so. It was just like this when your father brought me home, and they told me afterwards they liked the look of me at once they said.

TAWM: Good evening.

CUTHMAN: Good evening.

MOTHER: Good evening.

TAWM: Can I be of any help to you at all?

CUTHMAN: Perhaps you could tell us the name of this place.

TAWM: P'r'aps I could. I've lived here seventy years, so p'r'aps I could. It's Steyning, if I remember right.

CUTHMAN: Steyning… The church at Steyning.

TAWM: The church? If that's what you're after you've got the wrong place; there's no church here.

A WOMAN: This is a poor place and we're poor people; we must pray on the bare ground.

CUTHMAN: I've come to build a church.

(*This causes a sensation among the VILLAGERS.*)

MOTHER: It's an idea that my boy has; he has got it very much at heart. But I don't know what we can be looking like; I can't imagine at all. You must take us for tramps. Before my husband died I always hoped that one day we'd see the country together, but it really is very tiring. Someone ought to do something about the state of the roads. My husband was a farmer.

TAWM: Does the boy want work to do?

CUTHMAN: Yes, I do.

TAWM: How does he treat you, Mother? Does he pester you with shawls for your shoulders to keep the air off, with hats and overshoes and gloves? Eh, does he? Does he protect you from draughts and shade you from the sun and hurry you out of the rain?

MOTHER: Listen, my goodness me! He asks me that, when he can see for himself how it is. My son pushes me into a cart and bumps and bangs me a million miles until I am the colour of midnight. And then he tips me out onto the hard ground as though I was refuse. And then into the cart I go again and over the hills, with the sun on me and the rain on me, and snow would have been all the same if it had come. But he is a good boy and his singing voice has improved wonderfully on the journey.

TAWM: He's a credit to you, Mother, and I shall borrow him from you when the need arises. We must find him work to do. My son is a good son, too, but he has gone off to the city. He wasn't a ferret either. Here's the farmer coming along that he was shepherd to. He'll be short-handed without my boy. (*To CUTHMAN.*) Can you manage sheep?

CUTHMAN: I looked after them for my father.

MOTHER: He's a great lover of animals, aren't you, Cuthman? And, as I say to him, animals know. Even sheep know. He can do anything he likes with them.

(*The FARMER comes up to them.*)

FARMER: Good evening, Tawm.

TAWM: You'll be needing another hand, I shouldn't be surprised, now that my son has gone scrimshanking off to the city.

FARMER: It's a loss, Tawm, and a pity he couldn't settle himself down like anyone else. Work's heavy enough at this time of year without being hobbled by a man short.

TAWM: Never in all my years, Mister, have I known a time when young men were scarcer.

FARMER: That's true, Tawm; there never has been such a time.

TAWM: I've been thinking, Mister; there's a young man here might do you fine. He's just such a one as my son was. He knows the difference between a man and a piece of flimsy. –

FARMER: (*To CUTHMAN.*) Are you a shepherd, son?

CUTHMAN: Yes, sir; I was shepherd for my father.

FARMER: Strangers, eh?

CUTHMAN: Yes, sir; strangers.

FARMER: Well, you've come at a good time. We can do with you. Is this your mother?

MOTHER: I'm his mother and there's one thing in the world I need, and that's a cushion at my back. Give me a rest and I shall begin to understand that good fortune's come our way at last.

TAWM: You can think yourself lucky, Mother, that life isn't forever shoving a footstool under your feet.

FARMER: Come back to my house with me; we'll talk about this. There's a pot of stew on the fire that I shall be eating for three days if I can't find someone to help me out with it.

DAUGHTER: (*To TAWM.*) Father, come in do. Your supper will be spoiled and you'll be in bed tomorrow with this dew soaking into your feet.

TAWM: (*To MOTHER.*) You see how it is, neighbour; you see
 how it is.

MOTHER: It is just like old times to hear you calling me
 Neighbour; everything is most delightful.

CUTHMAN: I'll fetch the cart and catch you up.

(*Exeunt Omnes, except CUTHMAN, who goes to the cart.*)

You see what comfort you have brought to us,
Old rough and ready! But your work's not over.
Those others have already forgotten the church
I've come to build, or find it hard to believe.
But when creation's tide crawled on its first
Advance across the sand of the air, and earth
Tossed its tentative hills, this place of idle
Grass where we are idling took the imprint
Of a dedication, which interminable
History could not weather away. And now
The consummation climbs onto the hill:
A church where the sun will beat on the bell, a church
To hold in its sanctuary the last light.
God be on the hill, and in my heart
And hand. God guide the hammer and the plane.
As the root is guided. Let there be a church –

(*He grips the handles of the cart.*)

Come on now, rough and ready.

(*Exit CUTHMAN with the cart. Enter two brothers, ALFRED and
DEMIWULF, the sons of MRS FIPPS, who later will give her name
to Fippa's Pit:* Fippa Puteus.)

ALFRED: A fat lot of good it is mooching about with a scowl on
 your face. It only makes you look like a sick dog. We must
 make the place too hot to hold him; there's nothing else
 for it.

DEMIWULF: So we will, so we certainly will! I'll make sure he
 goes off with a flea in his ear! –

ALFRED: Well, let's see you. He's been here a week and you've
 done precious little so far, except grind your teeth.

DEMIWULF: That's all you know. I've been speaking to people
 about it.

ALFRED: And what good's that, I'd like to know? What earthly good is it? Nobody has any ears for anyone except this ninny hammer of a boy. There's no sociability in the village any longer, that's what I say. Nobody ever comes to play bowls on Saturday evenings. We can't even put up a shove-ha'penny team against Bramber. Nobody can think of anything except this crazy idea of building a church.

DEMIWULF: They're a lot of gooseheads; they're a set of nincompoops, all of them, the whole lot of them! There's not a body in the village that hasn't been bitten by it, except we two and Mother.

ALFRED: The farmer has given him the ground.

DEMIWULF: The builder has given him the bricks.

ALFRED: The woodman has given him the timber.

DEMIWULF: Everybody is making a fool of himself in his own way.

ALFRED: Except we two and Mother.

DEMIWULF: Let's walk over to Bramber. I'm sick of the whole thing.

(*Exeunt.*)

THE PEOPLE OF SOUTH ENGLAND:
 Let time rely on the regular interval
 Of days, but we do no such thing. We pull
 Down the weeks and months like a bough of cherry
 To decorate our room: strip off the year
 As lightly as we tear off the forgotten
 Calendar. But the story must be told.
 We make a country dance of Cuthman's labours
 And widely separated days become near neighbours.
 (*Enter CUTHMAN's MOTHER wearing a white apron.*)

MOTHER: It's an astonishing thing how time flies. It only seems yesterday that I was being bounced all over the world, and now we've been settled in Steyning for six months as though we had lived here all our lives. Every one has been very kind. Cuthman is earning quite good money from the gentleman we met on the first evening we came. We live in a very nice little cottage. There are rather too many steps but one can't

expect everything. Every day I put on a clean apron and the neighbours tell me that they liked the look of me at once. We are already very respected. And it is really wonderful the way everybody helps my son with his church. Every spare moment they have they go with him and do a little more. Besides giving the field, the gentleman we met on the first evening has also given two oxen to help with the work. I told Cuthman that I thought it was extremely generous and he ought to feel very fortunate. When I have finished my work I go down to the church and watch all the villagers singing and hammering in the cool of the day… Well, I must now draw to a close. I have some milk on the fire and by this time it will probably all be boiled over. (*Exit.*)

(*Enter CUTHMAN, dragging behind him an oxen-yoke. Enter to him ALFRED and DEMIWULF.*)

CUTHMAN: Good afternoon, neighbours.

(*The BROTHERS pass by without speaking.*)

Could you tell me – have you seen my oxen?

ALFRED: (*To DEMIWULF.*) Was the boy speaking to us?

DEMIWULF: I think he was. Something about oxen.

ALFRED: (*To CUTHMAN.*) Are you wanting something?

CUTHMAN: My two oxen have strayed away somewhere. They're working with us on the church and we're needing them. Have you seen them anywhere about?

ALFRED: Not a sign. We've seen two oxen belonging to your master.

CUTHMAN: My master gave them to me for the work of the church. Where did you see them?

DEMIWULF: They were on our land.

ALFRED: Trespassing.

DEMIWULF: So we shut them up.

CUTHMAN: I'm sorry they were trespassing. I'll see in future that they stay where they belong. If you could fetch them for me I'll put them to work.

ALFRED: Oh no.

DEMIWULF: Oh no. They stay where they are.

CUTHMAN: We need them.

ALFRED: Then it's a pity you let them go plunging about on other people's property.

DEMIWULF: Where they are they'll stay, and that's flat.

CUTHMAN: What purpose will they serve shut up in a barn? We need them for the building.

ALFRED: So we heard you say.

CUTHMAN: There's one thing that I'll not see any man destroy; there's one fire in me that no man shall put out. I am dangerous as I stand over the foundations of the church. I have the unsleeping eyes of a watch-dog.

DEMIWULF: Go and yoke yourself. No doubt you'll find somebody who'll be only too pleased to drive you.

CUTHMAN: I ask you again: Let me have those oxen.

ALFRED: I'm sorry. I'm afraid there's nothing we can do about it.

CUTHMAN: Then I must move. One day I took a crook
And drew a circle in pasture; and today
I draw a circle here to guard the church,
A circle of a stronger faith than I
Could ever have mastered then. Already you slough
Your little spite; it has deserted you,
And all your power to stir and strength to speak
Has fallen round your ankles, where it hangs
With the weight of chain. And you are naked
Without your fashion of malice, and dumb without
Your surly tongues. But you shall help with the church
Since you refuse the oxen. You shall have
Their glory.

(*He yokes them together. As he does so the NEIGHBOURS enter and stand a little way off.*)

1ST NEIGHBOUR: Look what Cuthman is doing!

2ND NEIGHBOUR: Look! He is yoking them!

OTHERS: Can he be joking? Is this in fun?
They would never permit. They'd never allow
Liberties for the sake of a laugh.
He is angry. He is driving them

As though they were shallow-skulls,
As though they were thick-skins,
As though they were beasts of the field.

1ST NEIGHBOUR: It is neither anger nor fun.
It is the same stress that we see
Knotting his forearm and kneading his forehead
To drops of sweat when he wrestles
With timber in the framework of the church.

2ND NEIGHBOUR: What will their mother have to say about it?

MRS FIPPS: (*Bursting through the crowd.*)
I'll show you what their mother will have to say!
What's come over you all to stand and gape,
With outrage running to seed under your eyes?
Do you want all our days to be choked with insults
And devilment? We've stood a lot too much
Nonsense from this canting baby,
A lot too much.

(*To CUTHMAN.*) Take that off the backs of my sons and get out of this place. Do you hear me? Get out of this place! Take it off, I tell you! And don't let me see you or your amiable mother skulking round these parts any longer. Do you hear what I say?

CUTHMAN: Wait a moment. Your sons have shut up the oxen that were helping with the church. I asked them to give them back to us, but that's something they're not prepared to do. The building shall not be interrupted. If they'll not return the oxen they must replace them.

MRS FIPPS: You overbearing little brat! You'll be shut up your-self if I have anything to do with it; I'll see to it! I'll put you and your mother on the way where you belong – in the ditch with vagrants! My poor Alfred, my poor Demiwulf, your mother will see that the nasty wicked boy doesn't hurt you... It's your mother talking to you. Alfred! Demiwulf! Can't you hear me? – You've murdered them on their legs, that's what you've done. Take that thing off their backs before I get my hands to you. Go on! You insolent bantam! Do what I say!...

(*A change comes over her.*) What's happening? I'm being pushed
over! I'm being knocked down!

NEIGHBOURS: What a wind has got up! What a gale!

MRS FIPPS: Help! Help! The wind is blowing me over!

NEIGHBOURS: Mind your heads! The chimneys will be off!
What a tornado!

MRS FIPPS: Help! It's whirling me round!
It'll have me off my feet!

NEIGHBOURS: It will have her down!
Look at her, look at her now!

MRS FIPPS: Help! Help!

(*The wind blows her out of sight.*)

THE PEOPLE OF SOUTH ENGLAND:
The arms of the wood were not ready for this,
The turbulent boy who has pitched himself suddenly in,
The headlong ruffian hurling himself in the lap
Of the valley:
What can protect us from this ragamuffin
Who has stampeded into his manhood with
The shudder of the first anger of a rocket?
He has slammed back the ocean's stable-doors
And slapped the sturdy bases of the earth,
Wrenched and worried into the heart of heaven
And dragged a bellowing Lucifer to ground.
He has belaboured the homeflight of the day
Into a staggered bird. The word's gone round:
There will be no quarter, no pouring of oil.
The roots clutch in the soil, frantic against
The sobbing of the bough. The gates of evening
Clang in vain. Darkness will topple down
Under the guns of the enormous air.
It has lifted an old woman off her feet!
This is a matter of considerable local interest.
It is carrying her up as high as the trees,
Zigzag like a paper bag, like somebody's hat!
There hasn't been a hurricane like this
In living memory. It only shows

How ludicrous it is to strut in a storm.
Zigzag like a paper bag, like somebody's hat!
It will be a long time before we have exhausted
All the possibilities of a story
As amazing as this one is. Up! Up! Up!

NEIGHBOURS: Up! Up! Up!

(*The NEIGHBOURS with shrieks and squeals rush off to follow the old woman's flight.*)

THE PEOPLE OF SOUTH ENGLAND:
You may not think it possible, but tradition
Has it that this old woman was carried five
Miles and dropped in a pond. It's scarcely
Credible, but that is the story that got
About. And when the hurricane had dropped her
It dropped itself and the incident was closed.

CUTHMAN: (*Unyoking the BROTHERS.*) Well that was an upheaval. You'd better go and look for your mother. She'll be some way off by this time.

ALFRED: I'm not feeling very well. It's as though I was convalescing after a long illness. My voice seems to be climbing back on my tongue.

DEMIWULF: I feel like a toad crawling out from under a stone.

CUTHMAN: Before you do anything else perhaps you would fetch the oxen for me? It's time we got busy with them.

ALFRED: We'll fetch them for you at once.

DEMIWULF: At once. We're sorry if you have been put to any inconvenience.

CUTHMAN: The inconvenience was mutual. I shall be at the church.

(*Exit CUTHMAN.*)

ALFRED (*As he and his brother go off.*) I wonder where mother is by now? She always disliked long journeys, but at any rate she hasn't got any luggage to worry about.

THE PEOPLE OF SOUTH ENGLAND:
Do you catch the time of the tune that the shepherd plays
Under the irregular bough of the oak-tree,
The tune of the tale he expects your brain to dance to,

The time of the tune as irregular as the bough?
It will not come as anything fresh to you
That instead of events keeping their proper stations
They are huddling together as though to find protection
From rain that spoils the mowers' crop
From wind sweeping old women off their feet.
We merely remind you, though we've told you before,
How things stand. We're apt to take the meticulous
Intervention of the sun, the strict
Moon and the seasons much too much for granted.

(Enter CUTHMAN's MOTHER and TAWM. Enter to them some
of the NEIGHBOURS, downcast.)

MOTHER: I can hardly wait for my son to know. He has already
grown to love you like a father, I know that; he has often
told me so. It is nearly two years since we first met. How
astonishing, two years! Do you remember how we arrived
with that dreadful cart? I was so ashamed. You must have
thought we were nothing but riff-raff, and little did I imagine
what was in store for us. Usually my intuition is most acute;
things say themselves to me. But oddly enough nothing said
to me, 'One day that dear man is going to be your husband',
nothing at all. – Here are some of the neighbours coming
from the church. It's getting on so nicely. Good evening,
neighbours. Is it nearly done?

1ST NEIGHBOUR: It'll never be done.

2ND NEIGHBOUR: It'll never be finished now.

1ST NEIGHBOUR: There'll be no church.

MOTHER: Never be finished? Tush and nonsense! What
creatures men are. You're up to the roof.

1ST NEIGHBOUR: Up to the roof we may be but we'll get no
further. The king-post has beaten us.

TAWM: You can't be beaten by a piece of timber; it isn't
princely in a man to be beaten by a piece of timber.

MOTHER: Listen to what he says and be ashamed of yourselves.
We are old, this dear man and I, and we know what is right.

1ST NEIGHBOUR: The work was almost done, and then
someone suddenly shouted 'The king-post has swung out

of position!' It had set other places wrong, that had been ready. For days we have laboured at it, and as time went on we laboured and prayed, but nothing will make it go into its place. We're not knowledgeable men with these things. It's not our work and a church isn't like a little cottage. We've none of the proper appurtenances for the job. There's no hope for it, even if we go on trying till we're whiteheaded.

MOTHER: But Cuthman – he thinks of nothing but how the building grows, nothing but of the day when it will be done – where is he? What is he doing?

2ND NEIGHBOUR: We couldn't get him away. For days he has tugged and tusselled with us, with the blood in his face and the veins pushing in his head. And now he has gone into a ghost. He smoothes the stone with his hand as though it were in a fever and sleepless. He pats it as though it were a horse that had brought him safely through battle. And then he stands heavily in the aisle with his misery staring to the east.

MOTHER: Poor Cuthman, poor sweet son! On our journey it was ahead of him like riches, and every moment of his holiday time he has run to it as though he had heaven at his shoulders. This will damage him. I'm afraid for him and I don't mind telling you.

TAWM: Here's the boy; here he is.

(*Enter CUTHMAN running. Other NEIGHBOURS join the group.*)

MOTHER: Cuthman, what has happened to you? Son, What is the matter?

CUTHMAN: The king-post is in place Again! The church will be finished.

MOTHER: But the neighbours Said there was no one with you. You were alone.

CUTHMAN: I was alone by the unattended pillar, Mourning the bereaved air that lay so quiet Between walls; hungry for hammer-blows. And the momentous hive that once was there. And when I prayed my voice slid to the ground

Like a crashed pediment.
There was a demolition written over
The walls, and dogs rummaged in the foundations,
And picnic parties laughed on a heap of stone.
But gradually I was aware of someone in
The doorway and turned my eyes that way and saw
Carved out of the sunlight a man who stood
Watching me, so still that there was not
Other such stillness anywhere on the earth,
So still that the air seemed to leap
At his side. He came towards me, and the sun
Flooded its banks and flowed across the shadow.
He asked me why I stood alone. His voice
Hovered on memory with open wings
And drew itself up from a chine of silence
As though it had longtime lain in a vein of gold.
I told him: It is the king-post.
He stretched his hand upon it. At his touch
It lifted to its place. There was no sound.
I cried out, and I cried at last 'Who are you?'
I heard him say' I was a carpenter'...

(*They fall upon their knees.*)

There under the bare walls of our labour
Death and life were knotted in one strength
Indivisible as root and sky.

THE PEOPLE OF SOUTH ENGLAND:

The candle of our story has burnt down
And Cuthman's life is puffed like a dandelion
Into uncertain places. But the hand
Still leads the earth to drink at the sky, and still
The messenger rides into the city of leaves
Under the gradual fires of September;
The spring shall hear, the winter shall be wise
To warning of aconite and freezing lily,
And all shall watch the augur of a star
And learn their stillness from a stiller heaven.
And what of us who upon Cuthman's world
Have grafted progress without lock or ratchet?

What of us who have to catch up, always
To catch up with the high-powered car, or with
The unbalanced budget, to cope with competition,
To weather the sudden thunder of the uneasy
Frontier? We also loom with the earth
Over the waterways of space. Between
Our birth and death we may touch understanding
As a moth brushes a window with its wing.

Who shall question then
Why we lean our bicycle against a hedge
And go into the house of God?
Who shall question
That coming out from our doorways
We have discerned a little, we have known
More than the gossip that comes to us over our gates.

A PHOENIX TOO FREQUENT

'To whom conferr'd a peacock's indecent,
A squirrel's harsh, a phoenix too frequent.'

Robert Burton quoting Martial

To my wife

Characters

DYNAMENE

DOTO

TEGEUS-CHROMIS

Scene: The tomb of Virilius, near Ephesus; night

Note: The story was got from Jeremy Taylor who had it from Petronius

A Phoenix Too Frequent was first performed at the Mercury Theatre, London, on 25 April 1946, with the following cast:

DYNAMENE, Hermione Hannen

DOTO, Eleanor Summerfield

TEGEUS-CHROMIS, Alan Wheatley

Director E Martin Browne

It was subsequently revived at the Arts Theatre, London, on 20 November 1946, with the following cast:

DYNAMENE, Hermione Hannen

DOTO, Joan White

TEGEUS-CHROMIS, Paul Scofield

Director Noël Willman

(An underground tomb, in darkness except for the very low light of an oil-lamp. Above ground the starlight shows a line of trees on which hang the bodies of several men. It also penetrates a gate and falls onto the first of the steps which descend into the darkness of the tomb. DOTO talks to herself in the dark.)

DOTO: Nothing but the harmless day gone into black
Is all the dark is. And so what's my trouble?
Demons is so much wind. Are so much wind.
I've plenty to fill my thoughts. All that I ask
Is don't keep turning men over in my mind,
Venerable Aphrodite. I've had my last one
And thank you. I thank thee. He smelt of sour grass
And was likeable. He collected ebony quoits.

(An owl hoots near at hand.)

O Zeus! O some god or other, where is the oil?
Fire's from Prometheus. I thank thee. If I
Mean to die I'd better see what I'm doing.

(She fills the lamp with oil. The flame burns up brightly and shows DYNAMENE, beautiful and young, leaning asleep beside a bier.)

Honestly, I would rather have to sleep
With a bald bee-keeper who was wearing his boots
Than spend more days fasting and thirsting and crying
In a tomb. I shouldn't have said that. Pretend
I didn't hear myself. But life and death
Is cat and dog in this double-bed of a world.
My master, my poor master, was a man
Whose nose was as straight as a little buttress,
And now he has taken it into Elysium
Where it won't be noticed among all the other straightness.

(The owl cries again and wakens DYNAMENE.)

Oh, them owls. Those owls. It's woken her.

DYNAMENE: Ah! I'm breathless. I caught up with the ship
But it spread its wings, creaking a cry of *Dew,*
Dew! and flew figurehead foremost into the sun.

DOTO: How crazy, madam.

DYNAMENE: Doto, draw back the curtains.

I'll take my barley-water.

DOTO: We're not at home
Now, madam. It's the master's tomb.

DYNAMENE: Of course!
Oh, I'm wretched. Already I have disfigured
My vigil. My cynical eyelids have soon dropped me
In a dream.

DOTO: But then it's possible, madam, you might
Find yourself in bed with him again
In a dream, madam. Was he on the ship?

DYNAMENE: He was the ship.

DOTO: Oh. That makes it different.

DYNAMENE: He was the ship. He had such a deck, Doto,
Such a white, scrubbed deck. Such a stern prow,
Such a proud stern, so slim from port to starboard.
If ever you meet a man with such fine masts
Give your life to him, Doto. The figurehead
Bore his own features, so serene in the brow
And hung with a little seaweed. O Virilius,
My husband, you have left a wake in my soul.
You cut the glassy water with a diamond keel.
I must cry again.

DOTO: What, when you mean to join him?
Don't you believe he will be glad to see you, madam?
Thankful to see you, I should imagine, among
Them shapes and shades; all shapes of shapes and all
Shades of shades, from what I've heard. I know
I shall feel odd at first with Cerberus,
Sop or no sop. Still, I know how you feel, madam.
You think he may find a temptation in Hades.
I shouldn't worry. It would help him to settle down.
(*DYNAMENE weeps.*)
It would only be *fun*, madam. He couldn't go far
With a shade.

DYNAMENE: He was one of the coming men.
He was certain to have become the most well-organised provost

The town has known, once they had made him provost.
He was so punctual, you could regulate
The sun by him. He made the world succumb
To his daily revolution of habit. But who,
In the world he has gone to, will appreciate that?
O poor Virilius! To be a coming man
Already gone – it must be distraction.
Why did you leave me walking about our ambitions
Like a cat in the ruins of a house? Promising husband,
Why did you insult me by dying? Virilius,
Now I keep no flower, except in the vase
Of the tomb.

DOTO: O poor madam! O poor master!
I presume so far as to cry somewhat for myself
As well. I know you won't mind, madam. It's two
Days not eating makes me think of my uncle's
Shop in the country, where he has a hardware business,
Basins, pots, ewers, and alabaster birds.
He makes you die of laughing. O madam,
Isn't it sad?

(*They both weep.*)

DYNAMENE: How could I have allowed you
To come and die of my grief? Doto, it puts
A terrible responsibility on me. Have you
No grief of your own you could die of?

DOTO: Not really, madam.

DYNAMENE: Nothing?

DOTO: Not really. They was all one to me.
Well, all but two was all one to me. And they,
Strange enough, was two who kept recurring.
I could never be sure if they had gone for good
Or not; and so that kept things cheerful, madam.
One always gave a wink before he deserted me,
The other slapped me as it were behind, madam;
Then they would be away for some months.

DYNAMENE: Oh Doto,

131

What an unhappy life you were having to lead.

DOTO: Yes, I'm sure. But never mind, madam,
It seemed quite lively then. And now I know
It's what you say; life is more big than a bed
And full of miracles and mysteries like
One man made for one woman, etcetera, etcetera.
Lovely. I feel sung, madam, by a baritone
In mixed company with everyone pleased.
And so I had to come with you here, madam,
For the last sad chorus of me. It's all
Fresh to me. Death's a new interest in life,
If it doesn't disturb you, madam, to have me crying.
It's because of us not having breakfast again.
And the master, of course. And. the beautiful world.
And you crying too, madam. Oh – Oh!

DYNAMENE: I can't forbid your crying; but you must cry
On the other side of the tomb. I'm becoming confused.
This is my personal grief and my sacrifice
Of self, solus. Right over there, darling girl.

DOTO: What here?

DYNAMENE: Now, if you wish, you may cry, Doto.
But our tears are very different. For me
The world is all with Charon, all, all,
Even the metal and plume of the rose garden,
And the forest where the sea fumes overhead
In vegetable tides, and particularly
The entrance to the warm baths in Arcite Street
Where we first met; – all! – the sun itself
Trails an evening hand in the sultry river
Far away down by Acheron. I am lonely,
Virilius. Where is the punctual eye
And where is the cautious voice which made
Balance-sheets sound like Homer and Homer sound
Like balance-sheets? The precision of limbs, the amiable
Laugh, the exact festivity? Gone from the world.
You were the peroration of nature, Virilius.
You explained everything to me, even the extremely

Complicated gods. You wrote them down
In seventy columns. Dear curling calligraphy!
Gone from the world, once and for all. And I taught you
In your perceptive moments to appreciate me.
You said I was harmonious, Virilius,
Moulded and harmonious, little matronal
Ox-eye, your package. And then I would walk
Up and down largely, as it were making my own
Sunlight. What a mad blacksmith creation is
Who blows his furnaces until the stars fly upward
And iron Time is hot and politicians glow
And bulbs and roots sizzle into hyacinth
And orchis, and the sand puts out the lion,
Roaring yellow, and oceans bud with porpoises,
Blenny, tunny and the almost unexisting
Blindfish; throats are cut, the masterpiece
Looms out of labour; nations and rebellions
Are spat out to hang on the wind – and all is gone
In one Virilius, wearing his office tunic,
Checking the pence column as he went.
Where's animation now? What is there that stays
To dance? The eye of the one-eyed world is out.

(*She weeps.*)

DOTO: I shall try to grieve a little, too.
It would take lessons, I imagine, to do it out loud
For long. If I could only remember
Anyone of those fellows without wanting to laugh.
Hopeless, I am. Now those good pair of shoes
I gave away without thinking, that's a different –
Well, I've cried enough about *them,* I suppose.
Poor madam, poor master.

(*TEGEUS comes through the gate to the top of the steps.*)

TEGEUS: What's your trouble?

DOTO: Oh!
Oh! Oh, a man. I thought for a moment it was something
With harm in it. Trust a man to be where it's dark.
What is it? Can't you sleep?

133

TEGEUS: Now, listen –
DOTO: Hush!
 Remember you're in the grave. You must go away.
 Madam is occupied.
TEGEUS: What, here?
DOTO: Becoming
 Dead. We both are.
TEGEUS: What's going on here?
DOTO: Grief.
 Are you satisfied now?
TEGEUS: Less and less. Do you know
 What the time is?
DOTO: I'm not interested.
 We've done with all that. Go away. Be a gentleman.
 If we can't be free of men in a grave
 Death's a dead loss.
TEGEUS: It's two in the morning. All
 I ask is what are women doing down here
 At two in the morning?
DOTO: Can't you see she's crying?
 Or is she sleeping again? Either way
 She's making arrangements to join her husband.
TEGEUS: Where?
DOTO: Good god, in the Underworld, dear man. Haven't
 you learnt
 About life and death?
TEGEUS: In a manner, yes; in a manner;
 The rudiments. So the lady means to die?
DOTO: For love; beautiful, curious madam.
TEGEUS: Not curious;
 I've had thoughts like it. Death is a kind of love.
 Not anything I can explain.
DOTO: You'd better come in
 And sit down.
TEGEUS: I'd be grateful.

DOTO: Do. It will be my last
 Chance to have company, in the flesh.
TEGEUS: Do you mean
 You're going too?
DOTO: Oh, certainly I am.
 Not anything I can explain.
 It all started with madam saying a man
 Was two men really, and I'd only noticed one,
 One each, I mean. It seems he has a soul
 As well as his other troubles. And I like to know
 What I'm getting with a man. I'm inquisitive,
 I suppose you'd call me.
TEGEUS: It takes some courage.
DOTO: Well, yes
 And no. I'm fond of change.
TEGEUS: Would you object
 To have me eating my supper here?
DOTO: Be careful
 Of the crumbs. We don't want a lot of squeaking mice
 Just when we're dying.
TEGEUS: What a sigh she gave then.
 Down the air like a slow comet.
 And now she's all dark again. Mother of me.
 How long has this been going on?
DOTO: Two days.
 It should have been three by now, but at first
 Madam had difficulty with the Town Council. They said
 They couldn't have a tomb used as a private residence.
 But madam told them she wouldn't be eating here,
 Only suffering, and they thought that would be all right.
TEGEUS: Two of you. Marvellous. Who would have said
 I should ever have stumbled on anything like this?
 Do you have to cry? Yes, I suppose so. It's all
 Quite reasonable.
DOTO: Your supper and your knees.
 That's what's making me cry. I can't bear sympathy

135

And they're sympathetic.

TEGEUS: Please eat a bit of something.
I've no appetite left.

DOTO: And see her go ahead of me?
Wrap it up; put it away. You sex of wicked beards!
It's no wonder you have to shave off your black souls
Every day as they push through your chins.
I'll turn my back on you. It means utter
Contempt. Eat? Utter contempt. Oh, little new rolls!

TEGEUS: Forget it, forget it; please forget it. Remember
I've had no experience of this kind of thing before.
Indeed I'm as sorry as I know how to be. Ssh,
We'll disturb her. She sighed again. O Zeus,
It's terrible! Asleep, and still sighing.
Mourning has made a warren in her spirit,
All that way below. Ponos! the heart
Is the devil of a medicine.

DOTO: And I don't intend
To turn round.

TEGEUS: I understand how you must feel.
Would it be – have you any objection
To my having a drink? I have a little wine here.
And, you probably see how it is: grief's in order,
And death's in order, and women – I can usually
Manage that too; but not all three together
At this hour of the morning. So you'll excuse me.
How about you? It would make me more comfortable
If you'd take a smell of it.

DOTO: One for the road?

TEGEUS: One for the road.

DOTO: It's the dust in my throat. The tomb
Is so dusty. Thanks, I will. There's no point in dying
Of everything, simultaneous.

TEGEUS: It's lucky
I brought two bowls. I was expecting to keep
A drain for my relief when he comes in the morning.

DOTO: Are you on duty?

TEGEUS: Yes.

DOTO: It looks like it.

TEGEUS: Well,

Here's your good health.

DOTO: What good is that going to do me?
Here's to an easy crossing and not too much waiting
About on the bank. Do you have to tremble like that?

TEGEUS: The idea – I can't get used to it.

DOTO: For a member
Of the forces, you're peculiarly queasy. I wish
Those owls were in Hades – oh no; let them stay where they are.
Have you never had nothing to do with corpses before?

TEGEUS: I've got six of them outside.

DOTO: Morpheus, that's plenty.
What are they doing there?

TEGEUS: Hanging.

DOTO: Hanging?

TEGEUS: On trees.
Five plane trees and a holly. The holly-berries
Are just reddening. Another drink?

DOTO: Why not?

TEGEUS: It's from Samos. Here's –

DOTO: All right. Let's just drink it.
– How did they get in that predicament?

TEGEUS: The sandy-haired fellow said we should collaborate
With everybody; the little man said he wouldn't
Collaborate with anybody; the old one
Said that the Pleiades weren't sisters but cousins
And anyway were manufactured in Lacedaemon.
The fourth said that we hanged men for nothing
The other two said nothing. Now they hang
About at the corner of the night, they're present
And absent, horribly obsequious to every
Move in the air, and yet they keep me standing

For five hours at a stretch.

DOTO: The wine has gone
Down to my knees.

TEGEUS: And up to your cheeks. You're looking
Fresher. If only –

DOTO: Madam? She never would.
Shall I ask her?

TEGEUS: No; no, don't dare, don't breathe it.
This is privilege, to – come so near
To what is undeceiving and uncorrupt
And undivided; this is the clear fashion
For all souls, a ribbon to bind the unruly
Curls of living, a faith, a hope, Zeus
Yes, a fine thing. I am human, and this
Is human fidelity, and we can be proud
And unphilosophical.

DOTO: I need to dance
But I haven't the use of my legs.

TEGEUS: No, no, don't dance,
Or, at least, only inwards; don't dance; cry
Again. We'll put a moat of tears
Round her bastion of love, and save
The world. It's something, it's more than something,
It's regeneration, to see how a human cheek
Can become as pale as a pool.

DOTO: Do you love me, handsome?

TEGEUS: To have found life, after all, unambiguous!

DOTO: Did you say Yes?

TEGEUS: Certainly; just now I love all men.

DOTO: So do I.

TEGEUS: And the world is a good creature again.
I'd begun to see it as mildew, verdigris,
Rust, woodrot, or as though the sky had uttered
An oval twirling blasphemy with occasional vistas
In country districts. I was within an ace
Of volunteering for overseas service. Despair

Abroad can always nurse pleasant thoughts of home.
Integrity, by god!

DOTO: I love all the world
And the movement of the apple in your throat.
So shall you kiss me? It would be better, I should think,
To go moistly to Hades.

TEGEUS: Hers is the way,
Luminous with sorrow.

DOTO: Then I'll take
Another little swiggy. I love all men,
Everybody, even you, and I'll pick you
Some outrageous honeysuckle for your helmet,
If only it lived here. Pardon.

DYNAMENE: Doto. Who is it?

DOTO: Honeysuckle, madam. Because of the bees.
Go back to sleep, madam.

DYNAMENE: What person is it?

DOTO: Yes, I see what you mean, madam. It's a kind of
Corporal talking to his soul, on a five-hour shift,
Madam, with six bodies. He's been having his supper.

TEGEUS: I'm going. It's terrible that we should have disturbed her.

DOTO: He was delighted to see you so sad, madam.
It has stopped him going abroad.

DYNAMENE: One with six bodies?
A messenger, a guide to where we go.
It is possible he has come to show us the way
Out of these squalid suburbs of life, a shade,
A gorgon, who has come swimming up, against
The falls of my tears (for which in truth he would need
Many limbs) to guide me to Virilius.
I shall go quietly.

TEGEUS: I do assure you –
Such clumsiness, such a vile and unforgivable
Intrusion. I shall obliterate myself
Immediately.

DOTO: Oblit – oh, what a pity

To oblit. Pardon. Don't let him, the nice fellow.

DYNAMENE: Sir: your other five bodies: where are they?

TEGEUS: Madam –

Outside; I have them outside. On trees.

DYNAMENE: Quack!

TEGEUS: What do I reply?

DYNAMENE: Quack, charlatan!

You've never known the gods. You came to mock me.
Doto, this never was a gorgon, never.
Nor a gentleman either. He's completely spurious.
Admit it, you creature. Have you even a feather
Of the supernatural in your system? Have you?

TEGEUS: Some of my relations –

DYNAMENE: Well?

TEGEUS: Are dead, I think;

That is to say I have connections –

DYNAMENE: Connections

With pickpockets. It's a shameless imposition.
Does the army provide you with no amusements?
If I were still of the world, and not cloistered
In a colourless landscape of winter thought
Where the approaching spring is desired oblivion,
I should write sharply to your commanding officer.
It should be done, it should be done. If my fingers
Weren't so cold I would do it now. But they are,
Horribly cold. And why should insolence matter
When my colour of life is unreal, a blush on death,
A partial mere diaphane? I don't know
Why it should matter. Oafish, non-commissioned
Young man! The boots of your conscience will pinch forever
If life's dignity has any self-protection.
Oh, I have to sit down. The tomb's going round.

DOTO: Oh, madam, don't give over. I can't remember
When things were so lively. He looks marvellously
Marvellously uncomfortable. Go on, madam.
Can't you, madam? Oh, madam, don't you feel up to it?

There, do you see her, you acorn-chewing infantryman?
You've made her cry, you square-bashing barbarian.

TEGEUS: O history, my private history, why
Was I led here? What stigmatism has got
Into my stars? Why wasn't it my brother?
He has a tacit misunderstanding with everybody
And washes in it. Why wasn't it my mother?
She makes a collection of other people's tears
And dries them all. Let them forget I came;
And lie in the terrible black crystal of grief
Which held them, before I broke it. Outside, Tegeus.

DOTO: Hey, I don't think so, I shouldn't say so. Come
Down again, uniform. Do you think you're going
To half kill an unprotected lady and then
Back out upwards? Do you think you can leave her like this?

TEGEUS: Yes, yes, I'll leave her. O directorate of gods,
How can I? Beauty's bit is between my teeth.
She has added another torture to me. Bottom
Of Hades' bottom.

DOTO: Madam. Madam, the corporal
Has some wine here. It will revive you, madam.
And then you can go at him again, madam.

TEGEUS: It's the opposite of everything you've said,
I swear. I swear by Horkos and the Styx,
I swear by the nine acres of Tityos,
I swear the Hypnotic oath, by all the Titans —
By Koeos, Krios, Iapetos, Kronos, and so on —
By the three Hekatoncheires, by the insomnia
Of Tisiphone, by Jove, by jove, and the dew
On the feet of my boyhood, I am innocent
Of mocking you. Am I a Salmoneus
That, seeing such a flame of sorrow —

DYNAMENE: You needn't
Labour to prove your secondary education.
Perhaps I jumped to a wrong conclusion, perhaps
I was hasty.

DOTO: How easy to swear if you're properly educated.
Wasn't it pretty, madam? Pardon.

DYNAMENE: If I misjudged you
I apologise, I apologise. Will you please leave us?
You were wrong to come here. In a place of mourning
Light itself is a trespasser; nothing can have
The right of entrance except those natural symbols
Of mortality, the jabbing, funeral, sleek-
With-omen raven, the death-watch beetle which mocks
Time: particularly, I'm afraid, the spider
Weaving his home with swift self-generated
Threads of slaughter; and, of course, the worm.
I wish it could be otherwise. Oh dear,
They aren't easy to live with.

DOTO: Not even a *little* wine, madam?

DYNAMENE: Here, Doto?

DOTO: Well, on the steps perhaps,
Except it's so draughty.

DYNAMENE: Doto! Here?

DOTO: No, madam;
I quite see.

DYNAMENE: I might be wise to strengthen myself
In order to fast again; it would make me abler
For grief. I will breathe a little of it, Doto.

DOTO: Thank god. Where's the bottle?

DYNAMENE: What an exquisite bowl.

TEGEUS: Now that it's peacetime we have pottery classes.

DYNAMENE: You made it yourself?

TEGEUS: Yes. Do you see the design?
The corded god, tied also by the rays
Of the sun, and the astonished ship erupting
Into vines and vine-leaves, inverted pyramids
Of grapes, the uplifted hands of the men (the raiders),
And here the headlong sea, itself almost
Venturing into leaves and tendrils, and Proteus
With his beard braiding the wind, and this

142

Held by other hands is a drowned sailor –

DYNAMENE: Always, always.

DOTO: Hold the bowl steady, madam.
Pardon.

DYNAMENE: Doto, have you been drinking?

DOTO: Here, madam?
I coaxed some a little way towards my mouth, madam,
But I scarcely swallowed except because I had to. The hiccup
Is from no breakfast, madam, and not meant to be funny.

DYNAMENE: You may drink this too. Oh, how the inveterate body,
Even when cut from the heart, insists on leaf,
Puts out, with a separate meaningless will,
Fronds to intercept the thankless sun.
How it does, oh, how it does. And how it confuses
The nature of the mind.

TEGEUS: Yes, yes, the confusion;
That's something I understand better than anything.

DYNAMENE: When the thoughts would die, the instincts will
 set sail
For life. And when the thoughts are alert for life
The instincts will rage to be destroyed on the rocks.
To Virilius it was not so; his brain was an ironing-board
For all crumpled indecision: and I follow him,
The hawser of my world. You don't belong here,
You see; you don't belong here at all.

TEGEUS: If only
I did. If only you knew the effort it costs me
To mount those steps again into an untrustworthy,
Unpredictable, unenlightened night,
And turn my back on – on a state of affairs,
I can only call it a vision, a hope, a promise,
A – By that I mean loyalty, enduring passion,
Unrecking bravery and beauty all in one.

DOTO: He means you, or you and me; or me, madam.

TEGEUS: It only remains for me to thank you, and to say
That whatever awaits me and for however long

143

I may be played by this poor musician, existence,
Your person and sacrifice will leave their trace
As clear upon me as the shape of the hills
Around my birthplace. Now I must leave you to your husband.

DOTO: Oh! You, madam.

DYNAMENE: I'll tell you what I will do.
I will drink with you to the memory of my husband,
Because I have been curt, because you are kind,
And because I'm extremely thirsty. And then we will say
Goodbye and part to go to our opposite corruptions,
The world and the grave.

TEGEUS: The climax to the vision.

DYNAMENE: (*Drinking.*) My husband, and all he stood for.

TEGEUS: Stands for.

DYNAMENE: Stands for.

TEGEUS: Your husband.

DOTO: The master.

DYNAMENE: How good it is,
How it sings to the throat, purling with summer.

TEGEUS: It has a twin nature, winter and warmth in one,
Moon and meadow. Do you agree?

DYNAMENE: Perfectly;
A cold bell sounding in a golden month.

TEGEUS: Crystal in harvest.

DYNAMENE: Perhaps a nightingale
Sobbing among the pears.

TEGEUS: In an old autumnal midnight.

DOTO: Grapes. – Pardon. There's some more here.

TEGEUS: Plenty.
I drink to the memory of your husband.

DYNAMENE: My husband.

DOTO: The master.

DYNAMENE: He was careless in his choice of wines.

TEGEUS: And yet
Rendering to living its rightful poise is not

Unimportant.

DYNAMENE: A mystery's in the world
Where a little liquid, with flavour, quality, and fume
Can be as no other, can hint and flute our senses
As though a music played in harvest hollows
And a movement was in the swathes of our memory.
Why should scent, why should flavour come
With such wings upon us? Parsley, for instance.

TEGEUS: Seaweed.

DYNAMENE: Lime trees.

DOTO: Horses.

TEGEUS: Fruit in the fire.

DYNAMENE: Do I know your name?

TEGEUS: Tegeus.

DYNAMENE: That's very thin for you,
It hardly covers your bones. Something quite different,
Altogether other. I shall think of it presently.

TEGEUS: Darker vowels, perhaps.

DYNAMENE: Yes, certainly darker vowels.
And your consonants should have a slight angle,
And a certain temperature. Do you know what I mean?
It will come to me.

TEGEUS: Now *your* name —

DYNAMENE: It is nothing
To any purpose. I'll be to you the She
In the tomb. You have the air of a natural-historian
As though you were accustomed to handling birds' eggs,
Or tadpoles, or putting labels on moths. You see?
The genius of dumb things, that they are nameless.
Have I found the seat of the weevil in human brains?
Our names. They make us broody; we sit and sit
To hatch them into reputation and dignity.
And then they set upon us and become despair,
Guilt and remorse. We go where they lead. We dance
Attendance on something wished upon us by the wife
Of our mother's physician. But insects meet and part

145

And put the woods about them, fill the dusk
And freckle the light and go and come without
A name among them, without the wish of a name
And very pleasant too. Did I interrupt you?

TEGEUS: I forget. We'll have no names then.

DYNAMENE: I should like
You to have a name, I don't know why; a small one
To fill out the conversation.

TEGEUS: I should like
You to have a name too, if only for something
To remember. Have you still some wine in your bowl?

DYNAMENE: Not altogether.

TEGEUS: We haven't come to the end
By several inches. Did I splash you?

DYNAMENE: It doesn't matter.
Well, here's to my husband's name.

TEGEUS: Your husband's name.

DOTO: The master.

DYNAMENE: It was kind of you to come.

TEGEUS: It was more than coming. I followed my future here,
As we all do if we're sufficiently inattentive
And don't vex ourselves with questions; or do I mean
Attentive? If so, attentive to what? Do I sound
Incoherent?

DYNAMENE: You're wrong. There isn't a future here,
Not here, not for you.

TEGEUS: Your name's Dynamene.

DYNAMENE: Who – Have I been utterly irreverent? Are you –
Who made you say that? Forgive me the question,
But are you dark or light? I mean which shade
Of the supernatural? Or if neither, what prompted you?

TEGEUS: Dynamene –

DYNAMENE: No, but I'm sure you're the friend of nature,
It must be so, I think I see little Phoebuses
Rising and setting in your eyes.

DOTO: They're not little Phoebuses,
They're hoodwinks, madam. Your name is on your brooch.
No little Phoebuses tonight.

DYNAMENE: That's twice
You've played me a trick. Oh, I know practical jokes
Are common on Olympus, but haven't we at all
Developed since the gods were born? Are gods
And men both to remain immortal adolescents?
How tiresome it all is.

TEGEUS: It was you, each time,
Who said I was supernatural. When did I say so?
You're making me into whatever you imagine —
And then you blame me because I can't live up to it.

DYNAMENE: I shall call you Chromis. It has a breadlike sound.
I think of you as a crisp loaf.

TEGEUS: And now
You'll insult me because I'm not sliceable.

DYNAMENE: I think drinking is harmful to our tempers.

TEGEUS: If I seem to be frowning, that is only because
I'm looking directly into your light: I must look
Angrily, or shut my eyes.

DYNAMENE: Shut them. – Oh,
You have eyelashes! A new perspective of you.
Is that how you look when you sleep?

TEGEUS: My jaw drops down.

DYNAMENE: Show me how.

TEGEUS: Like this.

DYNAMENE: It makes an irresistible
Moron of you. Will you waken now?
It's morning; I see a thin dust of daylight
Blowing on to the steps.

TEGEUS: Already? Dynamene,
You're tricked again. This time by the moon.

DYNAMENE: Oh well,
Moon's daylight, then. Doto is asleep.

TEGEUS: Doto
 Is asleep...

DYNAMENE: Chromis, what made you walk about
 In the night? What, I wonder, made you not stay
 Sleeping wherever you slept? Was it the friction
 Of the world on your mind? Those two are difficult
 To make agree. Chromis — now try to learn
 To answer your name. I won't say Tegeus.

TEGEUS: And I
 Won't say Dynamene.

DYNAMENE: Not?

TEGEUS: It makes you real.
 Forgive me, a terrible thing has happened. Shall I
 Say it and perhaps destroy myself for you?
 Forgive me first, or, more than that, forgive
 Nature who winds her furtive stream all through
 Our reason. Do you forgive me?

DYNAMENE: I'll forgive
 Anything, if it's the only way I can know
 What you have to tell me.

TEGEUS: I felt us to be alone;
 Here in a grave, separate from any life,
 I and the only one of beauty, the only
 Persuasive key to all my senses,
 In spite of my having lain day after day
 And pored upon the sepals, corolla, stamen, and bracts
 Of the yellow bog-iris. Then my body ventured
 A step towards interrupting your perfection of purpose
 And my own renewed faith in human nature.
 Would you have believed that possible?

DYNAMENE: I have never
 Been greatly moved by the yellow bog-iris. Alas,
 It's as I said. This place is for none but the spider,
 Raven and worms, not for a living man.

TEGEUS: It has been a place of blessing to me. It will always
 Play in me, a fountain of confidence

When the world is arid. But I know it is true
I have to leave it, and though it withers my soul
I must let you make your journey.

DYNAMENE: No.

TEGEUS: Not true?

DYNAMENE: We can talk of something quite different.

TEGEUS: Yes, we can!
Oh yes, we will! Is it your opinion
That no one believes who hasn't learned to doubt?
Or, another thing, if we persuade ourselves
To one particular Persuasion, become Sophist,
Stoic, Platonist, anything whatever,
Would you say that there must be areas of soul
Lying unproductive therefore, or dishonoured
Or blind?

DYNAMENE: No, I don't know.

TEGEUS: No. It's impossible
To tell. Dynamene, if only I had
Two cakes of pearl-barley and hydromel
I could see you to Hades, leave you with your husband
And come back to the world.

DYNAMENE: Ambition, I suppose,
Is an appetite particular to man.
What is your definition?

TEGEUS: The desire to find
A reason for living.

DYNAMENE: But then, suppose it leads,
As often, one way or another, it does, to death.

TEGEUS: Then that may be life's reason. Oh, but how
Could I bear to return, Dynamene? The earth's
Daylight would be my grave if I had left you
In that unearthly night.

DYNAMENE: O Chromis —

TEGEUS: Tell me,
What is your opinion of Progress? Does it, for example,
Exist? Is there ever progression without retrogression?

Therefore is it not true that mankind
Can more justly be said increasingly to Gress?
As the material improves, the craftsmanship deteriorates
And honour and virtue remain the same. I love you,
Dynamene.

DYNAMENE: Would you consider we go round and round?

TEGEUS: We concertina, I think; taking each time
A larger breath, so that the farther we go out
The farther we have to go in.

DYNAMENE: There'll come a time
When it will be unbearable to continue.

TEGEUS: Unbearable.

DYNAMENE: Perhaps we had better have something
To eat. The wine has made your eyes so quick
I am breathless beside them. It *is*
Your eyes, I think; or your intelligence
Holding my intelligence up above you
Between its hands. Or the cut of your uniform.

TEGEUS: Here's a new roll with honey. In the gods' names
Let's sober ourselves.

DYNAMENE: As soon as possible.

TEGEUS: Have you
Any notion of algebra?

DYNAMENE: We'll discuss you, Chromis.
We will discuss you, till you're nothing but words.

TEGEUS: I? There is nothing, of course, I would rather discuss,
Except – if it would be no intrusion – you, Dynamene.

DYNAMENE: No, you couldn't want to. But your birthplace,
Chromis,
With the hills that placed themselves in you forever
As you say, where was it?

TEGEUS: My father's farm at Pyxa.

DYNAMENE: There? Could it be there?

TEGEUS: I was born in the hills
Between showers, a quarter of an hour before milking time.
Do you know Pyxa? It stretches to the crossing of two

Troublesome roads, and buries its back in beechwood,
From which come the white owls of our nights
And the mulling and cradling of doves in the day.
I attribute my character to those shadows
And heavy roots; and my interest in music
To the sudden melodious escape of the young river
Where it breaks from nosing through the cresses and kingcups.
That's honestly so.

DYNAMENE: You used to climb about
Among the windfallen tower of Phrasidemus
Looking for bees' nests.

TEGEUS: What? When have I
Said so?

DYNAMENE: Why, all the children did.

TEGEUS: Yes: but, in the name of light, how do you *know* that?

DYNAMENE: I played there once, on holiday.

TEGEUS: O Klotho,
Lachesis and Atropos!

DYNAMENE: It's the strangest chance:
I may have seen, for a moment, your boyhood.

TEGEUS: I may
Have seen something like an early flower
Something like a girl. If I only could remember how I must
Have seen you. Were you after the short white violets?
Maybe I blundered past you, taking your look,
And scarcely acknowledged how a star
Ran through me, to live in the brooks of my blood forever.
Or I saw you playing at hiding in the cave
Where the ferns are and the water drips.

DYNAMENE: I was quite plain and fat and I was usually
Hitting someone. I wish I could remember you.
I'm envious of the days and children who saw you
Then. It is curiously a little painful
Not to share your past.

TEGEUS: How did it come
Our stars could mingle for an afternoon

So long ago, and then forget us or tease us
Or helplessly look on the dark high seas
Of our separation, while time drank
The golden hours? What hesitant fate is that?

DYNAMENE: Time? Time? Why – how old are we?

TEGEUS: Young,
Thank both our mothers, but still we're older than tonight
And so older than we should be. Wasn't I born
In love with what, only now, I have grown to meet?
I'll tell you something else. I was born entirely
For this reason. I was born to fill a gap
In the world's experience, which had never known
Chromis loving Dynamene.

DYNAMENE: You are so
Excited, poor Chromis. What is it? Here you sit
With a woman who has wept away all claims
To appearance, unbecoming in her oldest clothes,
With not a trace of liveliness, a drab
Of melancholy, entirely shadow without
A smear of sun. Forgive me if I tell you
That you fall easily into superlatives.

TEGEUS: Very well. I'll say nothing, then. I'll fume
With feeling.

DYNAMENE: Now you go to the extreme. Certainly
You must speak. You may have more to say. Besides
You might let your silence run away with you
And not say something that you should. And how
Should I answer you then? Chromis, you boy,
I can't look away from you. You use
The lamplight and the moon so skilfully,
So arrestingly, in and around your furrows.
A humorous ploughman goes whistling to a team
Of sad sorrow, to and fro in your brow
And over your arable cheek. Laugh for me. Have you
Cried for women, ever?

TEGEUS: In looking about for you.
But I have recognised them for what they were.

DYNAMENE: What were they?

TEGEUS: Never you: never, although
 They could walk with bright distinction into all men's
 Longest memories, never you, by a hint
 Or a faint quality, or at least not more
 Than reflectively, stars lost and uncertain
 In the sea, compared with the shining salt, the shiners,
 The galaxies, the clusters, the bright grain whirling
 Over the black threshing-floor of space.
 Will you make some effort to believe that?

DYNAMENE: No, no effort.
 It lifts me and carries me. It may be wild
 But it comes to me with a charm, like trust indeed,
 And eats out of my heart, dear Chromis,
 Absurd, disconcerting Chromis. You make me
 Feel I wish I could look my best for you.
 I wish, at least, that I could believe myself
 To be showing some beauty for you, to put in the scales
 Between us. But they dip to you, they sink
 With masculine victory.

TEGEUS: Eros, no! No!
 If this is less than your best, then never, in my presence,
 Be more than your less: never! If you should bring
 More to your mouth or to your eyes, a moisture
 Or a flake of light, anything, anything fatally
 More, perfection would fetch her unsparing rod
 Out of pickle to flay me, and what would have been love
 Will be the end of me. O Dynamene,
 Let me unload something of my lips' longing
 On to yours receiving. Oh, when I cross
 Like this the hurt of the little space between us
 I come a journey from the wrenching ice
 To walk in the sun. That is the feeling.

DYNAMENE: Chromis,
 Where am I going? No, don't answer. It's death
 I desire, not you.

TEGEUS: Where is the difference? Call me
 Death instead of Chromis. I'll answer to anything.
 It's desire all the same, of death in me, or me
 In death, but Chromis either way. Is it so?
 Do you not love me, Dynamene?

DYNAMENE: How could it happen?
 I'm going to my husband. I'm too far on the way
 To admit myself to life again. Love's in Hades.

TEGEUS: Also here. And here are we, not there
 In Hades. Is your husband expecting you?

DYNAMENE: Surely, surely?

TEGEUS: Not necessarily. I,
 If I had been your husband, would never dream
 Of expecting you. I should remember your body
 Descending stairs in the floating light, but not
 Descending in Hades. I should say, 'I have left
 My wealth warm on the earth, and, hell, earth needs it.'
 'Was all I taught her of love,' I should say, 'so poor
 That she will leave her flesh and become shadow?'
 'Wasn't our love for each other' (I should continue)
 'Infused with life, and life infused with our love?
 Very well; repeat me in love, repeat me in life,
 And let me sing in your blood forever.'

DYNAMENE: Stop, stop, I shall be dragged apart!
 Why should the fates do everything to keep me
 From dying honourably? They must have got
 Tired of honour in Elysium. Chromis, it's terrible
 To be susceptible to two conflicting norths.
 I have the constitution of a whirlpool.
 Am I actually twirling, or is it just sensation?

TEGEUS: You're still; still as the darkness.

DYNAMENE: What appears
 Is so unlike what is. And what is madness
 To those who only observe, is often wisdom
 To those to whom it happens.

TEGEUS: Are we compelled

To go into all this?

DYNAMENE: Why, how could I return
To my friends? Am I to be an entertainment?

TEGEUS: That's for tomorrow. Tonight I need to kiss you,
Dynamene. Let's see what the whirlpool does
Between my arms; let it whirl on my breast. O love,
Come in.

DYNAMENE: I am there before I reach you; my body
Only follows to join my longing which
Is holding you already. – Now I am
All one again.

TEGEUS: I feel as the gods feel:
This is their sensation of life, not a man's:
Their suspension of immortality, to enrich
Themselves with time. O life, O death, O body,
O spirit, O Dynamene.

DYNAMENE: O all
In myself; it so covets all in you,
My care, my Chromis. Then I shall be
Creation.

TEGEUS: You have the skies already;
Out of them you are buffeting me with your gales
Of beauty. Can we be made of dust, as they tell us?
What! dust with dust releasing such a light
And such an apparition of the world
Within one body? A thread of your hair has stung me.
Why do you push me away?

DYNAMENE: There's so much metal
About you. Do I have to be imprisoned
In an armoury?

TEGEUS: Give your hand to the buckles and then
To me.

DYNAMENE: Don't help; I'll do them all myself.

TEGEUS: O time and patience! I want you back again.

DYNAMENE: We have a lifetime. O Chromis, think, think
Of that. And even unfastening a buckle

Is loving. And not easy. Very well,
You can help me. Chromis, what zone of miracle
Did you step into to direct you in the dark
To where I waited, not knowing I waited?

TEGEUS: I saw
The lamplight. That was only the appearance
Of some great gesture in the bed of fortune.
I saw the lamplight.

DYNAMENE: But here? So far from life?
What brought you near enough to see lamplight?

TEGEUS: Zeus,
That reminds me.

DYNAMENE: What is it, Chromis?

TEGEUS: I'm on duty.

DYNAMENE: Is it warm enough to do without your greaves?

TEGEUS: Darling loom of magic, I must go back
To take a look at those boys. The whole business
Of guard had gone out of my mind.

DYNAMENE: What boys, my heart?

TEGEUS: My six bodies.

DYNAMENE: Chromis, not that joke
Again.

TEGEUS: No joke, sweet. Today our city
Held a sextuple hanging. I'm minding the bodies
Until five o'clock. Already I've been away
For half an hour.

DYNAMENE: What can they do, poor bodies,
In half an hour, or half a century?
You don't really mean to go?

TEGEUS: Only to make
My conscience easy. Then, Dynamene,
No cloud can rise on love, no hovering thought
Fidget, and the night will be only to *us*.

DYNAMENE: But if every half-hour —

TEGEUS: Hush, smile of my soul,

My sprig, my sovereign: this is to hold your eyes,
I sign my lips on them both: this is to keep
Your forehead – do you feel the claim of my kiss
Falling into your thought? And now your throat
Is a white branch and my lips two singing birds –
They are coming to rest. Throat, remember me
Until I come back in five minutes. Over all
Here is my parole: I give it to your mouth
To give me again before it's dry. I promise:
Before it's dry, or not long after.

DYNAMENE: Run,
Run all the way. You needn't be afraid of stumbling.
There's plenty of moon. The fields are blue. Oh, wait,
Wait! My darling. No, not now: it will keep
Until I see you; I'll have it here at my lips.
Hurry.

TEGEUS: So long, my haven.

DYNAMENE: Hurry, hurry!

(*Exit TEGEUS.*)

DOTO: Yes, madam, hurry; of course. Are we there
Already? How nice. Death doesn't take
Any doing at all. We were gulped into Hades
As easy as an oyster.

DYNAMENE: Doto!

DOTO: Hurry, hurry,
Yes, madam. – But they've taken out all my bones.
I haven't a bone left. I'm a Shadow: wonderfully shady
In the legs. We shall have to sit out eternity, madam,
If they've done the same to you.

DYNAMENE: You'd better wake up.
If you can't go to sleep again, you'd better wake up.
Oh dear. – We're still alive, Doto, do you hear me?

DOTO: You must speak for yourself, madam. I'm quite dead.
I'll tell you how I know. I feel
Invisible. I'm a wraith, madam; I'm only
Waiting to be wafted.

DYNAMENE: If only you *would* be.
Do you see where you are? Look. Do you see?
DOTO: Yes. You're right, madam. We're still alive.
Isn't it enough to make you swear?
Here we are, dying to be dead,
And where does it get us?
DYNAMENE: Perhaps you should try to die
In some other place. Yes! Perhaps the air here
Suits you too well. You were sleeping very heavily.
DOTO: And all the time you alone and dying.
I shouldn't have. Has the corporal been long gone,
Madam?
DYNAMENE: He came and went, came and went,
You know the way.
DOTO: Very well I do. And went
He should have, come he should never. Oh dear, he must
Have disturbed you, madam.
DYNAMENE: He could be said
To've disturbed me. Listen; I have something to say to you.
DOTO: I expect so, madam. Maybe I *could* have kept him out
But men are in before I wish they wasn't.
I think quickly enough, but I get behindhand
With what I ought to be saying. It's a kind of stammer
In my way of life, madam.
DYNAMENE: I have been unkind,
I have sinfully wronged you, Doto.
DOTO: Never, madam.
DYNAMENE: Oh yes. I was letting you die with me, Doto, without
Any fair reason. I was drowning you
In grief that wasn't yours. That was wrong, Doto.
DOTO: But I haven't got anything against dying, madam.
I may *like* the situation, as far as I like,
Any situation, madam. Now if you'd said mangling,
A lot of mangling, I might have thought twice about staying.
We all have our dislikes, madam.

DYNAMENE: I'm asking you
To leave me, Doto, at once, as quickly as possible,
Now, before – now, Doto, and let me forget
My bad mind which confidently expected you
To companion me to Hades. Now goodbye,
Goodbye.

DOTO: No, it's not goodbye at all.
I shouldn't know another night of sleep, wondering
How you got on, or what I was missing, come to that.
I should be anxious about you, too. When you belong
To an upper class, the netherworld might come strange.
Now I was born nether, madam, though not
As nether as some. No, it's not goodbye, madam.

DYNAMENE: Oh Doto, go; you must, you must! And if I seem
Without gratitude, forgive me. It isn't so,
It is far, far from so. But I can only
Regain my peace of mind if I know you're gone.

DOTO: Besides, look at the time, madam. Where should I go
At three in the morning? Even if I was to think
Of going; and think of it I never shall.

DYNAMENE: Think of the unmatchable world, Doto.

DOTO: I do
Think of it, madam. And when I think of it, what
Have I thought? Well, it depends, madam.

DYNAMENE: I insist,
Obey me! At once! Doto!

DOTO: Here I sit.

DYNAMENE: What shall I do with you?

DOTO: Ignore me, madam.
I know my place. I shall die quite unobtrusive.
Oh look, the corporal's forgotten to take his equipment.

DYNAMENE: Could he be so careless?

DOTO: I shouldn't hardly have thought so.
Poor fellow. They'll go and deduct it off his credits.
I suppose, madam, I suppose he couldn't be thinking
Of coming back?

DYNAMENE: He'll think of these. He will notice

He isn't wearing them. He'll come; he is sure to come.

DOTO: Oh.

DYNAMENE: I know he will.

DOTO: Oh, oh.

Is that all for tonight, madam? May I go now, madam?

DYNAMENE: Doto! Will you?

DOTO: Just you try to stop me, madam.

Sometimes going is a kind of instinct with me.

I'll leave death to some other occasion.

DYNAMENE: Do,

Doto. Any other time. Now you must hurry.

I won't delay you from life another moment.

Oh, Doto, goodbye.

DOTO: Goodbye. Life is unusual,

Isn't it, madam? Remember me to Cerberus.

(Re-enter TEGEUS. DOTO passes him on the steps.)

(As she goes.) You left something behind. Ye gods, what a moon!

DYNAMENE: Chromis, it's true; my lips are hardly dry.

Time runs again; the void is space again;

Space has life again; Dynamene has Chromis.

TEGEUS: It's over.

DYNAMENE: Chromis, you're sick. As white as wool.

Come, you covered the distance too quickly.

Rest in my arms; get your breath again.

TEGEUS: I've breathed one night too many. Why did I see you,

Why in the name of life did I see you?

DYNAMENE: Why?

Weren't we gifted with each other? O heart,

What do you mean?

TEGEUS: I mean that joy is nothing

But the parent of doom. Why should I have found

Your constancy such balm to the world and yet

Find, by the same vision, its destruction

A necessity? We're set upon by love

160

To make us incompetent to steer ourselves,
To make us docile to fate. I should have known:
Indulgences, not fulfilment, is what the world
Permits us.

DYNAMENE: Chromis, is this intelligible?
Help me to follow you. What did you meet in the fields
To bring about all this talk? Do you still love me?

TEGEUS: What good will it do us? I've lost a body.

DYNAMENE: A body?
One of the six? Well, it isn't with them you propose
To love me; and you couldn't keep it forever.
Are we going to allow a body that isn't there
To come between us?

TEGEUS: But I'm responsible for it.
I have to account for it in the morning. Surely
You see, Dynamene, the horror we're faced with?
The relatives have had time to cut him down
And take him away for burial. It means
A court martial. No doubt about the sentence.
I shall take the place of the missing man.
To be hanged, Dynamene! Hanged, Dynamene!

DYNAMENE: No; it's monstrous! Your life is yours, Chromis.

TEGEUS: Anything but. That's why I have to take it.
At the best we live our lives on loan,
At the worst in chains. And I was never born
To have life. Then for what? To be had by it,
And so are we all. But I'll make it what it is,
By making it nothing.

DYNAMENE: Chromis, you're frightening me.
What are you meaning to do?

TEGEUS: I have to die,
Dance of my heart, I have to die, to die,
To part us, to go to my sword and let it part us.
I'll have my free will even if I'm compelled to it.
I'll kill myself.

DYNAMENE: Oh, no! No, Chromis!

It's all unreasonable – no such horror
Can come of a pure accident. Have you hanged?
How can they hang you for simply not being somewhere?
How can they hang you for losing a dead man?
They must have wanted to lose him, or they wouldn't
Have hanged him. No, you're scaring yourself for nothing
And making me frantic.

TEGEUS: It's section six, paragraph
Three in the Regulations. That's my doom.
I've read it for myself. And, by my doom,
Since I have to die, let me die here, in love,
Promoted by your kiss to tower, in dying,
High above my birth. For god's sake let me die
On a wave of life, Dynamene, with an action
I can take some pride in. How could I settle to death
Knowing that you last saw me stripped and strangled
On a holly tree? Demoted first and then hanged!

DYNAMENE: Am I supposed to love the corporal
Or you? It's you I love, from head to foot
And out to the ends of your spirit. What shall I do
If you die? How could I follow you? I should find you
Discussing me with my husband, comparing your feelings,
Exchanging reactions. Where should I put myself?
Or am I to live on alone, or find in life
Another source of love, in memory
Of Virilius and of you?

TEGEUS: Dynamene,
Not that! Since everything in the lives of men
Is brief to indifference, let our love at least
Echo and perpetuate itself uniquely
As long as time allows you. Though you go
To the limit of age, it won't be far to contain me.

DYNAMENE: It will seem like eternity ground into days and days.

TEGEUS: Can I be certain of you, forever?

DYNAMENE: But, Chromis,
Surely you said –

TEGEUS: Surely we have sensed
 Our passion to be greater than mortal? Must I
 Die believing it is dying with me?
DYNAMENE: Chromis,
 You must never die, never! It would be
 An offence against truth.
TEGEUS: I cannot live to be hanged.
 It would be an offence against life. Give me my sword,
 Dynamene. O Hades, when you look pale
 You take the heart out of me. I could die
 Without a sword by seeing you suffer. Quickly!
 Give me my heart back again with your lips
 And I'll live the rest of my ambitions
 In a last kiss.

DYNAMENE: Oh, no, no, no!
 Give my blessing to your desertion of me?
 Never, Chromis, never. Kiss you and then
 Let you go? Love you, for death to have you?
 Am I to be made the fool of courts martial?
 Who are they who think they can discipline souls
 Right off the earth? What discipline is that?
 Chromis, love is the only discipline
 And we're the disciples of love. I hold you to that:
 Hold you, hold you.

TEGEUS: We have no chance. It's determined
 In section six, paragraph three, of the Regulations.
 That has more power than love. It can snuff the great
 Candles of creation. It makes me able
 To do the impossible, to leave you, to go from the light
 That keeps you.

DYNAMENE: No!
TEGEUS: O dark, it does. Goodbye,
 My memory of earth, my dear most dear
 Beyond every expectation. I was wrong
 To want you to keep our vows existent
 In the vacuum that's coming. It would make you

A heaviness to the world, when you should be,
As you are, a form of light. Dynamene, turn
Your head away. I'm going to let my sword
Solve all the riddles.

DYNAMENE: Chromis, I have it! I know!
Virilius will help you.

TEGEUS: Virilius?

DYNAMENE: My husband. He can be the other body.

TEGEUS: Your husband can?

DYNAMENE: He has no further use
For what he left of himself to lie with us here.
Is there any reason why he shouldn't hang
On your holly tree? Better, far better, he,
Than you who are still alive, and surely better
Than *idling* into corruption?

TEGEUS: Hang your husband?
Dynamene, it's terrible, horrible.

DYNAMENE: How little you can understand. I loved
His life not his death. And now we can give his death
The power of life. Not horrible: wonderful!
Isn't it so? That I should be able to feel
He moves again in the world, accomplishing
Our welfare? It's more than my grief could do.

TEGEUS: What can I say?

DYNAMENE: That you love me; as I love him
And you. Let's celebrate your safety then.
Where's the bottle? There's some wine unfinished in this bowl.
I'll share it with you. Now forget the fear
We were in; look at me, Chromis. Come away
From the pit you nearly dropped us in. My darling,
I give you Virilius.

TEGEUS: Virilius.
And all that follows.

DOTO: (*On the steps, with the bottle.*) The master. Both the masters.
(*The curtain falls.*)

164

THOR, WITH ANGELS

To E Martin Browne
and the Tewkesbury Summer 1939

Characters

CYMEN

CLODESUIDA, his wife

MARTINA, his daughter

QUICHELM, his elder son

CHELDRIC, his younger son

TADFRID, his brother-in-law

OSMER, his brother-in-law

COLGRIN, his steward

ANNA, Colgrin's wife

HOEL, a British prisoner

MERLIN

A MESSENGER

Scene: A Jutish farmstead, AD 596

Thor, With Angels was first performed at the Canterbury Festival in 1948.

*(A Jutish farmstead, both within and without. To the left a group
of trees, to the right a shed, in which COLGRIN, an elderly man,
is asleep among the straw. Enter QUICHELM. He hammers at
the farm door.)*

QUICHELM: Hyo, there! Who's awake? Where's
 The welcome of women for warfarers?
 Where's my Wodenfearing mother?
 Hey! hey! Spare some sleep for us:
 Leave us half a snore and a stale dream.
 Here's your battery of males come home!
 Our bones are aching; we're as wet
 As bogworms. Who's alive in there?

COLGRIN: There's an infernal clatter. What's the matter?
 Foof! Straw in the nostrils. That's bad.
 Who's blaspheming in the thick of the mist?
 I've got you on my weapon's point.
 (Where the Valhalla is it?)

QUICHELM: Colgrin,
 You scrawny old scurfscratcher, is that you?

COLGRIN: Frog-man, fen-fiend, werewolf, oul, elf,
 Or whatever unnatural thing you are
 Croaking in the voice of Master Quichelm
 Who I happen to know is away waging war,
 Stand away from the swiping of my sword.
 (Where in thunder did I put it?)

QUICHELM: Runt of an old sow's litter, you slop-headed
 Pot-scourer, come here, you buckle-backed
 Gutsack, come out of there!

COLGRIN: That's
 The young master. There's not a devil
 In the length of the land could pick such a posy of words
 And not swoon smelling it. Here I come, Here I come.
 Welcome home and so forth.

QUICHELM: Woden welt you for a sheeptick, where's
 my mother?

COLGRIN: That's a nice question. I must ponder.
　　Maybe asleep in her cot. Or not.

QUICHELM: I'll carve your dropsical trunk into a tassel.
　　Where's my sister? You were left to guard them,
　　Not to roll your pig-sweat in a snoring stupor.
　　Tell me where they are before I unbutton your throat.

MARTINA: (*Entering.*) We're here, Quichelm. I knew you'd
　　come today.
　　The cows this morning were all facing north.
　　Are you whole and hale?

QUICHELM: 　　　　　　Look me over. Ten
　　Fingers. You can take the toes for granted.
　　Where's my mother?

MARTINA: 　　　　　We went to early rite.
　　I wanted to stay and keep a watch out for you
　　But she made me go; you know what she is.

COLGRIN: That's what I said. Gone to early rite.
　　And my wife with her; a devout woman, but dismal
　　In some respects. They'll be back just now.
　　The sun's arisen.

QUICHELM: 　　You get stuck
　　Into some work, you white bellied weasel.
　　By dugs, I think I'll strike you anyway.

COLGRIN: Wasn't I there as bright and bristling
　　As Barney the boarhound, just as soon as I heard
　　Your honour's foot creak over the bridge?

MARTINA: Beat him tomorrow. Let's be affable.
　　Is father all right? And Cheldric?

QUICHELM: 　　　　　　　Cheldric's all right.

MARTINA: Why not father? Stop picking at your teeth.
　　Something is wrong. Was father killed?
　　I knew it. The house was crowned with crows this morning.

QUICHELM: Shut up. None of us is killed.
　　Are you still here?

COLGRIN: (*Going in.*) No, sir, no. It's what
　　You remember of me. There's trouble coming. I see that.

(*Enter CLODESUIDA and ANNA.*)

CLODESUIDA: Quichelm, you're back! Oh, fortunate day.

ANNA: Welcome home.

QUICHELM: Yes, the battle's finished.

CLODESUIDA: (*To ANNA.*) Rouse the fire up; and find them food.

 (*Exit ANNA.*)

MARTINA: Don't expect pleasure.

CLODESUIDA: Something is wrong. Is your father
 With you, and well?

QUICHELM: He's much as when you saw him.

CLODESUIDA: Much? What's that, much? Has he been hurt?

QUICHELM: No weapon has touched him.

CLODESUIDA: Then he's ill?
 Why do you talk to me in a kind of cloud?
 What has happened?

QUICHELM: Mother, we breathe cloud.
 It's the chief product of this island.

CLODESUIDA: Don't provoke me!
 Where is your father?

QUICHELM: Coming up the hill.

MARTINA: Dimly, yes; I can just see the shapes of them.

CLODESUIDA: And Cheldric, too? And your uncles?
 Yes,
 They all come. The mist is confusing. I could imagine
 There are five of them.

QUICHELM: So there are. My father
 Brings a prisoner.

CLODESUIDA: A prisoner? Are we
 To have an intolerable Saxon here?

QUICHELM: An even greater strain on your toleration:
 A Briton. A British slave who fought for the Saxons.

CLODESUIDA: But why? Why bring a benighted Briton here?
 I thought those heathen had been tidied away, once
 And for all. And the country's healthier for it.
 Your father's demented.

QUICHELM: You would have said so
 If you had seen him as we saw him in the battle.
 Like a madman, he saved this Briton when we'd have killed him:
 Burst in among us, blaspheming against Woden,
 Broke his sword in the air – he swore it broke
 Against a staggering light – and stood roaring,
 Swaying in a sweat of wax, bestraddled
 Over the fallen Briton. And then, as though
 The beast which had bragged in his brain had leapt away,
 Became himself again,
 Only in a fury with the light which broke his sword.

CLODESUIDA: How could the sword have broken?
 You make me afraid
 To see him. Are you sure that he blasphemed?
 That's the worst of all. It's hard enough
 To live well-thought-of by the gods.

MARTINA: We haven't
 Enough cattle to placate them more than twice a year.
 He knows we have to be careful.

QUICHELM: They're here. And you haven't heard the worst.

CLODESUIDA: The worst? What worse can there be? Quichelm,
 What else?...

QUICHELM: Don't let him know that I've been talking.
 He'd lay me flat.

CLODESUIDA: He'll notice how I tremble.

 (*Enter to the house CYMEN, his brothers-in-law TADFRID and
 OSMER, and his younger son CHELDRIC. CLODESUIDA and
 MARTINA stand staring at him.*)

CYMEN: Well? Have I come home? Or is this a place
 Of graven images? What's the silence for?
 I've laid down arms, so that arms
 Could take me up, a natural expectation.
 Where's my wife?

CLODESUIDA: You can see me. Here I am.

CYMEN: Where's my wife? Where's the head on my breast?
 Better. Where's my daughter? Where's the white

Hand hanging on my shoulder? Better, better.
I'll have a cup of mead.
Where's my mead? Where the devil's my mead?
Have I got to wring the water out of my shirt
To get a drink?

COLGRIN: (*Appearing.*) Here's your mead, my lord:
And the bees were proud to make themselves drunk
To make you drunk, and welcome home, my lord,
And Woden worship you and your victory,
Hear, hear!

CYMEN: Loki lacerate you for a liar
And my foot in your teeth.

COLGRIN: Quite so, exactly.

CYMEN: Wash my feet. Well, here's gut-comfort, anyway.
Who can be called defeated who can still imbibe
And belch?

CLODESUIDA: Defeated? Have you come back defeated
When I sacrificed a good half-goat...

CYMEN: No doubt
The wrong half, my jewel: the hind-quarters,
And it brought us rumping home. Well,
I'm still good enough for a bad joke.
Liquor. Down the throat, sunshine; hum
A lazy day to my inside. I'll doze
In the meadow of my stomach. There's no warmth in a wife.

CLODESUIDA: Who turns me cold? What besides defeat
Have you still to tell me?

CYMEN: Ask the dumb icebergs behind you.
Take stock of those long jowls, my jewel,
Those ruminating thundercoloured bulls
Your brothers: and our pastry-pallid sons
Who look on their father with such filial
Disapproval. A fine resentful march
This night has been, with no moon and no
Conversation: nothing to break the monotony
Except Tadfrid spitting once in every mile

And twenty-seven gurks from Osmer.
Spit some words at me instead, and gurk
Away your grudge. I'm tired of this subterranean
Muttering. Where's that water? My feet want comfort.

TADFRID: That's what this house will want before long, and may
Our guilt be forgiven us.

CLODESUIDA: What kind of talk is this?

CYMEN: Tell her, tell her. I'm humble.

CLODESUIDA: Do you say that?
Guilt, forgiveness, humility? What next?
Are you mad?

CYMEN: Tell her I am or you'll strangle yourselves
With an unspoken truth.

CLODESUIDA: Has none of you the courage
To speak?

TADFRID: Even though he's our overlord,
And though he may not at the time have been fully responsible –

OSMER: Let me tell her, Tadfrid; I speak faster.
It was approaching dusk, last evening.
We were catching a bright victory in our caps,
When Eccha, the earl, was killed by a thrust from the spear
Of this British brat:
And we were at the boy in the bat of an eye
To give him joy of our vengeance and a shove
To doom and a damned journey into dust,
When Cymen, our chief, our lord, your maleficent
Male –

CLODESUIDA: Though you're my brother I'll beat your mouth
If it passes a lie!

TADFRID: It's the truth that he says.

OSMER: All right.
It's the truth that I say. Like a bear-sark blundering
He hit up our downcoming swords, sprang in
As white as a water-spout spinning in a full moon,
Shouting 'The gods can go and beg for blood!
Let 'em learn of us!'

TADFRID: Word for word. 'Let 'em learn
 Of us.'

CLODESUIDA: It's certain they heard!

OSMER: From that moment, you could feel it,
 The sky turned round, Ceaulin's men broke through,
 Thor, in the scarlet dusk, swore and swung,
 And Woden rode in rancour, as well he might,
 And trod upon our dead.

TADFRID: And so we slogged
 Out from defeat, and he lugged the Briton with him.

CLODESUIDA: Is it believable?

CHELDRIC: Look, father's weeping.

QUICHELM: A nice inheritance we have, all watermarked
 With tears.

CLODESUIDA: Who's this man, spilling sawdust
 Like an old puppet? I never saw him till now.
 You make me ashamed, in front of our sons.

CYMEN: Can't I
 Have tears of rage? Why not the hot spout
 Of indignation? Is it better to spew?
 By the thousand and three thews of the muscular god,
 Some fiend of this land came at my back!
 I was thrown by a trick.

TADFRID: He should stand in the winter sea
 Till his clothes freeze to his flesh. It's the only way
 To be sure of a store of magic against such an evil.

CLODESUIDA: And catch death? That's an efficacious magic
 If you like. It's more decently religious
 To offer a sacrifice, than to offer himself
 To an early grave.

OSMER: What devil was it that damned him
 To its own design? Can he tell us that?

CYMEN: Some ancient
 Damp god of this dooming island, who spat
 The fungus out of his mouth and caught me napping.
 I curse this kingdom, water, rock and soil!

I accuse and curse the creaking of its boughs
And the slaver on the mouth of its winds! It makes
A fool of me! Too many voices rasp
Out of decaying rafters, out of every cave
And every hole in the yellow sodden hills.
This is the golden future our fathers died for!
The gods look at it! Here's the slice of fortune
They came to carve with their courage
When they pitched themselves on the narrow, shuddering sea
To deal and duck death under the hanging chalk.
I stack my curses on those first rich rumours
Which fetched us here, rollicking with ambition.
I curse the muck and gravel where we walk.
I'd curse each singular soaking blade of grass
Except that a grey hair ties me for time.
Here we live, in our fathers' mirage.
Cities, they'd heard of, great with columns,
Gay cities, where wealth was bulging the doors
And the floors were sagging with the weight of gold.
The orchards rang with fruit, the hills moved
With grain like a lion's mane, and wherever
A river sauntered the fish swam, and eels
Reeled in bright mud. Flocks were fair,
And cows like pendulous fountains of alabaster
Went lowing over land where silver skulked
Waiting for skill; a land where summer days
Could call to one another across the night
Under the northern pole. So here we live
And choke in our father's mirage. Dreams they were,
As well we know; we live in the skull
Of the beautiful head which swam in the eyes of our fathers.
Our ploughshares jag on the stumps of moonwhite villas.
And my brain swerves with the sudden sting of one
Of the island gods, the down-and-out divinities
Moping, mildewed with immortality,
Cross-boned on weedy altars. I curse this land
That curses me!

OSMER: Then cut yourself clear of its curse
 And win this house again for Woden, before
 We all know worse.

 (*He drags forward HOEL, the Briton.*)

 Here's the land you loathe,
 In bone and blood. Break its back.

CLODESUIDA: We have always
 Been god-fearing, but now it appears he fears
 More gods than he knows what to do with. What can we do?

TADFRID: Obliterate the cause of sin. Do the undeed,
 The death-lack which lost us our victory.
 Where's the difficulty?

OSMER: There is no difficulty.
 Here's the quivering black-haired flesh,
 As live as it was that time our blades were on him.
 Well, we swing back on time, and hope the gods
 Forget the indecision.

TADFRID: It may seem now
 To be somewhat in cold blood, but in fact his death
 Was given to him in the battle yesterday;
 This is merely the formal ceremony, which was overlooked.

QUICHELM: Kill him; make us respectable again.
 I feel that all the gods are looking at us.

CHELDRIC: Do, father, kill him, as any other fellow's
 Father would.

CLODESUIDA: Not inside the house!
 The walls would never let his death go out.

CYMEN: No, nor anywhere here, I'll tell you all
 Darker things yet. I have a great fear.

CLODESUIDA: Fear? Will you say that to the ears of your sons?

CYMEN: I say I fear myself, or rather
 That not-myself which took my will,
 Which forced a third strange eye into my head
 So that I saw the world's dimensions altered.
 I know no defence against that burst of fire.
 (*To HOEL.*) You can tell me; what flogged away my strength,

What furtive power in your possession
Pulled the passion of my sword? Name that devil!
I'll have our gods harry him through the gaps
Between the stars, to where not even fiends
Can feed. Name him!

HOEL: Who? Who am I to name?
I swear to God I know nothing of what you mean.

CYMEN: What God is that? You swear to a God?
What God?

HOEL: It was my grandfather who knew him well.
The One God, he's called. But I can't remember
The details; it's a long time ago that I saw
My grandfather, and I'm the last life
Of my family.

OSMER: Send him where the moles
Can teach him to dig in the dark.

TADFRID: His brows are marked
With the night already; douse the rest of him
And let's get to bed.

CYMEN: Why shouldn't we give you the mercy
You showed to Eccha our earl?

HOEL: It was all in the way
Of battle. I only expelled him from the world
As I let out my breath singing to the fame
Of Britain –

TADFRID: The fame of Britain! The fame of Britain
Is sung by us now. Let him echo Eccha
Into death, with the same ease.

OSMER: Easy death,
Easy as shutting a door!

CYMEN: This door shan't shut
Till I find what devil keeps it.

OSMER: Then, by plague,
I'll void my vows of allegiance to this damned house!

TADFRID: And I; like a rat I'll run
Before the water rises.

CLODESUIDA: Do you forget
 Your wife and children? A sacrifice, Cymen,
 This one sacrifice for our peace of mind.
CYMEN: What peace can we have until I know
 Whether or not the same misshapen fire again
 Will burn me? I've still got rags of reason
 To make our stark apprehension decent,
 And you shall be modest with me, or else bad-luck
 Will leer at the lot of us. If we kill him and bury him,
 I shall fill my lungs with relief and forget my fault
 And the flame will be on me while I whistle at a clear sky.
 No! This walking wound in my strength can walk on,
 Wake me in the morning, see me to my bed;
 He shall stand between me and the door so that his shadow
 Falls across everything I do: so every
 Moment shall have spears addressed to that dark
 Which lies in wait for my will. Alive,
 He's ours; dead, who knows to what
 Unfriendly power he will have given himself?
 Scowl at your own stampede of panic,
 Not at me. Look; the sun puts down
 The mist at last and looks out across the day.
 Here comes the burning sea of honey
 Over the grey sand of our defeat.
 We'll salute the sun that makes us men.
 Fill up the cups! (*To COLGRIN.*)
 O gigantic heart, beating in the breast of the sky,
 Lordlust the white-hot lion of the air,
 We are the men of the earth; our metal shouts
 With light only for you. (For chick's sake,
 Fill 'em up, fill 'em up!) –
 Give us huge harvest, potency and dominion.
 Make us pluck all from the teeth of this island.
 My strength comes back. By splendour,
 I'll send fear sprawling. By the zenith, I'll set
 My foot on the neck of the dark and get the gods

Again. (*He throws HOEL to the ground and puts his foot on his neck.*)
 Glory of life, I live!
We'll drink to our restored prosperity:
The sustaining sinews of tremendous Thor:
The unwearying, turbulent, blazing loins of Woden!
We raise our cups and drink, to the power of the gods,
This toast:
 'Let us love one another.'

(*His cup falls from his hand. He stands trembling.*)

OSMER: What madness is this?

CLODESUIDA: What words are these?

TADFRID: He has fallen
 Foul of his brain again, protect us!

CHELDRIC: 'Let us
 What,' did father say?

QUICHELM: 'Love one another';
 What a way to honour the gods!

CLODESUIDA: He's not himself.
 It's the patter of delirium he talks;
 A lack of sleep.

CYMEN: I'm in good health!
 No one shall excuse this fiend that twists my tongue,
 By saying I'm sick! Show, show, show,
 Devil! By the first yowl of the world's first babe
 I'll be the master of my own voice!
 Show! Come out of your secret place and let me
 See you climb to my sword. This time it means
 Death, your precious Briton's end, I kill him!

(*He makes to kill HOEL, but his sword is against QUICHELM.*)

QUICHELM: Father!

CLODESUIDA: No! Hold him! He's battle-blind.

OSMER: You madman, it's your son, Quichelm. What's
 The matter? Here's the road you have to take,
 The black-haired enemy. Turn here.

CYMEN: It seems
 All one, it seems all one. There's no distinction.

Which is my son?

QUICHELM: Can't you see me?

I'm your son.

CYMEN: And my enemy,
My own flesh. My sword knew you. Deny it:
My sword understood. Distinction has gone!

CLODESUIDA: Take him and make him sleep; it must be
The burning of his body. I'll not believe
He is mad. Get him to rest and sleep. Dip him
In sleep, that blue well where shadows walk
In water over their heads, and he'll be washed
Into reason. This has taken my strength, too.

CYMEN: All right, I'll sleep. I'll count myself as over
For a while. But let not you, not one of you,
Step between me and what's to come. This house
Is on my back; it goes my way. Dare nothing
Against the Briton, or dread will stay with you
Forever, like pock-marks. We'll master this mystery,
His death can keep; his death can wait for me.

(*Exeunt CLODESUIDA, CYMEN, QUICHELM, CHELDRIC.*)

OSMER: And we're kept jangling in the pocket of uncertainty
While Woden wonders how to spend us.

TADFRID: And sleep
Will lay us open to all the supernatural riffraff
That ever came crawling out of cobwebs. Pleasant
Dreams.

OSMER: (*To COLGRIN.*) Take him to the barn.
Hanging for you, if he escapes.

COLGRIN: A rope isn't my style. I haven't the neck for it.

(*Exeunt OSMER and TADFRID.*)

Lowest form of life; that's you. Next to lowest, me.
So you can show respect. We'll make the barn
A guard-room. Get inside. This dizzy-dazzy
World made of morning sun and fog-spittle
Is nothing to do with you. Orders are otherwise.

HOEL: Try to think of it: I might by now

Have been wading about in the sway of death,
But I'm blinking at the light; my head swims with it.

COLGRIN: It doesn't do a man any good, daylight.
It means up and doing, and that means up to no good.
The best life is led horizontal
And absolutely unconscious. Get inside!
You flick of muck off the back hoof of a mule!
There's a point in being sworn at; it gives you something
To hand onto your fellow men. Now mind,
No monkey-tricks, no trying to escape,
I've got you covered – if I knew where I'd put my weapon.

HOEL: Where do you think I should escape to?

COLGRIN: Why,
You'd skit off home.

HOEL: That's where I've just escaped from
When I escaped death. Here I lie –
Hanging onto what was once my country,
Like an idiot clinging to the body of his dead mother.
Why don't you hack me off her? Why don't you?
Fool I was, fool I was, not to hug their swords
When they bore down on me. Why don't I settle
To a steady job in the grave, instead of this damned
Ambition for life, which doesn't even offer
A living wage? I want to live, even
If it's like a louse on the back of a sheep, skewering
Into the wool away from the beaks of crows;
Even like a limpet on a sour rock.
I want to live!

COLGRIN: Me too;
Horizontal and absolutely unconscious.
But they keep us at it, they keep us at it.

(Enter ANNA.)

ANNA: Who at it? Not you at it. Don't you
Think he's ever at it; nobody's at it
Except old Anna. The farm's a hive
Of indolence: the place might as well be rubble.

Six upstanding men lying down, and nine
Cows lowing themselves into a cream cheese.

(*She goes into the barn to take down the washing from where it
hangs on COLGRIN's sword stuck in a post.*)

I won't say you're in my way
But I can't get to where I want to come to.

COLGRIN: (*To HOEL.*) My only wife!

ANNA: I'll take these into the sun.
Nothing ever dries in this country.

COLGRIN: There's my weapon!
There's my dimpled sword! What do you mean, woman,
Hanging wet linen all over it? It's wrong
If it's rusty.

ANNA: And a man is, too; and you're
So thick with rust you'd choke if you blew on yourself.

COLGRIN: I'm on special duty, Anna; I'm put to guard
A sad and savage Briton.

ANNA: He needn't think
He'll be savage with me. He's caused a lot of trouble
Having to be conquered, and that's enough from him.
I shall probably get to be fond of him, but I'll never
Like him. It wouldn't be right if I did, when you think
Of all our men who've been killed killing these heathen.
And *this* isn't going to get the baby washed.

COLGRIN: What baby washed?

ANNA: Can't I coin a phrase if I want to?

(*Exit ANNA. Enter MARTINA carrying an empty bowl.*)

COLGRIN: My sword for a clothes-line!
Stand to attention. Here's my lord's daughter
Look as though you're working.

HOEL: At what?

COLGRIN: Here,
Plait some straw.

MARTINA: Good morning, Colgrin.

COLGRIN: Good-morning.
 It's a bright day, lady, for the season.

MARTINA: Time, too. They made us wait for it.
 I'm old with being young in a long winter.
 I've almost forgotten how to walk on flowers.

COLGRIN: Everything would be all right if we'd been granted
 Hibernation.

MARTINA: We're not very favoured. The gods
 Mean us to know they rule. Are your gods any
 Kinder, Briton?

HOEL: When I was a boy I was only
 Allowed to have one, though in that One, they said,
 There were three. But the altars are broken up. I've tried
 To pick away the moss to read the inscriptions
 But I've almost forgotten our language. I only know
 The god was both father and son and a brooding dove.

MARTINA: He's a Christian, Colgrin; and if you ask my mother
 She'll tell you that's worse than having no god at all.
 We have a Christian queen, though we try to keep it
 Dark, and in one of our prayers to the gods we say
 Give us our daily bread and forgive us our Queen.
 But we drove the Britons into the mountains; for years
 They've lain furtively in the setting sun,
 Those who live. Why aren't you lurking there, too?
 You should be crouching craven in a cave
 Warming your hands at the spark of your old god
 Who let you be conquered.

HOEL: After my father was killed
 The Saxons kept me to work for them. My father
 Had always said What can one god do
 Against the many the invaders have?
 And he remembered earlier gods who still
 Harped on the hills, and hoped they would rally again.
 But they were too old. They only raised
 Infatuated echoes, and wept runnels.
 Then all the Britons were killed or fled, all

Except my grandfather and my hip-high self.
Him they kept for working metals which he did
With his whole heart, forgetting the end of his race
In a brooch design. He told me once.
How I'd been given in water to the One god.
Soon afterwards he died, beating silver.
When I had grown the Saxons let me fight for them
And gave me a little freedom in exchange.

MARTINA: Enough for my father to take from you.
It's a pity
You had to be born a Briton. I'm forced to hate you.

HOEL: If I had been a Saxon...

MARTINA: We should have killed you
To win your land, but considered you a brother.

COLGRIN: We should have killed you with consideration.
It isn't less fatal, of course, but it adds an air
Of glory, and we shake hands in Valhalla.
(*Enter CLODESUIDA.*)

CLODESUIDA: Martina, come, if you please! Two hands aren't
enough
To card and spin, and my brain goes with the wheel
Round and round in a horrible suspense.
What are you doing?

MARTINA: Watching the herons. I'm coming.
They haunt the dregs of the mist like ghosts
Left on the yellow morning by a tide of sleep.

CLODESUIDA: Where did you take the bowl of meat?

MARTINA: Where?

CLODESUIDA: I saw you come back from that old decaying
Tooth of a tower. And here's a string
Of bramble on your skirt, and burrs, and cleavers.
What were you doing there?

MARTINA: I go very often.
Particularly when the house is overbearded
With splendid uncles.

CLODESUIDA: Carrying a bowl of food?

MARTINA: Mother, I have to eat.

CLODESUIDA: Do you have to eat
 Among bird-droppings and birds' bones and beaks
 And owl-chawn mice and dead flies? Is that
 Nicer than your uncles? The tower's a spitting-place
 For all benighted life, a filthy ruin.
 You have someone hidden there.

MARTINA: Suppose I have...

CLODESUIDA: I do suppose you have; and I shall find who.
 I wear myself out securing us to the gods
 With every device that's orthodox, sacrificing
 To the hour, to the split minute of the risen sun.
 But how can I keep them kind if always
 They're being displeased by the rest of you? It isn't
 Easy to keep on the windy side of Woden
 As anyone knows. Who have you hidden in the ruin?

MARTINA: Hardly anyone at all. A very old man:
 Old enough to be his own grandfather

CLODESUIDA: But why –

MARTINA: I dug him up. He was rather buried.
 I found him in the quarry where it caved in.
 His beard was twisted like mist in the roots of an oak-tree,
 Beaded and bright with a slight rain, and he was crying
 Like an old wet leaf. His hands were as brown as a nest
 Of lizards, and his eyes were two pale stones
 Dropping in a dark well. I thought I couldn't
 Very well leave him where he was.

CLODESUIDA: You should
 Have left him, until we could find out more about him.
 Is he natural? Is he good or evil? Out of the quarry!
 He might be as fatal as a toadstool.

MARTINA: Maybe, maybe,
 Maybe. He comforts me.

CLODESUIDA: He comforts you!
 In what way, comfortable? Now we come to it.
 What does he do?

MARTINA: He screws up his eyes and looks
At my hand and tells my future. It's better
Than always having to placate the gods
For fear something should happen. Besides, I like
To know. He says, as far as he can remember,
Though he has a terrible memory for names,
His name is Merlin.

HOEL: (*To COLGRIN.*) What did she say?

COLGRIN: She said
I was so thick with rust I'd choke if I blew.
My sword for a clothes-line!

HOEL: Merlin!

CLODESUIDA: I only hope
He has done no harm to us yet, whatever he is,
Whatever his tongue clinks at, sitting with the rats.
It's no good having gods at the door if there
Are devils on the hearth. Your uncles, one or both,
Shall see him.

HOEL: She calls him Merlin. She has caught
An echo that booms in the deepest cave of my race
And brings it here, out into the winter light!

MARTINA: You shall see him for yourself.
Here he comes, with the red earth still on him
And his beard springing surprises on the breeze.
He promised not to break his hiding. Well,
You see how old he is. And how confused in the sun.
With two days' growth of shadow from the tower.
(*Enter MERLIN.*)
You've broken faith. You promised you'd lie low.
(*MERLIN moves on towards HOEL.*)

CLODESUIDA: What is he after?

MERLIN: (*To HOEL.*) Ail i'r ar ael Eryri
Cyfartal hoewal a hi. Ar oror wir arwa.

HOEL: Peth yw...peth yw... I can't remember
How to speak. I use the words of the Saxons.

187

CLODESUIDA: Another heathen! Did you know he was a Briton?
Is that why you hid him from me?

MERLIN: (*To HOEL.*) A British voice.
It breaks a fast of years; I roll you
Wonderfully on my tongue. I was half asleep
But I heard you. This wide harp of winter
Reverberates. I had stupidly imagined
The human landscape had left me forever.
The face of the foam for me (I told myself)
Until I die. All your expectation
Of friendship, old man (I said to myself)
Is a wink from the eye of a bullfinch
Or the slower solemnities of a tortoise
Or a grudging goodnight from the dark lungs of a toad.
And then your voice alights on my ear. I bless you
From the bottom of my slowly budding grave.

CLODESUIDA: You must speak to my brothers before we let
you wander
All over our land.

HOEL: Madam, this may be Merlin.
Still Merlin. Do you understand?

MERLIN: You are surprised, I see, to find me still
Giving and taking the air. You think I should long ago
Have sunk to the golden bed of the troubled river.
But I have obstreperous garments that keep me floating
I merely float, in a desultory, though
Delighted, kind of way. And my garments begin
To be heavy. Presently, on the surface of life,
You may observe a doting bubble, smiling
Inanely at the sun until it dissolves,
And then you'll know the time has been.

HOEL: It has gone
Already for us. We're lost and scattered.

MERLIN: Be lost
And then be found. It's an old custom of the earth
From year to year. I could do something;

But I lost my trumpet of zeal when Arthur died
And now I only wind a grey note –
Of memory, and the hills are quiet.

CLODESUIDA: Did you hear
What I said to you?

MARTINA: Father has come from the house.

(*Enter CYMEN.*)

CLODESUIDA: Oh, you should be sleeping.

CYMEN: No sleep came.
An occasional shadow across my bed from a cloud
Of weariness, but the glare of the brain persisted.
Where is the Briton?

CLODESUIDA: There in the barn, there,
Talking to an old man of his tribe, or an old
Sorcerer, or some brewer of trouble.
We should rid the country of these things which aren't
 ourselves.

CYMEN: Rid the brain of uncertainty, rid the heart
Of its fear.

(*He goes to the barn.*)

 How did this old man come here?
The kingdom has been scoured of you islanders.
What are you hanging about for?

MERLIN: I pluck at my roots
But they won't be fetched away from a world which
 possesses me
Like an unforgettable woman who was once my own.
I walk on the earth, besotted by her, waiting
To bring to her the devotion of my dust.

HOEL: It's Merlin. He's still among us.

CYMEN: What is he?
Is it one of your superstitions,
A damned invention of the air? Tell me
What your existence is or, by the night,
I'll ask your flesh with a sharper edge to the question.

Come on, now; are you superannuated god
Or working devil, or mere entangled man?

MERLIN: No god, I hope; that would take too much
Endurance. Whatever man may be
I am that thing, though my birth, I've been given to believe,
Had some darkness in it. But then, which of us
Can say he is altogether free of a strain
Of hell in his blood? My father could be called
Pure man, if such a thing existed.

CYMEN: Then
What powers pursue us here? You know this island
Thoroughly. Parade your spirits, good
And bad, and I'll identify the mischief!

CLODESUIDA: Will you ask *them,* men of the race
We conquered?

MARTINA: Ask the prisoner
If he isn't a Christian. He's a godless Christian
Even if he can't remember.

CLODESUIDA: Why can't we get rid of them
Once and for all? The gods will strike at them
And everyone knows how carelessly they aim. The blow
May fall on us.

COLGRIN: Colgrin will catch it, Colgrin
Is sure to catch it. The rest of the world will dodge
And I shall be in the way.

CYMEN: I'll ask the louse
In the filthy shirt of a corpse in the bottom of a ditch
If I can learn what it is I've learnt to dread.
I lay on my bed and felt it stand with its feet
Planted on either side of my heart, and I looked
Up the tower of its body to find the face
To know if it meant to help or hinder,
But it was blotted out by a shield of thunder.
Am I to sacrifice without end and then
Be given no peace? The skirts of the gods
Drag in our mud. We feel the touch

And take it to be a kiss. But they see we soil them
And twitch themselves away. Name to me
What mocked me with a mood of mercy and therefore
Defeat. Who desired that?

MERLIN: Who, apart
From ourselves, can see any difference between
Our victories and our defeats, dear sir?
Not beast, nor bird, nor even the anticipating
Vulture watching for the battle's end,
Nor a single mile of devoted dispassionate ground.
All indifferent. Much more so your gods
Who live without the world, who never feel
As the world feels in springtime the stab of the spear
And the spurt of golden blood,
Winter's wound-in-the-side, the place where life begins.
Nothing, it seems, cares for your defeat.

CLODESUIDA: How did I say these Britons would answer you?
It shames us to stand and listen. Didn't we conquer them?

MERLIN: Quest and conquest and quest again. It might well
Make you fretful if you weren't expecting it.

CYMEN: You are conquered. Both you or this boy
I can destroy now, and no questions asked.

MERLIN: Death is what conquers the killer, not the killed.
How pleasant it is to talk, even
In your language. I have a way – your daughter
May have told you – of looking ahead, having made
My peace with Time, at some expense to my soul.
It's curious to know that in the course
Of the movement of years which wears away distinction,
You, and moreover your conquerors, will bear
Kindly and as though by nature our name, the British
Name, and all the paraphernalia, legend
And history, as though you were our widow
Not our conqueror. And well may the weeds become you.

CYMEN: You're a hideous old wiseacre
Of sheepbitten kale. But give me an answer.

If, as you imagine, our gods have no care
Whether we win or lose, what cuckoo power
Is it that usurps the nest of my soul?

MERLIN: You ask an old pagan? Old Merlin, old
Eternal suckling, who cannot drag his lips
Away from the breast of the earth, even to grow
Into the maturity of heaven. Nothing can wean him
Until his mother puts upon her nipple
The vinegar of death, though, when I walked
Between the dog-rose hedges of my manhood,
It was in a Christian land: in Arthur's land.
There I gleamed in the iris of creation's
Eye, and there I laughed as a man should,
Between the pillars of my ribs in the wide
Nave of my chest. A Christian land. There
It was, and old Joseph's faithful staff
Breaking into scarlet bud in the falling snow.
But, as I said at the time, the miracle
Was commonplace: staves of chestnut wood
And maywood and the like perform it every year.
And men broke their swords in the love of battle,
And broke their hearts in the love of women,
And broke the holy bread in the love of God.
I saw them ride away between their loves
Into a circle of the snow-white wind
And so into my head's old yellow world
Of bone.

CYMEN: Your Christian land was weak, it shook
Down, it burnt, its ash was blown
Into our food and drink. What I'm inflicted with
Is strong, destroying me with a cry of love,
A violence of humility arrogantly
Demanding all I am or possess or have ambitions for,
Insistent as a tocsin which was sounded
When the sun first caught on fire, and ever since
Clangs alarm with a steady beat in the wild
Night of history. This doesn't come

From the watery light of what you think you remember.
A lashing logic drags me away from my gods.
Let it face me like a man!

MERLIN: It may be already
This power has faced you like a man, on a certain
Century's peak from which the circling low land
Is, to eternity, surveyed. Still, still,
Earth winds delicious arms; it isn't strange
Our human eyes should close upon her, like a flower
Closing on a globe of dew, and wish to see
Nothing but this. And here am I
Doting into oblivion.

CLODESUIDA: Send him off,
With his ancient ramifications; go to sleep
And be well.

CYMEN: (*To HOEL.*) Do I have to come to you again?
You, a speck of the dust which three of our generations
Have marched over: what light flung from you
To me? Why did my strength startle from your
Futility?

HOEL: On my soul, I've done nothing against you
Except to make war. I've known nothing except
Your mercy; that indeed was a kind of light to me.
I want to live, having a life in me
Which seems to demand it.

MERLIN: Having a death in him, too:
That death by drowning in the river of his baptism
From which he rose a dripping Christian child
In a land which had become a grave to us all,
Though in that grave of Britain old Merlin, for one,
Was happy enough because he could hold, both hill
And valley, his leafy love in his arms,
Old pagan that he is.

HOEL: The weather of twenty
Years has blown me dry, and long lost me
All the charms I ever had of that.

MERLIN: The spirit is very tenacious of such water.

CYMEN: The spirit again! You nod and look beyond me,
 And pretend to know nothing. Do you dare to say
 The world has a secret direction passing the gods?
 And does it run through me?
 (*To CLODESUIDA.*) Take me from them.
 I'm mad, mad to talk to the slaves.

CLODESUIDA: Rest, Cymen.

CYMEN: I am alive and so there is no rest.

CLODESUIDA: It's you who churn up the air; the air itself
 Is as unruffled as ever. Trust our gods
 And put these heathen to work.
 (*Enter ANNA.*)

ANNA: Master, master, master!
 Where is the master? The wolves, the savages!
 An old woman's no use! Oh, the master!

CYMEN: What's the matter?

ANNA: So many wolves, the fields
 Are a bear-garden – ma'am, your brothers! – grey,
 Snarling, vicious, a terrible pack – they're into
 The sheep!

CYMEN: The sheep!

CLODESUIDA: Brothers, help, help us,
 Wake, the wolves have come!

ANNA: The sheep and the lambs,
 All we have!

MARTINA: In the daylight, in daylight, too!
 What could have brought them?

ANNA: Why, hunger, hunger, the appetite,
 The spite of the belly!
 (*Enter TADFRID, OSMER, QUICHELM, and CHELDRIC.*)

OSMER: What's the cry?

CLODESUIDA: The wolves!
 They're falling on the flock!

TADFRID: So it begins,
 Bad-luck already.

OSMER: Down to them, then, and save
 What's still for saving.
 (CYMEN has already snatched COLGRIN's sword and gone;
 HOEL also, ahead of him. Now the rest follow, shouting to scatter
 the wolves.)

ANNA: I'm fit for nothing now
 But whisking eggs, I'm trembling so.
 Why should such things be? Such fangs, I have
 Sharp pains in the back just to have seen them
 Gnashing in the light. *(Seeing COLGRIN.)* Why are you here,
 You, taking up space as though time didn't begin
 Until the day after tomorrow? Do all legs move
 Except the two that keep the ground away from you?
 Why don't you go and help?

COLGRIN: My dear, good woman,
 I'm here on duty.

ANNA: What duty would you mean,
 I wonder? The prisoner's gone.

COLGRIN: All the more reason
 Why the other half of the arrangement should stand.
 If the horse gets out of the stable it doesn't mean
 The stable is justified in following.
 I'm a man who can be relied on.

ANNA: So you are.
 Well, at least when your time comes to be buried
 They'll have no trouble keeping you under the ground.
 But why should wolves be set upon us? Men
 Make enough misfortunes for themselves, without
 Natural calamities happening as well.
 The old gentleman agrees.

MERLIN: Considerable
 Age makes me nod; I neither agree
 Nor disagree. I'm too near-sighted now
 To be able to distinguish one thing from another,

The storm-swollen river from the tear-swollen eyes,
Or the bare cracked earth from the burnt-out face,
Or the forest soughing from the sighing heart.
What is in one is in the other, a mood
Of rage which turns upon itself to savage
Its own body, since there's nothing except itself
On which anger can alight; it sinks into time
Like a sword into snow
And the roots receive all weathers and subsist,
And the seasons are reconciled. When, years ago,
The Romans fell away from our branching roads
Like brazen leaves, answering
The hopeless windy trumpets from their home,
Your tribes waged winter upon us, till our limbs
Ached with the carving cold. You blackened
The veins of the valleys with our dried blood. And at last
Your lives croaked like crows on a dead bough
And the echoes clanged against you. But I can hear
Faintly on the twittering sea a sail
Moving greatly where the waves, like harvest-home,
Come hugely on our coast: the men of Rome
Returning, bringing God, winter over, a breath
Of green exhaled from the hedges, the wall of sky
Breached by larksong. Primrose and violet
And all frail privileges of the early ground
Gather like pilgrims in the aisles of the sun.
A ship in full foliage rides in
Over the February foam, and rests
Upon Britain.

COLGRIN: He's in the clouds, you see; he's away
On his own; he's blowing about like the hairs in his beard.

ANNA: Maybe, yes, and maybe also his beard
Has caught on something. He seems to have brought
The other side of the hill into his head.
It's good to see — we anticipate little enough —
And certainly today, I noticed myself,

Winter is wearing thin; it's beginning to show
The flowering body through.

COLGRIN: It's a hard time,
The spring; it makes me lose all my energy.
(*Enter CLODESUIDA.*)

CLODESUIDA: Did you see it, did ever your eyes? He must be
as wild
As an animal in his heart! Who ever saw
Such wrestling between hand and claw?

ANNA: Such what,
Such wrestling? I hadn't hard enough eyes
To put them again on those poor bleating lambs.
Are the wolves away now? Are the wolves away?
I still shake for the sake of those sheep.

CLODESUIDA: The wolves
Are beaten off. But the Briton killed the grimmest,
The greatest: with his hands, with his hands as bare
As mine: met and mauled the scavenger, with a grip
Under the blood and froth of the jaws, he shook
And choked the howling out of its fangs
And forced it to a carcase. It was horror
And hope and terror and triumph to see it.

ANNA: The boy? The Briton? with bare hands?

MERLIN: Like a shepherd
With a lion.

COLGRIN: With his bare hands?

ANNA: It's just as well
To hang the wet linen on your sword,
You heavy hero on my conscience.
(*Enter TADFRID, OSMER, QUICHELM, and CHELDRIC.*)

CLODESUIDA: It's a tale
I'll tell to my grave! My heart is hammering
And still hugging the fearful sport of the struggle.
What shall we do to reward him?

OSMER: Reward him? his death
Can reward him. Who's the fool who's going to kiss

Future trouble? Who does, deserves to lie
With the grass growing up through a crack in the skull.

CLODESUIDA: What do you mean? Didn't he enlist himself
Against our disaster?

TADFRID: But in what power's name?
Osmer fears –

OSMER: And very properly fears.
I'm not quite a child in this cleft-stick of life.

(*Enter CYMEN.*)

CYMEN: Are you still rolling your marbles of thunder?
I hear what you say. Still breaking wind to make
A hurricane. I am very tired.

OSMER: And so
Are we all with anxiety. And so no doubt
Are the crouching gods who contain their final leap
Waiting for wisdom from us.

TADFRID: And not holding
For long, now that the first roar has come.

CYMEN: That may be. I know well enough
The weight of the silence that's on our shoulders now.
I move under it like the moving mole
That raises the hackles of dead leaves.
Under me, silence; round me, silence, air,
The wind hushing the world to hear
The wind hushing the world; and over me,
Silence upon silence upon silence,
Unuttering vapour, unutterable void.
What do you want me to do?

OSMER: Make retribution
Before we're godsmitten again.

TADFRID: A sacrifice.

OSMER. The only possible sacrifice, the Briton.

CLODESUIDA: Can they be right, Cymen? Certainly
We must do what is necessary, though when
I saw the wolf destroyed –

OSMER: As now you shall see
 Our luck's neck fractured, unless we act.
 The Briton sprang on the back of a punishment
 Justly put upon us by the gods.

TADFRID: That's so. And by what muscle, except a devil's,
 Could he elbow himself between our gods and us?

OSMER: It's perfectly proper that we should contest our
 punishment,
 If we can. The gods relish a knock or two
 Before they lean back and insist on being
 Propitiated. But by no right does this Briton
 Break in and ruffle them beyond all hope.
 His demon rams him to it to make our world
 The worse for us.

QUICHELM: We've got to be free of him.
 Cut him to quiet. He's a flint that's going to skag us.
 Hit the spark of life out of him, father.

TADFRID: What else but a power of the dark would send him
 Scudding into the teeth and talons
 Of a probable death, for us, his enemies?
 If you let him live among us —

 (Enter HOEL, helped by MARTINA. His shoulders have been
 clawed by the wolf. They walk across to the barn, watched in silence
 by the others.)

CYMEN: I will sacrifice.

OSMER: Then back we come to easy breathing
 And a chance of pleasure.

CLODESUIDA: Let me think of the harm
 He would do us, his brain's blackened teeth,
 And not sicken at his killing. What the gods
 Want we'll give them, even though our blood
 Freezes.

CYMEN: I will sacrifice.
 I'll pay off whatever dark debts there are
 And come to the morning, square. I am tired, tired
 Of being ground between the staring stones

Of air and earth. I'll satisfy the silence.
Bring me one of the white goats.

TADFRID / OSMER: A goat?

CYMEN: One silence of death is as deep as another
To satisfy the silence. It will do
To patch wherever a whisper from above
Can still creep out. Bring me the goat.

CLODESUIDA: But this
Can't please them if they demand the Briton?

OSMER: It's livestock thrown away.

TADFRID: Look, he goes
To pray to them.

CYMEN: (*At the altar.*) Gods, our gods, gods
Of the long forced-march of our blood's generations
Dead and living. Goaders, grappling gods,
Whose iron feet pace on thunder's floor
Up and down in the hall where chaos groaned
And bore creation sobbing. Boding gods,
Who broad in the universe consume our days
Like food, and crunch us, good and bad,
Like bones. What do I do by sacrifice?
The blood flows, the ground soaks it up,
The poisoned nightshade grows, the fears go on,
The dread of doom gropes into the bowels,
And hope, with her ambitious shovel, sweats
To dig the pit which swallows us at last.
The sacrifice is despair and desperation!
The deed of death is done and done and always
To do, death and death and death; and still
We cannot come and stand between your knees.
Why? By what stroke was the human flesh
Hacked so separate from the body of life
Beyond us? You make us to be the eternal alien
In our own world. Then I submit. Separation
To separation! Dedicated stones
Can lie asunder until the break is joined!

(*CYMEN throws down the stones of the altar. The rest, except HOEL, throw themselves in horror onto the ground.*)

Answer, then, answer! I am alone, without hope.
The outlaw, no longer the groveller on the knee.
Silence me! Come down and silence me!
Then at least I shall have some kind of part
With all the rest.

(*They wait.*)

 Not even that?

Is separation between man and gods
So complete? Can't you even bring me to silence?

(*A voice from a short way off is heard calling 'Cymen! Cymen of the Copse!' CYMEN stands startled. The rest raise themselves partly from the ground in apprehension. The voice calls, again, nearer.*)

What is it? Who is it? I am here on my ground.

(*Enter a MESSENGER.*)

MESSENGER: Cymen of the Copse, is he here?

CYMEN: I'm that man.

MESSENGER: You're summoned to the general assemblage
 Of all householders, copyholders, smallholders, and tenant
 farmers,
 At the command of Ethelbert, lord and king of Kent,
 To receive the person and words of Augustine
 Exponent of the Christian god.
 Proper precautions are being taken, and all
 Provision made, to protect each person present
 From being taken at a disadvantage
 By the craft of any spirit whatsoever,
 Evil or good. Therefore you will take your stand
 Not under the king's roof
 But where the air keeps open house
 And the sun in the sky suffers all for all,
 Or at least if any charms are set afoot
 They will be less concentrated, owing to the wind.

CYMEN: Am I called to the king?

MESSENGER: You assemble on the western hill
 To receive the person and words –

MERLIN: Of Augustine
 Sent by Gregory of Rome who on a market-day
 Saw angels where we see our enemies.

ANNA: He knew, that's what he said, he saw them coming
 In a ship full of primroses from Rome!

CYMEN: (*To the MESSENGER.*) I am slow to understand you. I
 was up
 On the bare back of dreadful thoughts. Who chose
 That you should come to me now? What ground
 Am I dismounting onto, your ordinary summons
 To the king?

MESSENGER: You find it unpleasant? The news, I see,
 Has reached you already, and distaste, I suppose,
 Is understandable, though all you're supposed to do
 Is to sit and give the appearance of paying attention
 Out of consideration for the queen.

CLODESUIDA: She would like to make heathen of us all!
 We're on poor enough terms with the gods as it is
 Without seeming to keep open minds.

OSMER: They're only
 Hesitating over the choice of weapons
 They mean to use against us.

TADFRID: The sky is clear,
 The sun still shines, but there's little doubt
 Their indignation is mounting under the self-control
 Of the horizon. Let the king indulge the queen
 If it keeps her wife-minded, but here more than ever
 We've got to remain rigid with reality.

MESSENGER: In my opinion you're taking devoutness too hard.
 The gods won't object to our being a bit diplomatic.
 I'll leave you to make your way, Cymen of the Copse.

CYMEN: Time makes my way, and I go on with time.
 What is contrives what will be. Yes, I shall come.

 (*Exit the MESSENGER.*)

TADFRID: Will you go and leave us now to suffer
In whatever suffering comes of your blasphemy?

OSMER: Let him go.

CLODESUIDA: But now of all times isn't the time;
He's so wretched from his brainstorm of wrong,
Every pore of his skin's wide open to punishment.

OSMER: Let him go, let him go.

CYMEN: (*To HOEL.*) Your god has come, perhaps,
Or lies in wait on the lips of a man from Rome.
Strange. As though a spirit in you, like
A wild fowl hiding in the mere of your flesh,
Heard the sound far off and flew up clamouring
Rousing a spirit in me. We're in the path
Of change. And I must go to meet the change,
Being unable to live unaltered.

HOEL: Is it true,
Indeed? Is the One god making his way again
In through the many?

CYMEN: I go to know.
I go to dare my arm into the thicket
To know what lifts its head there, whether rose
Or tiger, or tiger and rose together.
Be undisturbed, my dear disturbed wife.
If I rock, it's with the rocking of the world;
It will get me to sleep in time. As for the rest of you,
Wait, with a certain degree of trust.
Yes, you can build up the altar again if you must.
It will be somewhere to sit when the days are warmer.
Meanwhile, the silence keep you, the silence
Be gracious unto you and give you peace.

(*Exit CYMEN. TADFRID and OSMER have started, and now
continue, to rebuild the altar. CLODESUIDA watches CYMEN
on his way.*)

CLODESUIDA: Should he go? He walks steadily enough now,
Very much as he does behind a plough. Is this only
A lull on his brain? Can he avoid trouble

After what he has done?

TADFRID: The air is clearer without him.
And let's hope the bloodshot eyes above us
Have followed him and don't still fix on us here.

QUICHELM: It was awful to watch him. We must make it right
with the gods.
They can't expect sons to carry the blame for fathers.
Would they make us suffer because of our blood?

HOEL: Yes;
Or from whose example would men have learnt that trick?

OSMER: You'll scream yourself sorry if we turn ourselves to you.

MARTINA: (*To HOEL.*) You're still a Briton, even though I have
Washed your wounds. Lie low, and don't make trouble.

CHELDRIC: Our mother's blood flows in us too, uncle,
And mother fears the gods. Won't that be taken
Into account?

CLODESUIDA: The same with the gods as with men;
Women are only camp-followers, they take
Our obedience for granted. If *we* blasphemed
They would pinch our cheeks and resume the course of history
As though nothing had happened. We succeed or suffer
According to our men.

ANNA: Then I roughen my hands
For a fine lark.

CLODESUIDA: Day's work is still to do,
Whatever the day's doom. I have no hope
To be able to know what hope to have. My hands
Can only draw their everyday conclusions.

ANNA: Yes, we must busy ourselves, and try to forget
The complication of what's up there beyond us.
(*To COLGRIN.*) Are you still rooted to the spot with duty?

COLGRIN: Unavoidably static.

OSMER: Get onto your work.

COLGRIN: But suppose the prisoner –

OSMER: Suppose

You do what you're told and quick.

COLGRIN: Quick? I'll suppose

 Anything once; but that's not how I am.

 I was born midway between the quick and the dead.

ANNA: Budge over a little farther from the grave.

 (*Exeunt CLODESUIDA, COLGRIN and ANNA.*)

TADFRID: What do we mean to do? The altar stones

 Now stand as they were. But not to them.

 To them the stones are still pitching and blundering

 From jutting god to jutting god, down

 The scowling scarp of their everlasting memory.

 They say the gods were formed

 Out of the old hurt pride of rejected chaos

 Which is still lusting for the body of the world we walk on.

OSMER: If they'll give us time and the merest shove

 In the lucky direction we're leaning to already,

 We shall be able to elude the allegiance to Cymen

 Which is such an obstacle in the way of well-doing,

 Nullify guilt and mollify the gods

 And bury the brat's guts for good in the ground.

 You shall see; it will be as I say

 If the gods give us time.

TADFRID: But Cymen claimed

 His death to himself.

OSMER: We'll do it in his name;

 If a moment which insists on action

 Comes while he's away, he would expect us

 To live the moment for him.

TADFRID: If the crisis came.

QUICHELM: What's the talk? Do you think we're in for
 the worst?

 Do you see any hope that we can relax

 Now that father's gone, or what's your guess?

CHELDRIC: Isn't the danger less?

OSMER: Come away from here.

 I've got a screw of courage you can chew;

We're not committed to damnation yet.

Let your sister stay. We'll pray, with a certain purpose.

(*Exeunt TADFRID, OSMER, QUICHELM and CHELDRIC.*)

MARTINA: They hate you; and that's easy to understand.
 We have existence on such hard terms,
 As though birth into the world had been a favour
 Instantly regretted. We haven't the air
 To spare for strangers. I hope the claw-marks heal.
 I've done my best for them.

HOEL: Thanks. Are you going in?

MARTINA: Of course. There's nothing to keep me here.

HOEL: No; there's nothing.

MARTINA: What do you want?

HOEL: I wonder
 What it was that came and wielded your father and left me
 Alive?

MARTINA: I'll not worry about my father,
 Nor my mother, nor my uncles nor, between ourselves,
 The gods. The universe is too ill-fitting
 And large. I am very careful about small
 Things, such as wearing green in the third month
 Or bringing blackthorn under the roof;
 But the big things, such as gods, must look after themselves.

HOEL: Still, I'm curious about the One god.
 I've never completely shaken him off. He seems
 To insist.

MARTINA: You're a born heathen. Get some sleep.
 You look too tired to be hated
 And that won't do at all.

HOEL: Do you have to hate me?

MARTINA: It isn't one of my easiest duties. But how else
 Can we keep our footing or our self-esteem?
 Now sleep and look malignant when you wake.

HOEL: Sleep, yes. My fields need rain. Sleep
 Can drench down and welcome.

(Exit MARTINA. HOEL lies in the straw and sleeps.)

MERLIN: Welcome, sleep;
 Welcome into the winter head of the world
 The sleep of Spring, which grows dreams,
 Nodding trumpets, blowing bells,
 A jingle of birds whenever the sun moves,
 Never so lightly; all dreams,
 All dreams out of slumbering rock:
 Lambs in a skittle prance, the hobbling rook
 Like a witch picking sticks,
 And pinnacle-ears the hare
 Ladling himself along in the emerald wheat:
 All dreams out of the slumbering rock,
 Each dream answering to a shape
 Which was in dream before the shapes were shapen;
 Each growing obediently to a form,
 To its own sound, shrill or deep, to a life
 In water or air, in light or night or mould;
 By sense or thread perceiving,
 Eye, tendril, nostril, ear; to the shape of the dream
 In the ancient slumbering rock.
 And above the shapes of life, the shape
 Of death, the singular shape of the dream dissolving,
 Into which all obediently come.
 And above the shape of death, the shape of the will
 Of the slumbering rock, the end of the throes of sleep
 Where the stream of the dream wakes in the open eyes
 Of the sea of the love of the morning of the God.
 Here's an old man whiling away a spring
 Day, with thoughts so far beyond the moss
 He roots in, they're as nebulous
 As the muted flute of a dove to the root of a tree.
 Never mind. However warmly I curl
 My tail around my feet and admire myself
 Reflected in the nut before I bite,
 Still I observe the very obdurate pressure
 Edging men towards a shape beyond

The shape they know. Now and then, by a spurt
Of light, they manage the clumsy approximation,
Overturn it, turn again, refashion
Nearer the advising of their need.
Always the shape lying over the life.
Pattern of worm in the sand was not the shape,
Nor the booming body of enormous beast,
Nor the spread fan of the blue-eyed quivering tail,
Nor the weave of the nest, nor the spun wheel of the web,
Nor the maze and cellarage of honey, nor
The charts and maps of men. The shape shone
Like a faint circle round a moon
Of hazy gods, and age by age
The gods reformed according to the shape,
According to the shape that was a word,
According to Thy Word. Here's more than half
A pagan whiling away the spring sunshine.
The morning has come within a distant sight
Of evening, and the wandering shadows begin
To stretch their limbs a little. I shall move
Myself, into the quiet of the tumbling tower,
For an hour or two of casual obliteration
And break more ground for dreams.

(*Exit MERLIN. Enter, after a pause, MARTINA with a bowl of
food. She goes to HOEL, who is still asleep.*)

MARTINA: You're even less of an enemy when you sleep.
Wake up. You've gone where we're all of one size.
Bring yourself back and know your station.

HOEL: Yes?
This isn't where I sleep. Why is my heart
So heavy?

MARTINA: Here is food. You have to be
A good enemy and eat.

HOEL: You went indoors.
I thought you might not come back again.

MARTINA: Aren't you hungry?

HOEL: Perhaps. From where I sit
 On the kerb of sleep I feel I know you better
 Than I did before. Take the bowl in your hands
 And let me eat the food from there.

MARTINA: Am I your servant?

HOEL: I'm your servant. I slept
 When you said sleep, and I'll eat like a tame swan
 Out of your hands.

MARTINA: Too black for a swan,
 You'd make me a good shadow. I'll ask my father
 To give you to be my personal shadow,
 To walk behind me in the morning, and before me
 In the evening, and at noon I'll have you
 Under my feet.

HOEL: I shall adjust myself
 Easily to noon.

MARTINA: You'll feel humiliated
 And bite the dust.

HOEL: I shall feel delighted
 And kiss the sole of your foot.

MARTINA: It's clear you're nothing
 But a poor-spirited Briton if you're willing
 To become a girl's shadow.

HOEL: Yes, indeed;
 A poor-spirited Briton; you remind me
 In good time.

MARTINA: But a Briton who, if he were a Jute,
 Would be brave and agreeable. So be glad of that.

HOEL: What simple-witted things the affections are,
 That can't perceive whether people are enemies
 Or friends. You would think the strong distinction
 Between race and race would be clear even to the heart
 Though it does lie so retired
 Beating its time away in the human breast.

MARTINA: You talk of nothing that interests me. Eat
 Your food.

(*Enter TADFRID, OSMER, QUICHELM and CHELDRIC.*)

OSMER: You see, she has gone to him again.
It's the way I said it would be. His damned contagion
Spreads.

TADFRID: It flies first to the weakest place.
That girl sees nothing but an eye and a mouth
And doesn't care.

QUICHELM: She can go and eat grass
Before I call her sister again.

OSMER: She gives us
The grounds for getting him where the gods want him.
He is ours and his blood's as good as gone to them.
If we hesitated now even Cymen would say
We were as puny as pulp.

MARTINA: (*To HOEL.*) You look so sad.

(*She kisses him on the forehead.*)

QUICHELM: (*Leaping forward.*) Leper-flesh!

CHELDRIC: He snared her!

MARTINA: What's so wrong?

QUICHELM: You and the flicker of your rutting eyes are wrong!

OSMER: Toleration has gone to the limit. Now
We strike. You black pawn of the devil's game,
Come out.

HOEL: Why, what is it you mean to do?

OSMER: Make much of you, make a god's meal of you,
And make our peace with you, with you as peacemaker,
And not too soon. It's a quiet future for you.
I said come out.

MARTINA: No! My father said he was not to be harmed!

OSMER: He wouldn't say it now. Uncertainty
Has dandled us enough to make us sick
For life. Now we're not going to fob
The gods off any longer.

QUICHELM: Must we wait?
Give me the word, and I'll fetch his cringing carcase

Out for you.

MARTINA: Don't dare to touch him!

TADFRID: Niece,
We must submit to the wish of what we worship.
We rid the world of an evil. Let's not rage.
We do what's demanded of us, with solemnity,
Without passion. Fetch him out.

MARTINA: No, you shall not!

OSMER: Take her!

(*CHELDRIC drags back MARTINA and holds her. OSMER
and QUICHELM fetch HOEL to the centre of the stage.*)

MARTINA: Cowards!

HOEL: Let me live, do, do
Let me live.

TADFRID: Bring him to the tree; we'll offer him
In Woden's way, the Woden death. Come on;
We'll be well out of our fear.

MARTINA: Cowards, cowards,
Cowards, sneakthieves, only dare with father gone!

(*They fasten him to the tree with his arms spread.*)

HOEL: Is this the end indeed? Where now for me?

MARTINA: Father! Father!

HOEL: Son and the brooding dove.
Call him again.

MARTINA: Father!

OSMER: We set this house
Free from fear and guilt and the working of darkness.

QUICHELM: We clean our hearts.

TADFRID: The sun flows on the spear.
The spear answers the sun. They are one, and go
To the act in the concord of a sacrifice.

HOEL: Death, be to me like a hand that shades
My eyes, helping me to see,
Into the light.

OSMER: Woden, we pay your dues
Of blood.

TADFRID: Receive it and receive us back
Into a comfortable security.

(*OSMER makes to plunge the spear. MARTINA breaks free of CHELDRIC and crying 'No!' tries to prevent the stroke. Enter CLODESUIDA.*)

CLODESUIDA: Have they struck at us again, the gods?
What more
Have we to bear?

MARTINA: Look, look!

CLODESUIDA: (*Covering her eyes.*) It has to be
For our good; we must endure these things, to destroy
Error, and so the gods will warm towards us.

QUICHELM: Here comes my father home!

OSMER: Well, home he comes.
We're in the right.

TADFRID: He will understand this tree
By reason of our plight had to bear such fruit.

(*Enter CYMEN. He goes towards the barn, near which CLODE-SUIDA is now standing.*)

CYMEN: Clodesuida, a peaceful heart to you now.
I am well; I have seen our terrible gods come down
To beg the crumbs which fall from our sins, their only
Means of life. This evening you and I
Can walk under the trees and be ourselves
Together, knowing that this wild day has gone
For good. Where is the Briton? You still think
You must be afraid and see in him
The seed of a storm. But I have heard
Word of his God, and felt our lonely flesh
Welcome to creation. The fearful silence
Became the silence of great sympathy,
The quiet of God and man in the mutual word.
And never again need we sacrifice, on and on
And on, greedy of the gods' goodwill

But always uncertain; for sacrifice
Can only perfectly be made by God
And sacrifice has so been made, by God
To God in the body of God with man,
On a tree set up at the four crossing roads
Of earth, heaven, time, and eternity
Which meet upon that cross. I have heard this;
And while we listened, with our eyes half-shut.
Facing the late sun, above the shoulder
Of the speaking man I saw the cross-road tree,
The love of the God hung on the motes and beams
Of light, as though –

MARTINA: Father!

(*CYMEN turns and sees HOEL.*)

CYMEN: Is it also here?
Can the sun have written it so hotly onto my eyes –
What have you done?

OSMER: The unavoidable moment
Came while you were gone –

CYMEN: What have you done?

TADFRID: Would *you* not break the body of our evil?

CYMEN: I will tell you what I know. Cut him down.
O pain of the world! – I will tell you what I know.
Bring him here to me.

CLODESUIDA: We have to live.

CYMEN: We have still to learn to live.

(*They bring HOEL to CYMEN.*)

 They say,
The sacrifice of God was brought about
By the blind anger of men, and yet God made
Their blindness their own saving and lonely flesh
Welcome to creation. Briton, boy,
Your God is here, waiting in this land again.
Forgive me for the sorrow of this world.

MARTINA: You haven't made the sorrow –

CYMEN: All make all:
 For while I leave one muscle of my strength
 Undisturbed, or hug one coin of ease
 Or private peace while the huge debt of pain
 Mounts over all the earth,
 Or, fearing for myself, take half a stride
 Where I could leap; while any hour remains
 Indifferent, I have no right or reason
 To raise a cry against this blundering cruelty
 Of man.

OSMER: Shall we let the light of our lives
 Be choked by darkness?

CYMEN: Osmer,
 What shall we do? We are afraid
 To live by rule of God, which is forgiveness,
 Mercy, and compassion, fearing that by these
 We shall be ended. And yet if we could bear
 These three through dread and terror and terror's doubt,
 Daring to return good for evil without thought
 Of what will come, I cannot think
 We should be the losers. Do we believe
 There is no strength in good or power in God?
 God give us courage to exist in God,
 And lonely flesh be welcome to creation.
 Carry him in.

(As they carry HOEL away, CYMEN, CLODESUIDA, and MARTINA following, the voices of Augustine's men are heard singing.)

A SLEEP OF PRISONERS

To Robert Gittings

Characters

PRIVATE DAVID KING

PRIVATE PETER ABLE

PRIVATE TIM MEADOWS

CORPORAL JOE ADAMS

A Sleep of Prisoners was first performed in Oxford at the University Church on 23 April 1951 and in London at St Thomas' Church, Regent Street, on 15 May 1951, with the following cast:

PRIVATE DAVID KING, Leonard White

PRIVATE PETER ABLE, Denholm Elliott

PRIVATE TIM MEADOWS, Hugh Pryse

CORPORAL JOE ADAMS, Stanley Baker

Produced by Michael MacOwan

(The interior of a church, turned into a prison camp. One prisoner, PETER ABLE, is in the organ loft, playing 'Now the day is over' with one finger. Another, DAVID KING, is looking at the memorial tablets on the wall. Four double bunks stand between the choirstalls. A pile of straw and a pile of empty paillasses are on the chancel steps.)

DAVID: *(Shouting up to the organ loft.)* Hey, Pete, come down and tell me what this Latin
Says. If it's Latin.

PETER: *(Still playing.)* Why, what for?

DAVID: For the sake of that organ. And because I want to know
If 'Hic jacet' means what it looks like.

(PETER changes the tune to 'Three Blind Mice'.)

(In a flash of temper.) And because I said so, that's what for, because
I said so! And because you're driving me potty.

PETER: Excuse me a minute: this is the difficult bit.

DAVID: If you want it difficult, go on playing. I swear
I'll come up there and put my foot through you.

(As the playing goes on DAVID suddenly howls like a dog and starts tearing up a hymn-book.)

PETER: *(The playing over.)* It's the universal language, Dave.
It's music.

DAVID: Music my universal aunt. It's torture.

(He finds himself with a page or two of the hymn-book in his hand.)

Here, I know this one.

(Sings.) 'All things bright and beautiful –'

PETER: *(Coming down from the loft.)* That doesn't mean you, Davy.
Put it down.

DAVID: 'All creatures great and small –'
Well, one of those is me: I couldn't miss it,
'All things wise and wonderful –'

(CORPORAL JOE ADAMS comes to the steps with more straw.)

ADAMS: Come and get it!

PETER: What is it? Soup?

ADAMS: Straw.

PETER: Never could digest it.

(*TIM MEADOWS, a middle-aged man – indeed he looks well on towards sixty – limps up to the pile of straw.*)

ADAMS: How's the leg feel, Meadows?

MEADOWS: Ah, all right.
 I wouldn't be heard saying anything about one leg
 I wouldn't say about the other.

PETER: Where
 Did you get it, chum?

MEADOWS: I had it for my birthday.
 Quite nice, isn't it? Five toes, it's got.

PETER: I mean where was the fighting, you wit?

MEADOWS: (*Jerking his head.*) Down the road.
 My Uncle George had a thumping wooden leg,
 Had it with him, on and off, for years.
 When he gave up the world, it got out in the wash house.

DAVID: Has anybody thought what it's going to be like
 Suppose we stay here for months or years?

ADAMS: Best they can do. You heard the towzer Commandant:
 'All more buildings blow up into sky.
 No place like home now. Roof here. Good and kind
 To prisoners. Keep off sun, keep off rain.'

PETER: Keep off the grass.

DAVID: It's a festering idea for a prison camp.
 You have to think twice every time you think,
 In case what you think's a bit on the dubious side.
 It's all this smell of cooped-up angels
 Worries me.

PETER: What, us?

DAVID: Not mother's angels,
 Dumb-cluck, God's angels.

PETER: Oh yes, them,
 We're a worse fug to them, I shouldn't wonder,

We shall just have to make allowances.

DAVID: Beg pardon:

I'm talking to no-complaints Pete: arrangements perfect.

ADAMS: Too many pricking thistles in this straw:
Pricked to hell.

(*PETER has wandered across to the lectern.*)

PETER: Note his early perpendicular
Language. Ecclesiastical influence.
See this? They've put us an English Bible.
There's careful nannies for you... 'These were the sons
Of Caleb the son of Hur, the firstborn of Ephratah:
Shobal the father of Kirjath-jearim, Salma
The father of Beth-lehem, Hareph the father
Of Beth-gader. And Shobal the father of Kirjath-
Jearim had sons: Haroeh, and half of the Manahethites –'
Interesting, isn't it?

DAVID: Stuff it, Pete.

PETER: 'And these were the sons of David, which were born unto
Him in Hebron: the firstborn Amnon, of Ahinoam the
Jezreelitess: the second Daniel, of Abigail the
Carmelitess: the third Absalom the son of Maacah the
Daughter of Talmai king of Geshur: the fourth Adonijah
The son of Haggith: the fifth Shephatiah of Abital:
The sixth Ithream by Eglah his wife...'

 Doing

All right, aren't you, Davey?

DAVID: So I did in Sunday school. You know what Absalom
Said to the tree? 'You're getting in my hair.'
And that's what I mean, so shut up.

PETER: Shut up we are.
Don't mind me. I'm making myself at home.
Now all I've got to do is try the pulpit.

ADAMS: Watch yourself, Pete. We've got years of this.

DAVID: (*His temper growing.*)
Any damn where he makes himself at home.
The world blows up, there's Pete there in the festering

Bomb-hole making cups of tea. I've had it
Week after week till I'm sick. Don't let's mind
What happens to anybody, don't let's object to anything,
Let's give the dirty towzers a cigarette,
There's nothing on earth worth getting warmed up about!
It doesn't matter who's on top, make yourself at home.

ADAMS: Character of Private Peter Able:
And not so far out at that. What we're in for
We've got to be in for and know just what it is.
Have some common sense, Pete. If you're looking for trouble
Go and have it in the vestry.

PETER: (*Up in the pulpit.*) How can I help it if I can't work myself up
About the way things go? It's a mystery to me.
We've had all this before. For God's sake
Be reasonable, Dave. Perhaps I was meant
To be a bishop.
(*He turns to the nave.*) Dearly beloved brothers
In a general muck-up, towzers included…

DAVID: What the hell do you think we're stuck here for
Locked in like lunatics? Just for a nice
New experience, with nice new friends
With nice new rifles to look after us ?
We're at war with them, aren't we? And if we are
They're no blaming use!

PETER: (*Continuing to preach.*) We have here on my left
An example of the bestial passions that beset mankind.
(*DAVID, beside himself, leaps up the steps and attacks PETER in
the pulpit.*)
Davey, Dave…don't be a lunatic!

ADAMS: Come out of it,
King. Come down here, you great tomfool!
(*He goes to drag DAVID away. DAVID has his hands on PETER's
throat and has pushed him across the edge of the pulpit.*)

DAVID: (*Raging.*) You laugh: I'll see you never laugh again.
Go on: laugh at this.

MEADOWS: If you don't get your hands away
You'll wish you never had 'em. Give over! Give over!

(*DAVID releases his hold. He pushes past ADAMS and comes down
from the pulpit.*)

I see the world in you very well. 'Tisn't
Your meaning, but you're a clumsy, wall-eyed bulldozer.
You don't know what you're hitting.

(*DAVID goes past him without a word, and throws himself onto
his bed.*)

 Ah, well,
Neither do I, of course, come to that.

ADAMS: All right, Peter?

PETER: Think so, Corporal,
I'm not properly reassembled yet.
There's a bit of a rattle, but I think I had that before.

ADAMS: Dave had better damp down that filthy volcano
Or let me know what.

PETER: Oh, lord, I don't know,
It's who we happen to be. I suppose I'd better
Hit him back some time, or else he'll go mad
Trying to make me see daylight. I don't know.
I'll tell you my difficulty, Corp. I never remember
I ought to be fighting until I'm practically dead.
Sort of absent-fisted. Very worrying for Dave.

(*They have come down from the pulpit. PETER sways on his feet.
ADAMS supports him.*)

ADAMS: You're all in, Pete.

PETER: Say 'Fall out' and watch me
Fall.

ADAMS: All right, come on, we'll put you to bed.

(*MEADOWS has limped across with two blankets for PETER's
bunk. DAVID is watching anxiously.*)

DAVID: What's wrong, Pete?

ADAMS: The best thing for you is keep
Out of this.

PETER: Dog-tired, that's all. It comes
 Of taking orders. Dog collar too tight.

DAVID: I'll see to him.

ADAMS: I've seen you see to him.
 Get back on your bed.

DAVID: I've never killed him yet.
 I'm a pal of his.

ADAMS: That's right. I couldn't have expressed it
 Better myself. We'll talk about that tomorrow.

 (*He goes over to make up his own bunk. DAVID unlaces PETER's boots.*)

DAVID: How d'you feel now, Pete?

PETER: Beautiful.

DAVID: Why don't
 You do some slaughtering sometimes? Why always
 Leave it to me? Got no blood you can heat
 Up or something? I didn't hurt you, did I,
 Pete? How d'you feel?

PETER: (*Almost asleep.*) Um? Fine.

DAVID: (*Taking off PETER's socks for him.*)
 The world's got to have us. Things go wrong.
 We've got to finish the dirty towzers. It's been
 A festering day, and I'm stinking tired. See you
 Tomorrow.

 (*He leaves PETER sleeping, goes over to his own bunk, and throws himself down.*)

ADAMS: (*To MEADOWS.*) I sometimes feel a bit like Dave
 Myself, about Pete. You have to tell him there's a war on.

 (*MEADOWS has taken his boots and socks off and is lying on top of his blankets.*)

MEADOWS: Sometimes I think if it wasn't for the words, Corporal,
 I should be very given to talking. There's things
 To be said which would surprise us if ever we said them.

ADAMS: Don't give us any more surprises, for God's sake.

224

MEADOWS: There's things would surprise us.

ADAMS: (*Studying the sole of his foot.*) Like the size of that blister.

MEADOWS: Or even bigger. Well, good night, Corporal.

ADAMS: G'night, boy.

MEADOWS: I'm old enough to be
 Your father.

ADAMS: I thought you might be. How did you get
 Pulled in on this?

MEADOWS: I thought I would.
 I got in under the fence. Not a soul
 At the War Office had noticed me being born.
 I'd only my mother's word for it myself,
 And she never knew whether it was Monday washing-day
 Or Thursday baking-day. She only knew
 I made it hindering awkward.

ADAMS: Are you glad
 You came?

MEADOWS: Ah, now. Well,
 Glad, yes, and sorry, yes, and so as that.
 I remember how it came over me, as I
 Was dunging a marrow bed. Tim, I said to me –
 'Cos being a widower I do the old lady's
 Talking for her, since she fell silent – Tim,
 You're in the way to curse. Thinking of the enemy
 And so as that. And I cursed up and about.
 But cursing never made anything for a man yet.
 So having had the pleasure of it, I came along
 To take a hand. But there's strange divisions in us,
 And in every man, one side or the other.
 When I'm not too good I hear myself talking away
 Like Tim Meadows MP, at the other end of my head.
 Sounds all right. I'd like to know what I say.
 Might be interesting.

ADAMS: I shouldn't worry.
 I'm going to take a last look at Pete.
 G'night, boy.

MEADOWS: (*Already almost asleep.*) Hope so.

 (*ADAMS goes over to PETER'S bunk.*)

DAVID: Corp.

ADAMS: Hullo.

DAVID: How long are we here for?

ADAMS: A million years.

 So you'd better get to like it.

DAVID: Give us

 Cassock and surplice drill tomorrow, Joe.

ADAMS: OK. Wash your feet.

DAVID: How's Pete? Asleep?

ADAMS: Couldn't be more if he died.

DAVID: (*Starting up on his elbow.*) What do you mean?

ADAMS: I mean he's breathing like an easy conscience. Why
 don't you
 Get down to it yourself? There's tomorrow to come,
 According to orders. Good night, King of Israel.

DAVID: Oh, go

 And discard yourself. G'night, Corporal Joseph Adams.

 (*ADAMS goes to his bunk. MEADOWS turns in his sleep. The
 church clock strikes a single note.*)

MEADOWS: (*Asleep.*) Who's that, fallen out? How many men?
 How many? I said only one.
 One was enough.
 No, no, no. I didn't ask to be God.
 No one else prepared to spell the words.
 Spellbound. B-o-u-n-d. Ah-h-h-h...
 (*He turns in his sleep again.*)
 It's old Adam, old, old, old Adam.
 Out of bounds. No one said fall out.
 What time did you go to bad?
 Sorrow, Adam, stremely sorrow.
 (*CORPORAL ADAMS comes towards him, a dream figure.*)
 Adam, Adam, stand easy there.

ADAMS: Reporting for duty, sir.

MEADOWS: As you were, Adam.

ADAMS: No chance of that, sir.

MEADOWS: As you were, as you were.

ADAMS: Lost all track of it now, sir.

MEADOWS: How far back was it, Adam?

ADAMS: (*With a jerk of the head.*) Down the road. Too dark to see.

MEADOWS: Were you alone?

ADAMS: A woman with me, sir.

MEADOWS: I said Let there be love,
 And there wasn't enough light, you say?

ADAMS: We could see our own shapes, near enough,
 But not the road. The road kept on dividing
 Every yard or so. Makes it long.
 We expected nothing like it, sir.
 Ill-equipped, naked as the day,
 It was all over and the world was on us
 Before we had time to take cover.

MEADOWS: Stand at peace, Adam: do stand at peace.

ADAMS: There's nothing of that now, sir.

MEADOWS: Corporal Adam.

ADAMS: Sir?

MEADOWS: You have shown spirit.

ADAMS: Thank you, sir.
 Excuse me, sir, but there's some talk of a future.
 I've had no instructions.

MEADOWS: (*Turning in his sleep.*) Ah-h-h-h-h.

ADAMS: Is there any immediate anxiety of that?

 (*DAVID, as the dream figure of Cain, stands leaning on the lectern, chewing at a beet.*)

 How far can we fall back, sir?

DAVID: (*Smearing his arms with beet juice.*) Have you lost something?

ADAMS: Yes, Cain: yes, I have.

DAVID: Have you felt in all your pockets?

227

ADAMS: Yes, and by searchlight all along the grass
 For God knows howling. Not a sign,
 Not a sign, boy, not a ghost.

DAVID: When do you last
 Remember losing it?

ADAMS: When I knew it was mine.
 As soon as I knew it was mine I felt
 I was the only one who didn't know
 The host.

DAVID: Poor overlooked
 Old man. Allow me to make the introduction.
 God: man. Man: God.

 (PETER, the dream figure of Abel, is in the organ-loft fingering
 out 'Now the day is over'.)

ADAMS: I wish it could be so easy.

DAVID: Sigh, sigh, sigh!
 The hot sun won't bring you out again
 If you don't know how to behave.
 Pretty much like mutiny. I'd like to remind you
 We're first of all men, and complain afterwards.
 (Calling.) Abel! Abel! Hey, flock-headed Peter,
 Come down off those mountains.
 Those bleating sheep can look after themselves.
 Come on down.

PETER: What for?

DAVID: Because I said so!

PETER: (Coming down.) I overlooked the time. Is it day or night?

DAVID: You don't deserve to inherit the earth.
 Am I supposed to carry the place alone?

PETER: Where will you carry it?
 Where do you think you're going to take it to,
 This prolific indifference?
 Show me an ending great enough
 To hold the passion of this beginning
 And raise me to it.
 Day and night, the sun and moon

Spirit us, we wonder where. Meanwhile
Here we are, we lean on our lives
Expecting purpose to keep her date,
Get cold waiting, watch the overworlds
Come and go, question the need to stay
But do, in an obstinate anticipation of love.
Ah, love me, it's a long misuse of breath
For boys like us. When do we start?

DAVID: When you suffering god'sbodies
Come to your senses. What you'll do
Is lose us life altogether.
Amply the animal is Cain, thank God,
As he was meant to be: a huskular strapling
With all his passions about him. Tomorrow
Will know him well. Momentous doings
Over the hill for the earth and us.
What hell else do you want?

PETER: The justification.

DAVID: Oh, bulls and bears to that.
The word's too long to be lived.
Just if, just if, is as far as ever you'll see.

PETER: What's man to be?

DAVID: Content and full.

PETER: That's modest enough.
What an occupation for eternity.
Sky's hollow filled as far as forever
With rolling light: place without limit,
Time without pity:
And did you say all for the sake of our good condition,
All for our two-footed prosperity?
Well, we should prosper, considering
The torment squandered on our prospering.
From squid to eagle the ravening is on.
We are all pain-fellows, but nothing you dismay,
Man is to prosper. Other lives, forbear
To blame me, great and small forgive me

If to your various agonies
My light should seem hardly enough
To be the cause of the ponderable shadow.

DAVID: Who do you think you are, so Angel-sick?
Pain warns us to be master: pain prefers us.
Draws us up.

PETER: Water into the sun:
All the brooding clouds of us!

DAVID: All right.
We'll put it to the High and Mighty.
Play you dice to know who's favoured.

PETER: What's he to do with winning?

DAVID: Play you dice.
Not so sure of yourself, I notice.

PETER: I'll play you. Throw for first throw.
Now creation be true to creatures.

ADAMS: Look, sir, my sons are playing.
How silent the spectators are,
World, air, and water.
Eyes bright, tension, halt.
Still as a bone from here to the sea.

DAVID: (*Playing.*) Ah-h-h-h!

ADAMS: Sir, my sons are playing. Cain's your man.
He goes in the mould of passion as you made him.
He can walk this broken world as easily
As I and Eve the ivory light of Eden.
I recommend him. The other boy
Frets for what never came his way,
Will never reconcile us to our exile.
Look, sir, my sons are playing.
Sir, let the future plume itself, not suffer.

PETER: (*Playing.*) How's that for a nest of singing birds?

ADAMS: Cain sweats: Cain gleams. Now do you see him?
He gives his body to the game.
Sir, he's your own making, and has no complaints.

DAVID: Ah! What are you doing to me, heaven and earth?

PETER: Friendly morning.

DAVID: (*Shaking the dice.*) Numbers, be true to nature.

> Deal me high,
> Six dark stars
> Come into my sky.

(*He throws.*)

Blight! What's blinding me
By twos and threes? I'm strong, aren't I?
Who's holding me down? Who's frozen my fist
So it can't hatch the damn dice out?

PETER: (*Shaking and throwing.*) Deal me high, deal me low.

> Make my deeds
> My nameless needs.
> I know I do not know.

… That brings me home!

(*DAVID roars with rage and disappointment.*)

DAVID: Life is a hypocrite if I can't live
The way it moves me! I was trusted
Into breath. Why am I doubted now?
Flesh is my birthplace. Why shouldn't I speak the tongue?
What's the disguise, eh? Who's the lurcher
First enjoys us, then disowns us?
Keep me clean of God, creation's crooked.

ADAMS: Cain, steady, steady, you'll raise the world.

DAVID: You bet your roots I will.
I'll know what game of hide and seek this is.
Half and half, my petering brother says,
Nothing of either, in and out the limbo.
'I know I do not know' he says.
So any lion can BE, and any ass,
And any cockatoo: and all the unbiddable
Roaming voices up and down
Can live their lives and welcome
While I go pestered and wondering down hill
Like a half-wit angel strapped to the back of a mule.
Thanks! I'll be as the body was first presumed.

PETER: It was a game between us, Cain.

DAVID: (*In a fury.*)

Your dice were weighted! You thought you could trick
The life out of me. We'll see about that.
You think you're better than you're created!
I saw the smiles that went between
You and the top air. I knew your game.
Look helpless, let him see you're lost,
Make him amiable to think
He made more strangely than he thought he did!
Get out of time, will you, get out of time!

(*He takes PETER by the throat. ADAMS goes to part them.*)

ADAMS: Cain, drop those hands!

(*He is wheeled by an unknown force back against his bunk.*)

 O Sir,
Let me come to them. They're both
Out of my reach. I have to separate them.

DAVID: (*Strangling PETER.*)

You leave us now, leave us, you half-and-half:
I want to be free of you!

PETER: Cain! Cain!

ADAMS: Cain, Cain!

DAVID: If life's not good enough for you
Go and justify yourself!

ADAMS: Pinioned here, when out of my body
I made them both, the fury and the suffering,
The fury, the suffering, the two ways
Which here spreadeagle me.

(*DAVID has fought PETER back to the bed and kills him.*)

O, O, O,
Eve, what love there was between us. Eve,
What gentle thing, a son, so harmless,
Can hang the world with blood.

DAVID: (*To PETER.*) Oh,
You trouble me. You are dead.

ADAMS: How ceaseless the earth is. How it goes on.
 Nothing has happened except silence where sound was,
 Stillness where movement was. Nothing has happened,
 But the future is like a great pit.
 My heart breaks, quiet as petals falling
 One by one, but this is the drift
 Of agony forever.

DAVID: Now let's hope
 There will be no more argument,
 No more half-and-half, no more doubt,
 No more betrayal. – You trouble me,
 You trouble me.

MEADOWS: (*In his sleep.*) Cain.
 (*DAVID hides.*)

 Cain. Where is
 Your brother?

DAVID: How should I know? Am I
 His keeper?

ADAMS: Where is keeping?
 Keep somewhere, world, the time we love.
 I have two sons, and where is one,
 And where will now the other be?
 I am a father unequipped to save.
 When I was young the trees of love forgave me:
 That was all. But now they say
 The days of such simple forgiveness are done,
 Old Joe Adam all sin and bone.

MEADOWS: Cain: I hear your brother's blood
 Crying to me from the ground.

DAVID: Sir, no: he is silent.
 All the crying is mine.

MEADOWS: Run, run, run. Cain
 Is after you.

DAVID: What shall I do?

MEADOWS: What you have done. It does it to you.
 Nowhere rest. Cage of the world

Holds your prowling. Howl, Cain, jackal afraid.
And nowhere, Cain, nowhere
Escape the fear of what men fear in you.
Every man's hand will be against you,
But never touch you into quietness.
Run! Run!

DAVID: The punishment
Is more than I can bear. I loved life
With a good rage you gave me. And how much better
Did Abel do? He set up his heart
Against your government of flesh.
How was I expected to guess
That what I am you didn't want?
God the jailer, God the gun
Watches me exercise in the yard,
And all good neighbourhood has gone.
The two-faced beater makes me fly,
Fair game, poor game, damned game
For God and all man-hunters.

MEADOWS: They shall never kill you.

DAVID: Death was a big word, and now it has come
An act so small, my enemies will do it
Between two jobs. Cain's alive,
Cain's dead, we'll carry the bottom field:
Killing is light work, and Cain is easily dead.

MEADOWS: Run on, keep your head down, cross at the double
The bursts of open day between the nights.
My word is Bring him in alive.
Can you feel it carved on your body?

(*DAVID twists as though he felt a branding iron touch him.*)

DAVID: God in heaven! The drag!
You're tearing me out of my life still living !
This can't last on flesh forever.
Let me sleep, let me, let me, let me sleep.
God, let me sleep. God, let me sleep.

(*He goes into the shadows to his bed.*)

MEADOWS: (*Turning in bed.*) This can't last on flesh forever.
Let me sleep.

(*There follows a pause of heavy breathing. The church clock in the tower strikes the three-quarters. MEADOWS wakes, props himself up on his elbow.*)

 Any of you boys awake?
Takes a bit of getting used to, sleeping
In a looming great church. How you doing?
I can't rest easy for the night of me.
… Sleeping like great roots, every Jack of them.
How many draughts are sifting under the doors.
Pwhee-ooo. And the breathing: and breathing: heavy and deep:
Breathing: heavy and deep.
Sighing the life out of you. All the night.

(*DAVID stirs uneasily.*)

DAVID: I don't have to stay here! I'm a King.

MEADOWS: David, that you? You awake, David?
A dream's dreaming him. This is no place
For lying awake. When other men are asleep
A waking man's a lost one. Tim, go byes.

(*He covers his head with his blanket.*)

DAVID: (*In his sleep.*) I'm King of Israel. They told me so.
I'm doing all right. But who is there to trust?
There are so many fools. Fools and fools and fools,
All round my throne. Loved and alone
David keeps the earth. And nothing kills them.

(*PETER, as the dream figure of Absalom, stands with his back pressed against a wall as though afraid to be seen.*)

PETER: Do you think I care?

DAVID: Who is that man down there
In the dark alleyway making mischief?

PETER: Do you think I care?

DAVID: Corporal Joab:
There's a man in the dark way. Do you see
That shadow shift? It has a belly and ribs.
It's a man, Joab, who shadows me. He lurks

Against my evening temper. Dangerous.

(*ADAMS appears as the dream figure of Joab.*)

ADAMS: I think you know already.

DAVID: He has got to be named. Which of us does it?

ADAMS: He's your own son: Absalom.

DAVID: Now
 The nightmare sits and eats with me.
 He was boy enough.
 Why does he look like a thief?

ADAMS: Because
 He steals your good, he steals your strength,
 He riddles your world until it sinks,
 He plays away all your security,
 All you labour and suffer to hold
 Against the enemy.

DAVID: The world's back
 Is bent and heavily burdened, and yet he thinks
 He can leapfrog over. Absalom,
 Absalom, why do you play the fool against me?

PETER: You and your enemies! Everlastingly
 Thinking of enemies. Open up.
 Your enemies are friends of mine.

DAVID: They gather against our safety. They make trash
 Of what is precious to us. Absalom,
 Come over here. I want to speak to you.

PETER: (*Running up into the pulpit.*) Do you think I care?

ADAMS: If you let him run
 He'll make disaster certain.

DAVID: Absalom,
 Come alive. Living is caring.
 Hell is making straight towards us.

PETER: (*In the pulpit.*) Beloved, all who pipe your breath
 Under the salted almond moon,
 Hell is in my father's head
 Making straight towards him. Please forget it.
 He sees the scarlet shoots of spring

And thinks of blood. He sees the air
Streaming with imagined hordes
And conjures them to come. But you and I
Know that we can turn away
And everything will turn
Into itself again. What is
A little evil here and there between friends?
Shake hands on it: shake hands, shake hands:
Have a cigarette, and make yourselves at home.
Shall we say what we think of the King of Israel?
Ha – ha – ha!

(*Jeering laughter echoes round the roof of the church.*)

DAVID: Don't do it to me, don't make the black rage
Shake me, Peter. I tremble like an earthquake
Because I can't find words which might
Put the fear of man into you.
Understand! The indecisions
Have to be decided. Who's against us
Reeks to God. Where's your hand?
Be ordinary human, Absalom.

ADAMS: Appeal's no use, King. He has
A foiling heart: the sharp world glances off
And so he's dangerous.

DAVID: I think so too.
Who can put eyes in his head? Who'll do it,
Eh, Joab? We have to show him
This terse world means business, don't we, Corporal,
Don't we?

ADAMS: He has to be instructed.

DAVID: Make a soldier of him. Make him fit
For conflict, as the stars and stags are.
He belongs to no element now. We have
To have him with us. Show him the way,
Joe Adams.

(*PETER is lounging at the foot of the pulpit. ADAMS turns to him.*)

ADAMS: Get on parade.

PETER: What's the music?

ADAMS: I'll sing you, Absalom, if you don't get moving.
 And I'll see you singing where you never meant.
 Square up.

PETER: What's this?

ADAMS: Square up, I said.

PETER: Where do we go from here?

ADAMS: It's unarmed combat.
 It's how your bare body makes them die.
 It's old hey-presto death: you learn the trick
 And death's the rabbit out of the hat:
 Rolling oblivion for someone.
 You've got to know how to get rid of the rats of the world.
 They're up at your throat. Come on.

PETER: What nightmare's this you're dragging me into?

ADAMS: Humanity's. Come on.

PETER: I know
 Nothing about it. Life's all right to me.

ADAMS: Say that when it comes.

 (*The unarmed combat, ADAMS instructing.*)

DAVID: Where is he going now? He carries
 No light with him. Does he know
 The river's unbound: it's up above
 Every known flood-mark, and still rising.

PETER: (*Who has got away from ADAMS.*)
 I'm on the other side of the river
 Staying with friends, whoever they are.
 Showery still, but I manage to get out,
 I manage to get out.
 The window marked with a cross is where I sleep.
 Just off to a picnic with your enemies.
 They're not bad fellows, once you get to know them.

DAVID: (*To ADAMS.*) I have heard from my son.

ADAMS: What's his news?

DAVID: He's with the enemy. He betrays us, Joab.

 He has to be counted with them.

 Are we ready?

ADAMS: Only waiting for the word.

DAVID: We attack at noon.

ADAMS: Only hoping for the time.

 Good luck.

DAVID: Good luck.

 (*ADAMS walks down the chancel steps and crouches, keeping a steady eye on his wrist-watch. ADAMS gives a piercing whistle. PETER leaps up and hangs on to the edge of the pulpit. ADAMS cuts him down with a tommy-gun. He cries out. DAVID starts up in his bunk. PETER and ADAMS fall to the floor and lie prone.*)

 (*Awake.*) What's the matter, Peter? Pete! Anything wrong?

 (*He gets out of his bunk and goes across to PETER's.*)

 Pete, are you awake?

 (*He stands for a moment and then recrosses the floor.*)

MEADOWS: (*Awake.*) Anything the matter?

 Can't you sleep either?

DAVID: (*Getting back into his bunk.*) I thought I heard

 Somebody shout. It woke me up.

MEADOWS: Nobody shouted.

 I've been lying awake. It's just gone midnight.

 There's a howling wind outside plays ducks and drakes

 With a flat moon: just see it through this window:

 It flips across the clouds and then goes under:

 I wish I could run my head against some sleep.

 This building's big for lying with your eyes open.

 You could brush me off, and only think you're dusting.

 Who's got the key of the crypt? (*He yawns.*)

 Thanks for waking. It brings the population

 Up to two. You're a silent chap. Dave?

 Have you gone to sleep again already?

 Back into the sea, like a slippery seal.

 And here am I, high and dry.

DAVID: (*Asleep.*) Look, look, look.

MEADOWS: Away he goes,
Drifting far out. How much of him is left?
Ah, lord, man, go to sleep: stop worrying.

(*ADAMS drags or carries PETER to PETER's bunk.*)

DAVID: Joab, is that you? Joab, is that you?
What are you bringing back?

ADAMS: The victory.

DAVID: Are you sure it is the victory, Joab?
Are we ever sure it's the victory?
So many times you've come back, Joab,
With something else. I want to be sure at last.
I want to know what you mean by victory.
Is it something else to me? Where are you looking?
There's nothing that way. But look over here:
There's something. Along the road, starting the dust,
He wants to reach us. Why is that?
So you're going to walk away.

ADAMS: (*Going to his bunk.*) I've done my best.
I can't be held responsible for everything.

DAVID: Don't leave me, Joab. Stay and listen.

ADAMS: (*Covering himself over.*) I'm dead beat.
The enemy's put to flight. Good night, you King of Israel.

DAVID: Bathed in sweat, white with dust. Call him here.
Come up. I am the King.
I shall wait patiently until your voice
Gets back the breath to hit me. I'm here, waiting.

(*DAVID sits on the edge of his bunk, a red army blanket hanging
from his shoulder.*)

MEADOWS: (*Awake.*) Where are you off to, Davey?
Get you back to bed. A dream
Has got you prisoner, Davey, like
The world has got us all. Don't let it
Take you in.

DAVID: Come here to me, come over
Here, the dusty fellow with the news,
Come here. Is the fighting over ? Unconditionally?

(*MEADOWS has left his bunk and crossed to DAVID.*)

MEADOWS: Lie down, boy. Forget it. It's all over.

DAVID: Is the young man Absalom safe?

MEADOWS: Lie down, Dave.
Everybody's asleep.

ADAMS: (*From his bunk.*) The boy's dead.
You might as well be told: I say
The boy's dead.

(*DAVID, giving a groan, lies back on his bed.*)

MEADOWS: The night's over us.
Nothing's doing. Except the next day's in us
And makes a difficult sort of lying-in.
Here, let's cover you up. Keep the day out of this.
Find something better to sleep about.
Give your living heart a rest. Do you hear me,
Dave, down where you are? If you don't mind,
While I'm here, I'll borrow some of that sleep:
You've got enough for two.

(*He limps back to his bunk, passing ADAMS, who wakes.*)

ADAMS: Hullo, Meadows:
What's worrying you?

MEADOWS: Dave was. He couldn't
Let go of the day. He started getting up
And walking in his sleep.

ADAMS: All right now?

MEADOWS: Seems running smoother.

ADAMS: Is that him talking?

(*PETER has begun to talk in his sleep.*)

MEADOWS: Muttering monkeys love us, it's the other one now:
Peter's at it.

PETER: Do I have to follow you?

ADAMS: You needn't hear him if you get your ears
Under the blankets. That's where I'm going.
Goodnight, boy.

(*He disappears under his blankets. MEADOWS climbs into his bunk.*)

MEADOWS: Hope so. It's a choppy crossing
We're having still. No coast of daylight yet for miles.

(*He also disappears from view. A pause.*)

PETER: (*Asleep.*) Why did you call me? I'm contented here:
They say I'm in a prison. Morning comes
To a prison like a nurse:
A rustling presence, as though a small breeze came,
And presently a voice. I think
We're going to live. The dark pain has gone,
The relief of daylight
Flows over me, as though beginning is
Beginning. The hills roll in and make their homes,
And gradually unfold the plains. Breath
And light are cool together now.
The earth is all transparent, but too deep
To see down to its bed.

(*DAVID, the dream figure of Abraham, stands beside PETER.*)

DAVID: Come with me.

PETER: Where are we going?

DAVID: If necessary
To break our hearts. It's as well for the world.

PETER: There's enough breaking, God knows. We die,
And the great cities come down like avalanches.

DAVID: But men come down like living men.
Time gives the promise of time in every death,
Not of any ceasing. Come with me.
The cities are pitifully concerned.
We need to go to the hill.

PETER: What shall we do?

DAVID: What falls to us.

PETER: Falling from where?

DAVID: From the point of devotion, meaning God.
Carry this wood, Isaac, and this coil
Of rope.

PETER: I'm coming.

DAVID: There has to be sacrifice.
 I know that. There's nothing so sure.

PETER: You walk so fast. These things are heavy.

DAVID: I know. I carry them too.

PETER: I only want
 To look around a bit. There's so much to see.
 Ah, peace on earth, I'm a boy for the sights.

DAVID: Don't break my heart. You so
 Cling hold of the light. I have to take it
 All away.

PETER: Why are you so grave?
 There's more light than we can hold. Everything
 Grows over with fresh inclination
 Every day. You and I are both
 Immeasurably living.

 (*DAVID has been walking towards the pulpit. PETER still lies in bed. He starts to whistle a tune, though the whistling seems not to come from his lips but from above him.*)

DAVID: What do you whistle for?

PETER: I whistle for myself
 And anyone who likes it.

DAVID: Keep close to me.
 It may not be for long. Time huddles round us,
 A little place to be in. And we're already
 Up the heavy hill. The singing birds
 Drop down and down to the bed of the trees,
 To the hay-silver evening, O
 Lying gentleness, a thin veil over
 The long scars from the nails of the warring hearts.
 Come up, son, and see the world.
 God dips his hand in death to wash the wound,
 Takes evil to inoculate our lives
 Against infectious evil. We'll go on.
 I am history's wish and must come true,
 And I shall hate so long as hate

243

Is history, though, God, it drives
My life away like a beaten dog. Here
Is the stone where we have to sacrifice.
Make my heart like it. It still is beating
Unhappily the human time.

PETER: Where is the creature that has to die?
There's nothing here of any life worth taking.
Shall we go down again?

DAVID: There is life here.

PETER: A flinching snail, a few unhopeful harebells.
What good can they be?

DAVID: What else?

PETER: You, father,
And me.

DAVID: I know you're with me. But very strangely
I stand alone with a knife. For the simple asking.
Noon imperial will no more let me keep you
Than if you were the morning dew. The day
Wears on. Shadows of our history
Steal across the sky. For our better freedom
Which makes us living men: for what will be
The heaven on earth, I have to bind you
With cords, and lay you here on the stone's table.

PETER: Are you going to kill me? No! Father!
I've come only a short way into life
And I can see great distance waiting.
The free and evening air
Swans from hill to hill.
Surely there's no need for us to be
The prisoners of the dark? Smile, father.
Let me go.

DAVID: Against my heart
I let you go, for the world's own ends
I let you go, for God's will
I let you go, for children's children's joy
I let you go, my grief obeying.

The cords bind you against my will
But you're bound for a better world.
And I must lay you down to sleep
For a better waking. Come now.

(*In mime he picks Isaac up in his arms and lays him across the front of the pulpit.*)

PETER: (*In his bunk.*) I'm afraid.
And how is the earth going to answer, even so?

DAVID: As it will. How can we know?
But we must do, and the future make amends.

PETER: Use the knife quickly. There are too many
Thoughts of life coming to the cry.
God put them down until I go.
Now, now, suddenly!

DAVID: (*The knife raised.*) This
Cuts down my heart, but bitter events must be.
I can't learn to forgive necessity:
God help me to forgive it.

(*ADAMS appears as the dream figure of the Angel.*)

ADAMS: Hold your arm.
There are new instructions. The knife can drop
Harmless and shining.

DAVID: I never thought to know,
Strange voice of mercy, such happy descending.
Nor my son again. But he's here untouched,
And evening is at hand
As clear and still as no man.

PETER: Father, I feel
The air go over me as though I should live.

DAVID: So you will, for the earth's while. Shall I
Undo the cords?

ADAMS: These particular. But never all.
There's no loosening, since men with men
Are like the knotted sea. Lift him down
From the stone to the grass again, and, even so free,
Yet he will find the angry cities hold him.

But let him come back to the strange matter of living
As best he can: and take instead
The ram caught here by the white wool
In the barbed wire of the briar bush:
Make that the kill of the day.

DAVID: Readily.

PETER: Between the day and the night
The stars tremble in balance.
The houses are beginning to come to light.
And so it would have been if the knife had killed me.
This would have been my death-time.
The ram goes in my place, in a curious changing.
Chance, as fine as a thread,
Cares to keep me, and I go my way.

MEADOWS: (*A dream figure.*) Do you want a ride across the sands,
Master Isaac?

PETER: Who are you?

MEADOWS: Now, boy, boy,
Don't make a joke of me. Old Meadows,
The donkey man, who brought you up the hill.
Not remember me? That's a man's memory,
Short measure as that. Down a day.
And we've been waiting, Edwina and me,
As patient as two stale loaves, to take you down.

PETER: But I climbed the hill on foot.

MEADOWS: (*Patting the bunk.*) No credit, Edwina girl, no credit.
He thinks you're a mangy old moke. You tell him
There's none so mangy as thinks that others are.
You have it for the sake of the world.

PETER: All right, she can take me down. I'm rasping tired.
My whole body's like three days' growth of beard.
But I don't know why she should have to carry me.
She's nothing herself but two swimming eyes
And a cask of ribs.

MEADOWS: A back's a back.
She's as good as gold while she lives,

And after that she's as good as dead. Where else
Would you find such a satisfactory soul?
Gee-up, you old millennium. She's slow,
But it's kind of onwards. Jog, jog,
Jog, jog.

PETER: There's a ram less in the world tonight.
My heart, I could see, was thudding in its eyes.
It was caught, and now it's dead.

MEADOWS: Jog, jog,
Jog, jog, jog, jog, jog,
Jog, jog.

PETER: Across the sands and into the sea.
The sun flocks along the waves.
Blowing up for rain of sand.
Helter-shelter.

MEADOWS: Jog. Jog. Jog.
Donkey ride is over. In under
The salty planks and corrugated iron.
Stable for mangy mokes. Home, old girl,
Home from the sea, old Millie-edwinium.
Tie up here.

(*He has climbed into his bunk.*)

PETER: No eyes open. All
In sleep. The innocence has come.
Ram's wool hill pillow is hard.

(*He sighs and turns in his bunk. The church clock strikes one. An
aeroplane is heard flying over the church. PETER wakens and sits
up in his bunk, listening.*)

Is that one of ours?

MEADOWS: (*His face emerging from the blankets.*)
 Just tell me: are you awake
Or asleep?

PETER: Awake. Listen. Do you hear it?
Is it one of ours?

MEADOWS: No question: one of ours.
Or one of theirs.

PETER: Gone over. Funny question:
 'Was I asleep?' when I was sitting up
 Asking you a question.

MEADOWS: Dave's been sitting up
 Asking questions, as fast asleep as an old dog.
 And you've been chatting away like old knitting-needles,
 Half the night.

PETER: What was I saying?

MEADOWS: I know all
 Your secrets now, man.

PETER: I wish I did.
 What did I say?

MEADOWS: Like the perfect gentleman
 I obliterated my lug-holes:
 Under two blankets, army issue.
 A man must be let to have a soul to himself
 Or souls will go the way of tails.
 I wouldn't blame a man for sleeping.
 It comes to some. To others it doesn't come.
 Troubles differ. But I should be glad
 To stop lying out here in the open
 While you underearthly lads
 Are shut away talking night's language like natives.
 We only have to have Corporal Adams
 To make a start, and I might as well
 Give up the whole idea. Oh, lord, let me
 Race him to it. I'm going under now
 For the third time.

(He covers his head with the blankets.)

PETER: Sorry if I disturbed you.
 I'll go back where I came from, and if I can
 I'll keep it to myself. Poor old Meadows:
 Try thinking of love, or something.
 Amor vincit insomnia.

MEADOWS: That's enough
 Of night classes. What's it mean?

PETER: The writing on the wall. So turn
 Your face to it: get snoring.

MEADOWS: Not hereabouts:
 It wouldn't be reverent. Good night, then.

PETER: Same to you.

(They cover their heads. A pause. ADAMS, asleep, lies flat on his bunk, looking down over the foot of it.)

ADAMS: Fish, fish, fish in the sea, you flash
 Through your clouds of water like the war in heaven:
 Angel-fish and swordfish, the silver troops…
 And I am salt and sick on a raft above you,
 Wondering for land, but there's no homeward
 I can see.

(He turns on his back.)
 God, have mercy
 On our sick shoals, darting and dying.
 We're strange fish to you. How long
 Can you drift over our sea, and not give up
 The ghost of hope? The air is bright between us.
 The flying fish make occasional rainbows,
 But land, your land and mine, is nowhere yet.

(DAVID, a dream figure, comes to meet him.)
 How can a man learn navigation
 When there's no rudder ? You can seem to walk,
 You there: you can seem to walk:
 But presently you drown.

DAVID: Who wants us, Corporal?

ADAMS: I wish I knew. I'm soaked to the skin.
 The world shines wet. I think it's men's eyes everywhere
 Reflecting light. Presently you drown.

DAVID: Have you forgotten you're a prisoner?
 They marched us thirty miles in the pouring rain.
 Remember that? They, they, they, they.

(PETER comes down towards DAVID, marching but exhausted. As he reaches DAVID he reels and DAVID catches him.)

PETER: What happens if I fall out, Dave?

249

DAVID: You don't fall out, that's all.

PETER: They can shoot me if they like.
 It'll be a bit of a rest.

DAVID: You're doing all right.

PETER: I wouldn't know. It. Feels.
 Damned. Odd. To me.

DAVID: Corporal Adams,
 Man half-seas overboard!
 Can you lend a hand?

ADAMS: (*Jumping from his bunk.*) Here I come.
 Does he want to be the little ghost?
 Give us an arm. Dave and I will be
 Your anchor, boy: keep you from drifting
 Away where you're not wanted yet.

PETER: Don't think you've got me with you.
 I dropped out miles ago.

ADAMS: We'll keep the memory green.

 (*They do not move forward, but seem to be trudging.*)

DAVID: They, they, they, they.

ADAMS: Be careful how you step. These logs we're on
 Are slimy and keep moving apart.

DAVID: (*Breaking away.*) Where do you think we are?
 We're prisoners, God! They've bricked us in.

ADAMS: Who said you were dismissed?

PETER: Forget your stripes
 For a minute, Corporal: it's my birthday next month,
 My birthday, Corporal: into the world I came,
 The barest chance it happened to be me,
 The naked truth of all that led the way
 To make me. I'm going for a stroll.

 (*He wanders down towards the lectern.*)

ADAMS: Where are you going? Orders are
 No man leaves unless in a state of death.

DAVID: There's nowhere to go, and he knows

There's nowhere to go. He's trying to pretend
We needn't be here.

PETER: Don't throttle yourself
With swallowing, Dave. Anyone
Would think you never expected the world.
Listen to the scriptures:

(*As though reading the Bible.*)

Nebuchadnezzar, hitting the news,
Made every poor soul lick his shoes.
When the shoes began to wear
Nebuchadnezzar fell back on prayer.

Here endeth the first lesson. And here beginneth
The second lesson...

DAVID: I'll read the second lesson:
God drown you for a rat, and let the world
Go down without you.

PETER: Three blind mice of Gotham,
Shadrac, Meshac and Abednego:
They went to walk in a fire.
If the fire had been hotter
Their tales would have been shorter.

Here endeth –

ADAMS: Get into the ranks.

PETER:What's worrying you? We're not
On active service now. Maybe it's what
They call in our paybooks 'disembodied service':
So drill my spirit, Corporal, till it weeps
For mercy everywhere.

DAVID: It had better weep,
It had better weep. By God, I'll say
We have to be more than men if we're to man
This rising day. They've been keeping from us
Who we are, till now, when it's too late
To recollect. (*Indicating PETER.*) Does he know?

ADAMS: Shadrac, Meshac, Abednego
We didn't have those names before: I'll swear

We were at sea. This black morning
Christens us with names that were never ours
And makes us pay for them. Named,
Condemned. What they like to call us
Matters more than anything at heart.
Hearts are here to stop
And better if they do. God help us all.

PETER: Do I know what?

ADAMS: We are your three blind mice:
Our names are Shadrac, Meshac, and Abednego.
This is our last morning. Who knows truly
What that means, except us?

PETER: And which of us
Knows truly? O God in heaven, we're bound
To wake up out of this. Wake, wake, wake:
This is not my world! Where have you brought me?

DAVID: To feed what you've been riding pick-a-back.

PETER: I can believe anything, except
The monster.

DAVID: And the monster's here.

ADAMS: To make
Sure we know eternity's in earnest.

PETER: It's here to kill. What's that in earnest of?
But the world comes up even over the monster's back.
Corporal, can we make a dash for the hill there?

ADAMS: We're under close arrest.

DAVID: O God, are we
To be shut up here in what other men do
And watch ourselves be ground and battered
Into their sins? Let me, dear God, be active
And seem to do right, whatever damned result.
Let me have some part in what goes on
Or I shall go mad!

PETER: What's coming now
Their eyes are on us. Do you see them?

ADAMS: Inspection. The powers have come to look us over
 To see if we're in fettle for the end.
 Get into line.

DAVID: What, for those devils?
 Who are they?

ADAMS: Nebuchadnezzar and his aides.
 Do what you're told.

PETER: Is that him with one eye?

DAVID: Are they ours or theirs?

ADAMS: Who are we, Dave, who
 Are we? If we could get the hang of that
 We might know what side they're on. I should say
 On all sides. Which is why the open air
 Feels like a barrack square.

PETER: Is that him
 With one eye?

ADAMS: If we could know who we are –

DAVID: I've got to know which side I'm on.
 I've got to be on a side.

ADAMS: – They're coming up.
 Let's see you jump to it this time: we're coming
 Up for the jump. We can't help it if
 We hate his guts. – Look out. – Party, 'shun!
 (*They all come to attention.*)
 The three prisoners, sir. – Party, stand
 At ease!

PETER: Purple and stars and red and gold.
 What are they celebrating?

DAVID: We shall know soon.

ADAMS: Stop talking in the ranks.
 (*They stand silent for a moment.*)

PETER: What bastard language
 Is he talking? Are we supposed to guess?
 Police on earth. Aggression is the better
 Part of Allah. Liberating very high

The dying and the dead. Freedoom, freedoom.
Will he never clear his throat?

DAVID: He's moving on.

ADAMS: Party, at-ten-tion!

(*They bring their heels together, but they cannot bring their hands
from behind their backs.*)

PETER: Corporal, our hands are tied!

DAVID: They've played their game
In the dark: we're theirs, whoever calls us.

ADAMS: Stand at ease.

DAVID: Our feet are tied!

PETER: Hobbled,
Poor asses.

ADAMS: That leaves me without a word of command
To cover the situation, except
Fall on your knees.

PETER: What's coming, Corporal?

ADAMS: You two, let's know it: we have to meet the fire.

DAVID: Tied hand and foot: not men at all!

PETER: O how
Shall we think these moments out
Before thinking splits to fear. I begin
To feel the sweat of the pain: though the pain
Hasn't reached us yet.

ADAMS: Have your hearts ready:
It's coming now.

DAVID: Every damned forest in the world
Has fallen to make it. The glare's on us.

PETER: Dead on.
And here's the reconnoitring heat:
It tells us what shall come.

ADAMS: Now then! Chuck down
Your wishes for the world: there's nothing here
To charm us. Ready?

DAVID: I've been strong.

The smoke's between us. Where are you, Adams?

ADAMS: Lost.

PETER: Where are you, Adams?

(*ADAMS cries out and falls to his knees.*)

DAVID: It's come to him, Peter!

PETER: We shall know!

DAVID: Scalding God!

(*They, too, have fallen to their knees.*)

ADAMS: What way have I come down, to find
 I live still, in this round of blaze?
 Here on my knees. And a fire hotter
 Than any fire has ever been
 Plays over me. And I live. I know
 I kneel.

DAVID: Adams.

ADAMS: We're not destroyed.

DAVID: Adams.

PETER: Voices. We're men who speak.

DAVID: We're men who sleep and wake.
 They haven't let us go.

PETER: My breath
 Parts the fire a little.

ADAMS: But the cords
 That were tying us are burnt: drop off
 Like snakes of soot.

PETER: Can we stand?

DAVID: Even against this coursing fire we can.

PETER: Stand: move: as though we were living,
 In this narrow shaking street
 Under the eaves of seven-storeyed flames
 That lean and rear again, and still
 We stand. Can we be living, or only
 Seem to be?

ADAMS: I can think of life.
 We'll make it yet.

DAVID: That's my devotion.
 Which way now?
PETER: Wait a minute. Who's that
 Watching us through the flame?
 (*MEADOWS, a dream figure, is sitting on the side of his bunk.*)
DAVID: Who's there?
ADAMS: Keep your heads down. Might be
 Some sniper of the fire.
 (*MEADOWS crows like a cock.*)
PETER: A lunatic.
ADAMS: (*Calling to MEADOWS.*) Who are you?
MEADOWS: Man.
ADAMS: Under what command?
MEADOWS: God's.
ADAMS: May we come through?
MEADOWS: If you have
 The patience and the love.
DAVID: Under this fire?
MEADOWS: Well, then, the honesty.
ADAMS: What honesty?
MEADOWS: Not to say we do
 A thing for all men's sake when we do it only
 For our own. And quick eyes to see
 Where evil is. While any is our own
 We sound fine words unsoundly.
ADAMS: You cockeyed son
 Of heaven, how did you get here?
MEADOWS: Under the fence. I think they forgot
 To throw me in. But there's not a skipping soul
 On the loneliest goat-path who is not
 Hugged into this, the human shambles.
 And whatever happens on the farthest pitch,
 To the sand-man in the desert or the island-man in the sea,
 Concerns us very soon. So you'll forgive me
 If I seem to intrude.

PETER: Do you mean to stay here?

MEADOWS: I can't get out alone. Neither can you.
 But, on the other hand, single moments
 Gather towards the striking clock.
 Each man is the world.

PETER: But great events
 Go faster.

DAVID: Who's to lead us out of this?

MEADOWS: It's hard to see. Who will trust
 What the years have endlessly said?

ADAMS: There's been a mort of time. You'd think
 Something might have come of it. These men
 Are ready to go, and so am I.

PETER: But there's no God-known government anywhere.

MEADOWS: Behind us lie
 The thousand and the thousand and the thousand years
 Vexed and terrible. And still we use
 The cures which never cure.

DAVID: For mortal sake,
 Shall we move? Do we just wait and die?

MEADOWS: Figures of wisdom back in the old sorrows
 Hold and wait forever. We see, admire
 But never suffer them: suffer instead
 A stubborn aberration.
 O God, the fabulous wings unused,
 Folded in the heart.

DAVID: So help me, in
 The stresses of this furnace I can see
 To be strong beyond all action is the strength
 To have. But how do men and forbearance meet?
 A stone forbears when the wheel goes over, but that
 Is death to the flesh.

ADAMS: And every standing day
 The claims are deeper, inactivity harder.
 But where, in the maze of right and wrong,
 Are we to do what action?

PETER: Look, how intense
 The place is now, with swaying and troubled figures.
 The flames are men: all human. There's no fire!
 Breath and blood chokes and burns us. This
 Surely is unquenchable? It can only transform.
 There's no way out. We can only stay and alter.
DAVID: Who says there's nothing here to hate?
MEADOWS: The deeds, not those who do.
ADAMS: Strange how we trust the powers that ruin
 And not the powers that bless.
DAVID: But good's unguarded,
 As defenceless as a naked man.
MEADOWS: Imperishably. Good has no fear;
 Good is itself, whatever comes.
 It grows, and makes, and bravely
 Persuades, beyond all tilt of wrong:
 Stronger than anger, wiser than strategy,
 Enough to subdue cities and men
 If we believe it with a long courage of truth.
DAVID: Corporal, the crowing son of heaven
 Thinks we can make a morning.
MEADOWS: Not
 By old measures. Expedience and self-preservation
 Can rot as they will. Lord, where we fail as men
 We fail as deeds of time.
PETER: The blaze of this fire
 Is wider than any man's imagination:.
 It goes beyond any stretch of the heart.
MEADOWS: The human heart can go to the lengths of God.
 Dark and cold we may be, but this
 Is no winter now. The frozen misery
 Of centuries breaks, cracks, begins to move;
 The thunder is the thunder of the floes,
 The thaw, the flood, the upstart spring.
 Thank God our time is now when wrong
 Comes up to face us everywhere,

Never to leave us till we take
The longest stride of soul men ever took.
Affairs are now soul-size.
The enterprise
Is exploration into God.
Where are you making for? It takes
So many thousand years to wake,
But will you wake for pity's sake?
Pete's sake, Dave or one of you,
Wake up, will you? Go and lie down.
Where do you think you're going?

ADAMS: (*Waking where he stands.*) What's wrong?

MEADOWS: You're walking in your sleep.
So's Pete and Dave. That's too damn many.

ADAMS: Where's this place? How did I get here?

MEADOWS: You were born here, chum. It's the same for all of us.
Get into bed.

PETER: (*Waking.*) What am I doing here?

MEADOWS: Walking your heart out, boy.

ADAMS: Dave, Dave.

MEADOWS: Let him come to himself gentle but soon
Before he goes and drowns himself in the font.

ADAMS: Wake up, Dave.

PETER: I wish I knew where I was.

MEADOWS: I can only give you a rough idea myself.
In a sort of a universe and a bit of a fix.
It's what they call flesh we're in.
And a fine old dance it is.

DAVID: (*Awake.*) Did they fetch us up?

MEADOWS: Out of a well. Where Truth was.
They didn't like us fraternising. Corp,
Would you mind getting your men to bed
And stop them traipsing round the precincts?

ADAMS: Dave, we're mad boys. Sleep gone to our heads.
Come on.

DAVID: What's the time?

ADAMS: Zero hour.

DAVID: It feels like half an hour below. I've got cold feet.

PETER: (*Already lying on his bunk*)
 I've never done that before. I wonder now
 What gives us a sense of direction in a dream?
 Can we see in sleep? And what would have happened
 If we'd walked into the guard? Would he have shot us,
 Thinking we were trying to get out?

MEADOWS: So you were from what you said. I could stand
 One at a time, but not all three together.
 It began to feel like the end of the world
 With all your bunks giving up their dead.

ADAMS: Well, sleep, I suppose.

DAVID: Yeh. God bless.

PETER: Rest you merry.

MEADOWS: Hope so. Hope so.

(*They settle down. The church clock strikes. A bugle sounds in the distance.*)

CAEDMON CONSTRUED

or, One Thing More

To Michael Bakewell and Jane Morgan
who invited me and encouraged me
to write the play

Characters

BEDE

JODDY

KERN

WIDOW WIN

OVERMAN

CAEDMON

ABBESS HILDA

NOVICE NUN

YOUNG MAN

THE PERSON in the dream

GIRL in the dream

PRECENTOR

PRIOR

MONK

FARMWORKERS

Caedmon Construed was first performed at Chelmsford Cathedral, on 4 November 1986, with the following cast:

BEDE, Bernard Hepton

JODDY, Sylvester Morand

KERN, George Raistrick

WIDOW WIN, Fanny Carby

OVERMAN, Norman Jones

CAEDMON, Terrence Hardiman

ABBESS HILDA, Barbara Leigh-Hunt

NOVICE NUN, Geraldine Alexander

YOUNG MAN, Terence Budd

PERSON IN THE DREAM, Stephen Thorne

GIRL IN THE DREAM, Geraldine Alexander

PRECENTOR, George Raistrick

PRIOR, Sylvester Morand

MONK, Terence Budd

Director Michael Bakewell and Jane Morgan

Forenotes

BEDE: *Ecclesiastical History*

'... A person appeared to him in his sleep, and said, "Caedmon, sing some song to me." He answered, "I cannot sing; for that was the reason why I left the entertainment." The other replied, "However you shall sing." – "What shall I sing?" rejoined he. "Sing the beginning of created beings," said the other. Hereupon he presently began to sing verses to the praise of God, which he had never heard, the purport whereof was thus:

"We are now to praise the Maker of the heavenly kingdom, the power of the Creator and his counsel, the deeds of the Father of glory. How He, being the eternal God, became author of all miracles, who first, as almighty preserver of the human race, created heaven for the sons of men as the roof of the house, and next the earth."'

SOPHOCLES: *Philoctetes*

NEOPTOLEMUS: I see an empty hut, with no one there.

ODYSSEUS: And nothing to keep house with?

NEOPTOLEMUS: A pallet bed, stuffed with leaves, to sleep on, for someone.

ODYSSEUS: And nothing else? Nothing inside the house?

NEOPTOLEMUS: A cup, made of a single block, a poor workman's contrivance. And some kindling, too... And look, some rags are drying in the sun full of oozing matter from a sore.

ODYSSEUS: Yes, certainly he lives here, even now is somewhere not far off. He cannot go far, sick as he is, lame cripple for so long. It's likely he has gone to search for food or somewhere that he knows there is a herb to ease his pain.

GENESIS: XXXII. v. 24–29

'And Jacob was left alone: and there wrestled a man with him until the breaking of the day. And when he saw that he prevailed not against him, he touched the hollow of his thigh; and the hollow of Jacob's thigh was out of joint, as he wrestled with him. And he said, let me go, for the day breaketh. And he said, I will not let thee go, except thou bless me... And Jacob asked him, and said, Tell me, I pray thee, thy name. And he said, Wherefore is it that thou dost ask after my name? And he blessed him there.'

The play is introduced by one representing the Venerable BEDE of Jarrow.

BEDE: I, Bede, the servant of Christ and priest, have gathered together, before things have passed too far out of men's memories ever to be recovered, all that I could find by written record or word of mouth, of the history of our nation. Some things have been reported to me by those who took part in the events, others only by tradition, or at a generation's remove – as it is with the happening to be told now. It belongs to the year of Our Lord 664, nine years before I was born. The known facts are few, but there was a life in them once, and it may have been of some such kind as we shall imagine it to be. To start with certainty: the Lady Abbess Hilda, great niece of King Edwin, founded a monastery in a place called Streoneshalh, the Bay of the Lighthouse, or Whitby as your own time knows it. It is in that place, in the farmland by the monastery door, on a day before sunrise, that our speculation begins.

(A bright moon is in the west. The monastery bell rings for Prime. A cock crows and is answered by another farther off. The farm workers, JODDY, KERN and WIDOW WIN, with the OVERMAN, are starting to go about their work.)

JODDY: The moon has waited up for us.

KERN: *(Doffing his hat to the sky.)* Ma'am, we take it kindly.

WIDOW: *(A switch in her hand.)* Heathen! She's got a bitter gleam in her. Ah, there's no warm flesh to wake up to these mornings. I have to wait for the cow's breath on my cheek. I never thought to be widowed before I was ready.

(She goes off to round up the cows.)

JODDY: It's seven weeks since she lost him.

KERN: And the horses aren't quiet without him yet.

JODDY: All the stock's unsettled as though they smelt fox.

OVERMAN: It's the foreigner they smell. I caught sight of him again yesterday. It's always at this time, as soon as the bell rings for Prime. You see his dark shape near to the monastery walls. I'd have challenged him at a distance –

JODDY: Why didn't you?

OVERMAN: Well, he had his hat in his hand, and seemed to be leaning his head against the music. And there was such a turn of singing as the sun came out of the sea, I daredn't shout to him. When I went back to find out what was going on, Prime was over and the mortal man had gone.

JODDY: What's he after? He's done no poaching, has he? Damaged no fences?

KERN: Not as I know.

JODDY: Then what has he come here for?

OVERMAN: And now that he's here, what's he afraid of, making off as soon as the daylight taps his shoulder? I'll have a word if I can find him.

(*The distant sound of singing of Prime from the monastery, MONKS and NUNS singing antiphonally.*)

He'll be somewhere about, now the holy office has begun.

KERN: Have you listened, listened close, these last weeks since the Lady Abbess fetched the new sisters here?

JODDY: Why?

KERN: You listen. (*They stand listening.*) One of them, clear as a blackbird. I reckon it's one of the novices. There was never that sound before they came.

JODDY: The foreigner's no bad spirit if he can stand listening to that sweet noise. A bad spirit would have turned to vapour.

OVERMAN: Who said he was a bad spirit?

JODDY: Well, but he vanishes.

OVERMAN: I can prove he's no spirit. I found where he has made himself a shelter in the cliff, between the goat-walk and the shore.

JODDY: What did you see?

OVERMAN: A sack filled with leaves for sleeping on…

JODDY: And nothing else?

OVERMAN: A drinking horn, a hunk of bread as dry and as hard as the cave floor, a bramble branch with the berries

eaten – and some strips of rag drying in the sun; they may have been used to bind a wound.

JODDY: But he was nowhere? Perhaps he was gone to the town to find food – or to gather some herb for whatever his wound is, if he has one.

KERN: You can stand about considering the subject, if you like. It won't mend the hedges. You can fetch me at noonday if you mean to look for him.

OVERMAN: There's no need to hunt him. I'll have a word when I get the chance.

KERN: We should set our minds at rest. The women will get uneasy.

OVERMAN: I wouldn't say there's violence in him. As soon as I discover what the mystery is you shall hear of it.

(They go about their work. By now the chanting from the monastery has changed from the 5th-century hymn 'Jam lucis orto sidere' to Psalm 114: 'When Israel came out of Egypt', sung to the plainsong 'Tonus Peregrinus'. The singing stops.)

BEDE: The sun came up. The sea turned to fire. The Widow Win crossed a field from the cow-byre. She saw someone hurrying toward the cliff-path, anxious, it seemed, to avoid her company if he could.

(A shaft of sunlight strikes on a man, fifty years old, CAEDMON. He walks with a limp. He is the first person we have seen clearly. When he speaks he has the trace of a stammer. Enter the WIDOW.)

WIDOW: Hey, what man are you?

CAEDMON: G-good morning.

WIDOW: It may be for some – but who are you to tell me that? What right have you got to be in this field? –

CAEDMON: *(Staring at the sea.)* There's glory for you – the sun coming out of the sea.

WIDOW: Never mind the glory. What are you here for?

CAEDMON: It would be a g-good death to drown in that water.

WIDOW: Don't talk of death to me. I know something about death. It's your life I'm asking about: what is it doing here, where you're not known?

CAEDMON: There was music. I heard singing.

WIDOW: Give me patience – the sun, the sea, the singing! I can hear you're no Englishman, I can tell that; you're a Briton, back with your forefathers at least. Do you have a name to you?

CAEDMON: Caedmon.

WIDOW: Didn't I tell you so? A Briton, and a lame one, too. What's the matter?

CAEDMON: Oh, it's the ache of an old wound, that's all.

WIDOW: What gave it to you?

CAEDMON: A knife-blade, or an arrow-head. Or a snake-bite, if you don't like the thought of blood.

WIDOW: A quarrelsome man. At least we're clear about something.

CAEDMON: They weren't my quarrels. G-good day to you. (*He starts to limp away.*)

WIDOW: (*Calling after him.*) You can say it's none of my business, of course not – but you go the best way to rouse a woman's curiosity, with your half-answers, and hiding what you've made of your life. You can't blame a widow for giving way to questions when she comes on a man who won't describe himself, and who has no call anyway to be where she finds him.

(*The OVERMAN has entered.*)

OVERMAN: Is that the foreigner we've been looking out for? Here, Sir Prowler, I want to have a word with you. (*He follows CAEDMON and catches up with him.*)

WIDOW: Make sense of him if you can. It's more rewarding to milk the cows. (*Exit.*)

OVERMAN: (*To CAEDMON.*) Come on, you can't be loitering here morning after morning, without some intent. And if there's no intent there must be some fancy that brought

you here. If you come secretly onto abbey ground without seeking leave, we've a right to know what you mean by it.

CAEDMON: No harm, no harm.

OVERMAN: Whose word have we got for that? Answer me some questions. Where are you from?

CAEDMON: Where born, do you mean?

OVERMAN: To begin with.

CAEDMON: Yes, that's right; to begin with.

OVERMAN: Well?

CAEDMON: It was at Rookhope, beyond the River Wear.

OVERMAN: What else can you tell me? What has your work been?

CAEDMON: For thirty years I've hired out my sword-arm to wherever there was fighting. Men's blood being hot, I found enough to do.

OVERMAN: But hearts are at peace here, so that wasn't what brought you.

CAEDMON: No, that wasn't what brought me.

OVERMAN: And you fought for what cause?

CAEDMON: Any that would hire me. Any that would k-kill thoughts.

OVERMAN: You get pleasure from that?

CAEDMON: Some satisfaction when we held our g-ground from being driven always westward.

OVERMAN: Otherwise?

CAEDMON: When King Penda joined forces with us, and slaughter was for nothing but have-most g-grab-most, I was sickened with the sad crying in my head.

OVERMAN: That obstinate pagan, Penda, you fell in with that Woden-worshipper? And here you are, breathing out heathenry, where the Lady Abbess leads us into a different king's kingdom? God knows what to make of you.

CAEDMON: That's my hope, indeed.

OVERMAN: (*Puzzled.*) Are you a Christian, then?

CAEDMON: There was music. I heard singing. Are all your questions answered?

OVERMAN: Do you think you've answered any? Not even the first of them. Why did you come here?

CAEDMON: I gave my sword to a flooded river, and went back to the place I grew up in. After thirty years death had changed things. People, because of the wars, had moved away. I went looking for them, hoping I might find…to ask what had become of…but they told me…the one I asked for…one I never knew…had never seen… They believed that someone – as it might be k-kin – had come to this monastery. Perhaps it is so. At any rate, I have seen the place, heard the singing, eased the mind. Which is all I expected. And now you have been paid for my right of way. I have said everything. (*He turns away.*)

OVERMAN: (*Detaining him.*) Not to my way of thinking. I was never worse informed. As you've come so far, why don't you make yourself known?

CAEDMON: (*Showing some agitation.*) Well, haven't I? Haven't I used all the words I've g-got? Now I am leaving. You can put me out of your mind. I travelled here simply to see the place. I know how it is now: the colour of the stone, the sound of the sea, the lowing and bleating and the cock-crow and the voice of the bell. That's all I wanted. I've paid my dues. I can pass out of your head into a different landscape altogether.

OVERMAN: Where will you go?

CAEDMON: (*A faint smile.*) You said G-God knows what to make of me. That will do to begin with.

(*He nods and limps on. The OVERMAN stares after him and suddenly calls.*)

OVERMAN: Do you know how to handle horses?

(*CAEDMON stops but does not turn round.*)

CAEDMON: I do, yes.

OVERMAN: We have a place for you here if you want to take it. The stableman died two months ago; we've been short-

handed since. Better, I should think, than a hole in the rocks. (*CAEDMON turns.*) What's your answer?

CAEDMON: Why do you say this?

OVERMAN: I'm making you an offer.

CAEDMON: (*After a silence.*) Is this the pattern of things, then? Are you g-giving me a direction?

OVERMAN: If that's what you want.

CAEDMON: Let me have time to think of the dangers. I'm not sure. You'll never mention what I have told you?

OVERMAN: What would that be, exactly?

CAEDMON: Well, you can mock. I'll g-give an answer by the evening. (*He limps off.*)

OVERMAN: There the job is. (*As he goes back to his work.*) Am I asking for trouble? What is it that argues in the man, and what holds him here? What does he mean, the dangers? What sorrow or sin or old nightmare has got its claws into him? And yet he seems to look as straight at things as the warp of the world will let him. Anyhow, I've opened the road, wherever it leads.

(*The light fades to a concentration on BEDE.*)

BEDE: It was the year of the great Synod of Whitby. There had been controversy over the recent years between the followers of Bishop Aidan, and the followers of Ronan who affirmed that the Celtic church kept Easter Sunday at a time contrary to the custom of the universal church. This dispute began to influence the thoughts and hearts of many, anxious whether they were contradicting the true tradition derived from St Peter. It was agreed that a synod should be held at the monastery of Streoneshalh with the Abbess Hilda presiding, where this matter concerning Easter, and also the tonsure and other ecclesiastical matters, should be decided. – Now it has reached its end, and King Oswy, the bishops and priests, Colman, Agilbart, Agatho, Wilfred, James, Romanus and the saintly Cedd, have gone back to their different sees and territories. The Lady Abbess can find quiet in the cloister.

(*Walking with the ABBESS is a NOVICE NUN, recently come to the monastery.*)

ABBESS: This is the first day I have managed to hear the silence of the cloisters since the great debate began. Have there ever been so many bishops and good men together in one place, or so many words crowded into one week? When my afternoon-brain began to lose its ways in the argument I closed my eyes and tried to measure which of them said least in the longest possible way. But you haven't heard me say so, daughter. They are all great and Godly men and deeply to be reverenced.

NUN: You asked for me, Reverend Mother, because you had heard I was worried – but you should be left in peace this evening.

ABBESS: On the contrary. It's a welcome thing to have time for really important matters. How tranquil the air is now they have gone, the Synod over and the division closed…even though our Bishop Cedd and Bishop Colman were worsted in the debate. The old Easter must go; we must be at ease with the new one. As the King said in his summing up: those who expect the same kingdom in heaven must share the same church calendar on earth. Though there were times when I wondered if some of those who fought for the opposing views hadn't become somewhat deranged, by over-scrutiny of the mysteries of God. I had to remind them that patience, justice, humility and all charitableness were warmth enough to light this house… But forgive me, this isn't at all to our purpose. Something is troubling you. Are you unhappy?

NUN: Disturbed, Reverend Mother.

ABBESS: A very human condition. But in what way, child?

NUN: It's hard to explain. My thoughts play truant, I suppose that's it. I find that I'm more than half left out of the worship I make. And this over the past few days is increasing. My lips pray to a Father in heaven; I go about my day's duties in love and obedience to you as my spiritual mother. This is all the daughterhood I should ever need. And yet moving through

my prayers are another father and mother, unremembered, almost unimagined. I can remember my grandparents, though I was only ten when they died in the pestilence nineteen years ago. It was they who had brought me up at Rookhope. They said my mother had died when I was born. But when I asked them about her, how she looked, how old she was, my grandmother cried; they both turned away from me. In the end it was a neighbour who told me she had been only a girl when she died, barely sixteen. But no one would open their memories to me; and no one would speak of my father, nor tell me his name or what had become of him. And yet these parents are strangely active in me, as though they stood between me and God, casting a shadow of longing over me, when I should be wholly and simply His. And in the last two or three days the sin has been growing in me: has become like an invading presence, especially in the early morning as we assemble for Prime... I am very afraid. If the devil is out to distract me he has certainly found the way, for how can I pray for strength to defy him when prayer is what has become so uncertain?

ABBESS: Let us, with very proper respect, leave the devil aside for the present. Curiosity is not the devil; unanswered questions are not the devil. These thoughts are part of yourself, are they not? They are not the devil's thoughts: they are your thoughts. They are part of yourself, just as your father and mother are part of yourself, and by these thoughts you bring yourself to be with them, even though you never knew them. When you feel that you can't be wholly and simply with God because of these things, you are bringing your living curiosity, and the father and mother in you – indeed your father and mother themselves – and your division and your complexity, to be with Him. This *is* your wholeness and simplicity. (*She pauses. The NUN is still.*) How unprofitable for God if we had nothing to give Him except our undivided attention.

(*The NUN stoops and kisses the hand of the ABBESS HILDA as the light leaves them.*)

BEDE: We had left Caedmon uncertain whether to leave his
hiding place and the bare subsistence of his life, to become
stableman to the monastery. He was afraid of coming too
near to what was contained there, and of weakening the
defences which he had spent so many years building. And
yet, as he said, he felt directed by the pattern of things, as if a
hand were under his elbow guiding him further into his life.
So he went back to the Overman and agreed to take charge
of the horses, and this he continued to do to everyone's
content, withdrawn but not unfriendly as the weeks went by.
And now we have come to the day of the long-remembered
solar eclipse of the year 664. On the evening of that day
the farmworkers have come together in the great barn to
celebrate a holiday feast.

(*In the great barn; preparations for a feast, benches and a table
being set. The FARMWORKERS, men and women.*)

KERN: As for me I'm thankful this day is to end with some
friendliness and belly-timbering and a forgiving tide of ale
to flow smoothly over us. When the light went out of the
day this morning I felt like a child that had thieved from his
mother's pocket.

JODDY: Ah, surely. There's nothing like nature being unnatural
to make a man think of his sins, those of us who have them.

WIDOW: Since when have you escaped out of the common lot?
I saw you crumbling your cap in your hands when all the
birds stopped singing.

JODDY: When the heavens fall out with themselves a man has
a right to feel strung up. (*As CAEDMON comes into the barn.*)
What does Stableman say?

CAEDMON: About what?

OVERMAN: The sun's eclipse, he means.

JODDY: When that creeping night-in-day took us over, did your
knees begin to sag at the thought of the Day of Judgement?

CAEDMON: I held my breath, indeed, at the silence of the
world.

WIDOW: He's done little else but hold his breath since he came among us. Whoa, mare; gee-up; gk,gk,gk, is all he wants to tell us of any interest.

CAEDMON: It's not myself, but the words that are unwilling. As for the thought of the Day of Judgement, is there ever a time that isn't Judgement Day? Each hour of each morning I know I stand in the dock.

JODDY: Come on now, grinder! We all came through into daylight again.

CAEDMON: That's right, indeed. And what words can be found for that?

KERN: Whose death, or whose birth, or what victory or calamity does it signify? — That's what it makes you wonder. There's the common day, and the body working untroubled, and you suddenly feel life draining out of the air around you: the animals whimpering as if a ghost unseen is walking; and familiar things become shapes of the night. And then, as Stableman says, the silence of the world.

WIDOW: Stars in the sky, too, of all things to misguide you!

KERN: And a chill in the earth like a toad's funeral.

OVERMAN: Until you feel the world being given back to us: the pleasure, eh, of finding something you thought you had lost? The glint back onto the tines of the pitchfork, the blush onto the turnips, a new warmth putting a hand across the back of your neck; and the veins in Joddy's nose plain for all to see. What a comfort *that* was, after we'd been denied it for a full twenty minutes.

KERN: Well, you can shake it off now it's over, but who knows what bane or benefit has been decided for the immediate future?

JODDY: I know the benefit that's been decided for my immediate future, and it's waiting for the spigot to come out of the barrel.

OVERMAN: Kern's right. What better can we do than give our thanks that we've still got the world with us yet. And here's

the Widow Win with a fistful of straws. Who draws the short one takes the harp and makes what he can of it.

(*The WIDOW takes the fistful of straws round the assembled company and the men choose. While doing so:*)

VOICES: Luck, keep my fingers from finding me guilty! – Ah, that's a relief! – I'm too hoarse with sheep-gathering to have any voice for it – bless my old ma who prays for me! – (*A YOUNG MAN draws the short straw.*) Ah, not me, not me on this thirsty night!

(*The WOMEN bring jugs of ale and pour the drink for the men. A YOUNG MAN has taken the harp in his hands.*)

YOUNG MAN: And my fingers raw with the hurdle-making.

ANOTHER: (*Encouragingly.*) Come on, now, you know you can play it.

(*The YOUNG MAN strikes the strings of the harp, and begins tentatively, speaking the words, with an occasional chord to accompany them, warming up as he goes.*)

YOUNG MAN: Who has the bad hap
To be first one to bring
Harp onto lap
To strum a cold string
With finger and thumb
Before the drink chases
Warm fire into faces
And makes the blood spin
For good comfort within –
This man, though I says it,
Who so bravely will face it,
Is worthy of worship,
Of lordship, of sirship,
And so he'll continue
To woo you and win you,
To rhyme you and spin you
With muscle and sinew
To midnight and worse
Until some man looses

The strings of his purse —
(*He starts to go on, with groans and laughter from the others, until some coins are thrown to him.*)
So who's going to be willing
To forfeit a shilling
Or any, or any
To fish out a penny —
(*He collects the coins and holds the harp over his head.*)
Who's going to take the harp, then?

VOICES: Kern, Kern! Give us 'When I was walking'!

KERN: Shall I do that?

VOICES: Do that, do that, Kern! Let's hear it again!

KERN: (*After striking a note.*)
When I was walking
In a green glade
A lady was loitering
Shyly in shade.
'Take a step, a step,'
I said, 'till I see
The sun touch your lip
And lie over your knee.'

She stood up so straight,
A birch tree become.
'Go back to your mate,
I've a husband at home.'
'Then better walk into
The daylight,' I said,
'For deeds that are darkest
Are done in the shade.'

OTHERS: (*Chanting.*) For deeds that are darkest
Are done in the shade.

VOICE: Go on with it, Kern! What happened next?

KERN: When I felt for her breast
She became a gazelle,
Said, 'Now if you ride me
I'll take you to hell,

And there you will suffer
The truth of your creed;
The deeds that are darkest
Are done in the shade.'

OTHERS: The deeds that are darkest
Are done in the shade.

(*Applause. The harp is passed to OVERMAN.*)

OVERMAN: What stuff is that for a celebration? Refill, now,
refill, and a toast to the oast! (*Twangs the harp.*)
All true men of thirst
Outpour me who durst
Alleluia!
Now you shall hear
The singing of beer
If it's brewed
As it should
Tongue and throat will hear
How it sings deep and clear
Winking sunlight in the air
Skirrilappit tóldero.

No man has a fault
Who turns barley to malt
Alleluia!
Who ferments the wort
Will come to no hurt
If it's brewed
As it should
In the sweating and roasting
Be ready for boasting
The toast of our feasting.
Skirrilappit tóldero.

Skirrilappit tóldero.
What moper will ask
To bung up the cask?
Alleluia!
Of beer for good sake

No prisoner will we make
 If it's brewed
 As it should
But let it come leaping
From sifting and seeping
Until the time for sleeping.
 Skirrilappit tóldero.
 Heigh-ho.
 Skirrilappit tóldero.

Then holding our heads
We are off to our beds.
 Alleluia!
Deep dreams never fail
Men kissed by the ale
 If it's brewed
 As it should
We shall float like an ark
On the deluge of dark
To the rise of the lark.
Skirrilappit tóldero.
Heigh-ho, heigh-ho, heigh-ho.
Skirrilappit tóldero.

(*During the last 'Skirrilappit' chorus CAEDMON has nervously moved away to the edge of the group, ready to make his escape.*)

JODDY: What now, Overman? Who's to have the harp now?

WIDOW: Caedmon the Stableman! He has never yet sung for his supper. Give him the instrument!

OTHERS: That's who it should be. Give us your voice, Stableman! Where is he?

KERN: He's off and away again.

WIDOW: Did you ever know such ingratitude? Takes all the merry evening for himself and does nothing to earn it.

(*CAEDMON is making his way towards the stables. Some of the MEN have followed him and try to persuade him to return.*)

MEN: He'll come back, won't you, fellow? You don't mean to grow old in shyness, now. We'll help you along. Give us a verse anyway.

CAEDMON: I g-give you my word, there's no other word to give you. You'll have to accept me as the dumb man I am.

JODDY: There must be some rhyming of your own tribe you can remember. What rocked your cradle? What spun your top?

CAEDMON: N-nothing comes to mind that could possibly please you.

OVERMAN: That's how it is: let him be as he will, stay the way we find him. Here's Joddy hasn't strung out a line himself either. He can tell us what rocked *his* cradle. How about it, Joddy?

(As CAEDMON raises his arms and drops them in a kind of apology, one of the MEN gives him a farewell pat on the back, and CAEDMON makes his way towards his lodging. JODDY is given the harp and starts to sing as the scene fades from view.)

JODDY: Now, lie 'hedgehog', young to-and-fro,
Rolled in a ball while east winds blow.
Close your eyes; never see
Snow bloom on the icicle tree.
Under dreams heaped up deep
Curl in a do-nothing, know-nothing sleep…

BEDE: So Caedmon made his way through the night to his lodging over the stables. He was sick with himself for never finding, even for the sake of mirth, words that would make a bridge between himself and his fellow men. Over his head the night sky seemed only to shrink him to the size suited to his failure. Each morning he would still go through the half-light close to the monastery wall and listen to the voices singing Prime. But there was no music in himself, he knew that. He had good enough words for the horses, moving restlessly in their stalls, before he climbed the ladder with difficulty to his sleeping place. And there he slept. The sound of the singing and laughter from the great barn sank down through the dark and drained away. Owls took over

the silence. Distantly, beyond Caedmon's consciousness, the voices from the monastery were singing the Holy Office of night. The sea intoned its regular responses, sighed back into itself to let the next wave of intercession roll towards the shuddering 'And let our cry come unto Thee'. In Caedmon's unconscious consciousness he was borne on the wave, or was he himself the water of the wave drawn towards the waiting land? Almost the moment had come when he would break himself open on the rocks, burst into as many fragments as would populate a city. What rescued him from that he couldn't tell. He was set on his feet, between the goat-path and the shore, clambering back to his old shelter in the cliff, where he had left a sack filled with dry leaves for sleeping on, a hunk of bread as dry and as hard as the cave floor, and a bramble branch with the berries eaten.

A person was in the cave-mouth, as though a time had been agreed for meeting. Or was Caedmon seeing… Could it be himself that he saw waiting there? If only the sunlight wouldn't flash its feathers like a bird bathing.

THE PERSON: You have been taking your time, Caedmon.

CAEDMON: Yes, I move dangerously slowly, I know, considering how short life is. But I thought I had gone away from this place several days ago. I hadn't understood I was to come here again, or that you – that anyone would be expecting me. What am I to call you?

THE PERSON: Why should you want a name to make a division between us? Call me by your own name if you like. The breath of life isn't so very particular. What names did you give to the men you fought with in the wars before you killed them? You could have said Caedmon, Caedmon, Caedmon. Life would have had no reason to contradict you. Neither would it now while we wrestle together.

CAEDMON: Wrestle together? Why, what cause of contention do we have?

THE PERSON: Are you at peace with yourself?

CAEDMON: Is there such a word, between birth and death?

THE PERSON: Perhaps not. So your question of a cause was hardly worth asking. Why did you come away into silence from where the singing was?

CAEDMON: I felt unfitted.

THE PERSON: And yet fit for silence? That's a large claim.

CAEDMON: I mean there was no music in me.

THE PERSON: Never? There was never music?

(*CAEDMON hesitates. The distant sound of singing is heard, one woman's voice clear among the other voices.*)

CAEDMON: I heard the singing. It was like the sound of evening in a garden. A burning sword drove me out.

THE PERSON: You were young.

CAEDMON: I was twenty years old.

THE PERSON: Your feet easy on the earth. The air was as trustworthy as the milk in your mother's breast had been. Each day ratified the next, until suddenly the days threw out their boundaries like rays out of the sun. You were in love. Not even the trees ready to leaf were more believing. You were faith itself. You were the purpose of life.

CAEDMON: I thought so.

THE PERSON: You were part of the music then.

CAEDMON: I thought so.

THE PERSON: What happened next?

CAEDMON: It's already in your mind. Everything's known to you. Why do you have to ask? Why should I answer?

THE PERSON: You have been answering all the thirty years since. This is as good a time as any other.

CAEDMON: Let me go, let me be free of you!

THE PERSON: Perhaps I can help you over the worst. I will say the words that are hot coals on your tongue. She was very young, your love, not long out of childhood.

CAEDMON: She was sixteen.

THE PERSON: Yet she loved like a woman.

CAEDMON: (*In anguish.*) You know I gave death to her.

THE PERSON: Do I know? Is that what you tell me? At the time there was nothing (was there?) except love and life. And yet you dare to tell me... Why are you trying to hurt me by saying that? Love became two things: death and a child. That was what you meant to say.

CAEDMON: I gave the death.

THE PERSON: She held it in her arms. Is the child, the daughter, to be accused of the killing, too? What is your verdict?

CAEDMON: Innocent, innocent, innocent. Don't try to fool me. Whoever you are, this can't be made light of.

THE PERSON: More's the pity, since that may be the very aim of the dark mills.

CAEDMON: I shall be dust first. I became the destroyer – of such a wonder, earth hardly had time to value her. By what blind permission could it come about? Why should God make woman for a man's worship, to covet her beauty and make it his own, for death and guilt to come of it? Where's the mercy in that?

THE PERSON: (*Laughing.*) Where is your silence now?

CAEDMON: What I'm saying *is* the silence. What music can there be when God and the Devil are so interlocked in their purposes? They condemned me to be a destroyer, not a lover. I accepted the sentence, and went where the fighting was. I had seen God in life and He had given me death. Perhaps I should be seeing Him even plainer on the battlefield, where the wings of the blood beat in no confusion, their flight making for death anyway. But I saw Him only in the pain, in the unloving sword-hacking violence – and hoped His eyes were covered, in a shame for His own making.

THE PERSON: The water that turns the perfect wheel is turbulent. Travailing is travelling. Come out of the silence.

CAEDMON: It's too heavy on me. I cannot sing.

THE PERSON: However, you shall sing. You have broken the silence; by your own admission you have broken it. And what

is more, I have taken your wound into myself. Where's your gratitude?

CAEDMON: (*Bewildered.*) I still feel the pain of it.

THE PERSON: Believe that, if you like. What can truth do against a man's treasured convictions? None the less, the wound is mine now.

(*At a distance the GIRL who died in childbirth appears in CAEDMON's dream. In face she is very like the NOVICE NUN, but only 16 years old.*)

GIRL: It is his now. Are you ready to turn towards me? A mist is curling off the river. I am at the midway of the bridge. The light is behind me as I look towards you, which is why you begin to feel it fingering and tracing your face, as I used to do. I am touching you now.

CAEDMON: How is this?

THE PERSON: We have wrestled until the breaking of the day.

GIRL: We have gone into the cornfield. We have made a private harvest and eaten it. And you take a cup of leaves which is still holding the dew – so early in the morning it is – and ask me if I am thirsty. We drink it together, before the heat of the sun gets a tongue to it.

CAEDMON: Oh, my love!

GIRL: Why have you let me be lost in silence?

CAEDMON: You were taken away from me. And the child as well. I was never to see her. It wasn't I who made the silence.

GIRL: But it's you who keep it.

CAEDMON: I'm trying to come to you but the ground is clinging to me like deep trouble.

THE PERSON: I have told you. Give in. The wrestling is over.

GIRL: The trusting place of love is where we meet – and where our voices have become one voice as the sun comes up over the sea.

THE PERSON: Accept, Caedmon. Sing.

CAEDMON: What shall I sing?

THE PERSON: Sing the beginning of created things.

BEDE: (*Voice.*) So Caedmon dreamt. Even while he slept his
　　head was full of the sounds of life, calling from over the hill,
　　wind blowing and the flowing water, the alarm cry and the
　　skyward singing of birds, the lowing and whinneying and
　　bleating and cackling of living creatures with their utterances,
　　the cries, prayers and laughter of men and women. As though
　　a harp had been put into his hand, he sought out words
　　with the beat of the human pulse, trying to find, however
　　awkwardly, the indwelling music that created us.

THE PERSON: (*Voice.*) Sing the beginning of created things.

GIRL: (*Voice.*) Sing.

CAEDMON: I am ready to praise the measureless making
　　That in foreshadowing and seeking
　　Formed place and light, for all creation's sharing,
　　Those things without beginning yet begun,
　　By God-love given, by potency upholden,
　　The unimaginable shaped in substance,
　　In eternity made time's companion,
　　World and earth-kind, by God's grace guarded.

　　I am small to praise such Fathering,
　　Unknowable God, perfect in persuasion,
　　Of all wonder the awakener,
　　Who out of inward wanting spun the heavens,
　　Gave the body of space a heart for living
　　And called it Earth, in water-and-air-life eager,
　　Under tides, or wings clouding the brightness,
　　And creatures warm in their ways, the day possessing,
　　The secret night invading, speed and strength
　　And litheness held in a marvel of muscle.

　　Then the spirit of God moved across the world
　　Like a man's breathing and disturbed the dust.
　　The dust heard, stirred as a moon rising,
　　Came together in recognition. The dust saw.
　　The breath went in and out like the visiting of friends
　　And the dust knew. Then the hands of God
　　Clapped among the clouds, clear water sprang

Ringing from the rocks, and the dust spoke.
There was man, there was word in the world.
And from the neighbourhood of his heart
Eve took life, flower and fruit of the rib-stem.

BEDE: When Caedmon awoke from dreaming he knew he had
left the shelter where the bread was dry and as hard as the
cave floor. He remembered he had made words for a song
in his dream, and he remembered the words that had come
to him. Now the sun would soon be rising. He went about
his work in the half-light, muttering and chanting under his
breath, sometimes startling the animals by trumpeting out a
succession of words, as neck-stretched as a cock crowing.

CAEDMON: (*To himself.*) Let the earth bring forth grass, the
herb yielding seed, and the fruit tree...
And from the neighbourhood of his heart
Eve took life, flower and fruit of the rib-stem...
... Scarcely foretelling...all that the winter withheld...
between two mornings, leaves came like words to the
branches...
(*He speaks out.*) Generous the green is
With vigour of vine and forest
Searching the sunrays...
Up out of the blind soil
Flowers fetch their brilliance
Mined like gold and gemstone...

(*The singing of Prime is heard distantly as the light grows.
CAEDMON has taken fodder to the stables and returns.*)

BEDE: He listened to the choir of voices, as he had listened
each morning, and he heard clearly among the others a
woman's voice which seemed to be a part of his life, and
when he had listened to the Latin words being sung, *Jam lucis
orto sidere,* he began to pair them with words of his own.

CAEDMON: Now the morning tide of light
Flows across the sand of night
And lifts the heart that's gone aground
To ride creation's sea of sound.

(The OVERMAN has entered.)

OVERMAN: What's this, Stableman? I thought you told us that
we have to accept you as the dumb man you are. You said you
had nothing to give us when the harp came round.

CAEDMON: That was how it was. I promise you, dread was the
only thing in my mouth then.

OVERMAN: But now things are different. Is that what you're
saying?

CAEDMON: Yes, indeed, different; some most strange shift in
the brain's climate. I slept the silence away. You are going
to be puzzled, but not more than I am. I say to you I slept,
and I tell myself I dreamt, but what a reality it was, that
dreaming! More real than most things in my waking life. And
you needn't think I'm losing my reason.

OVERMAN: No reason that I should. A man's in good company
when he's dreaming, along with Joseph and his bowing
sheaves and the bobbing sun and moon and stars. Can you
describe it, this dream of yours?

CAEDMON: I was told to sing.

OVERMAN: At whose bidding?

CAEDMON: Ah. You are going to want answers. He asked me
why I should want to separate us with a name. I knew him
and didn't know him. I even wondered whether it wasn't that
part of myself where God still holds out, beleaguered though
he is, and improbable though it sounds.

OVERMAN: But you weren't tongue-tied any longer, eh?
Neither in sleep nor after? Like as a whole flock of birds
turns at one impulse. You'd say that? The air is full of strange
messages: you'd say that?

CAEDMON: Hey, you're scaring the words away again. I
can't tell you everything. Or take it all in myself. It was as
though… Thank God for 'as though'! I can only tell you
that in some sense, in that night time, death died into love.
And together, the two who were with me, put words into
my mind, as you might have put the harp into my hand. I

remembered the words when I woke; I remember them still.

(*He starts to go back to his work.*)

I am ready to praise the measureless making

That in foreshadowing and seeking

Formed place and light, for all creation's sharing...

OVERMAN: You're not limping any more!

(*CAEDMON turns and grins.*)

CAEDMON: He had taken my wound into himself, he said.

OVERMAN: (*Takes off his hat.*) The Lady Abbess ought to hear of this.

CAEDMON: Oh no, that's –

OVERMAN: When we've got the day's work finished, I'll take you to her.

CAEDMON: Because of a dream? What a fool I should feel, filling her ears with that.

OVERMAN: Not the dream, not so much the dream; the outcome of it.

CAEDMON: But it would mean going into the monastery.

OVERMAN: Why not? It's not a thieves' kitchen.

CAEDMON: That might be safer. It's nearer to the world's centre than I thought I should come. But all right, if the venture has to be made, I'll do as you say. And pray that I'm not breaking bounds.

OVERMAN: I'll add an Amen, if that's any help to you.

(*They go about their work.*)

BEDE: At the end of the day the Overman conducted him to the Abbess, who asked him to tell his dream in the presence also of the Prior and the Precentor, and to recollect for her the words he had made, so that they might give their judgement on what the dream was and how it had come about – though there was a part of the dream, the appearance in it of the girl who had borne his child, which he gave no hint of. To test him they recounted to him passages of sacred history, and told him to make these into his own form of song if he

could. So he went away and returned to them the next day ready to make his masters in their turn his hearers.

(*The ABBESS HILDA, with the PRIOR and the Chantry Priest or PRECENTOR.*)

ABBESS: I wonder how we shall find ourselves thinking when we have heard him again. Yesterday it seemed to me, as it seemed (am I right?) to you, Father Prior, that the man had drawn on a source beyond his own condition – to be taken, unlettered as he is, from such a fear of words to the readiness they had for him in his dream – if we're to call it a dream and not a vision. I was ready to believe a heavenly inspiration had alighted on him, like a nightingale on a thorn bush, however roughly he imitated the sound.

PRECENTOR: Was it so roughly? People have always sung before about battles and dragons and in praise of heroes. How are we to compare it?

PRIOR: I did think so yesterday, that the man might have been inspired. But can we be sure that what he recited to us hadn't been prepared over a length of time, and given this dream story to impress us? But we shall soon have an answer to that, one way or the other.

PRECENTOR: It wasn't an easy test you found for him, Father Prior, the plagues of Egypt and the forty years in the wilderness!

PRIOR: If the children of Israel could be brought dry-shod through the Red Sea, inspiration should have no trouble bringing this man as far as the plains of Moab.

PRECENTOR: I keep wondering where, somewhere, at some time, I have come across this man before.

ABBESS: Aren't you being over-scrupulous, Father Prior? Why should the good fellow pretend things were other than they were?

PRIOR: We must be careful not to be charmed by an illusion.

ABBESS: Or to stifle a truth with excess of caution.

PRIOR: I have thought of the Pentecostal Collect: 'God, who at this time did teach the hearts of the faithful people, by the

sending to them the light of the Holy Spirit, grant us by the same spirit to have a *right judgement* in all things…'

ABBESS: 'And evermore to rejoice in His holy comfort.' That's how the Collect ends, and that is how, I hope, this trial will end for us here.

PRECENTOR: As soon as I saw him I seemed to recognise him: older, of course, and yet in voice and in his ways recalling – or rather, not quite recalling some occasion, some event. Where could it have been? Perhaps some years ago now. How tantalising it is.

ABBESS: But how unimportant. Creation still goes on, continuing in every moment, so whenever we re-encounter a fellow human being it should be as though for the first time.

PRECENTOR: Yet it seems somehow important to me, this memory. Well, the mind plays tricks, I suppose.

PRIOR: Here he is, the man with his own mind to disclose playing or not playing tricks.

(*CAEDMON and the OVERMAN approach.*)

ABBESS: God save you both.

CAEDMON / OVERMAN: My Lady Abbess.

ABBESS: Well now, tell us, good Stableman, have the Israelites found their way out of Egypt?

CAEDMON: With much trouble preparing for it, my Lady, to themselves and to me, all night long.

ABBESS: But can we hope, when the dew had dried in the morning, 'the wilderness was white with a small round thing, as small as the hoar frost on the ground', manna to feed us?

CAEDMON: Reverend Mother…this time I was on my own: no persons of a dream to help me: only the occasional shuffle of the horses. There was nothing in my head except the sound of waiting. The words I had used in praying were disinclined to give way to anything else.

PRIOR: There it is; we mustn't expect every appearance of light to signal the day. You needn't apologise, my son.

PRECENTOR: There aren't words for everything, I'm sure,
 though I haven't gone into it.

ABBESS: Is that what you came to tell us, Stableman?

OVERMAN: No, Reverend Mother, I can vouch for him there.
 Would I have brought the harp along for nothing?

CAEDMON: Well, yes, some sort of speaking found its way
 through my thick skull in the end: so thick, I imagine, that
 it takes any kind of music a long time to penetrate. But
 something spoke in the end. The real sound is always at a
 great remove, unobtainable, at least by me. You see a face in
 the water; your fingertips touch it and the face trembles and
 breaks up.

ABBESS: We understand that, Stableman, very well, but can't
 we taste a little of the water?

CAEDMON: Why, yes, Reverend Mother, if you will. (*He smiles
 and looks at the OVERMAN who plucks a few notes from the harp.*)
 In the soon-over of life, a space no wider
 Than white wand of daylight, crossing the floor
 From a door not perfectly open –
 No longer than sparrow's flight through a firelit hall
 Out of the night away to the night again –
 In that small span may be a great journey,
 Hard and far to the flesh of the foot,
 Hard to the scarred mind
 But outlasting the desert, inheriting
 The country promised – not Eden, but Eden forgiven,
 Or at least echoed in water under the palm-trees.
 Have you brought me to say that every true journey
 Starts in a storm of pain? Smeared on the lintel
 The blood; in a midnight unmerciful
 The throb, throb of death-wings passing over.
 That was how you spoke of it.
 You told me other things, said Go with them
 As God did. In the setting-out hopes were high,
 Larksong no higher, trumpets of liberation
 Drowned all the lamentation of Egypt.

> And God was vanguard and rearguard
> And a way through the deep waters.
> Hearts failed them still, bodies broke,
> There was anger, terror, despair still, there was death:
> But also always a pillar of cloud by day
> Paced that shadow of people moving across the wilderness,
>> And a pillar of protective fire
>> Stood over their sleeping. Yet, yet, yet
> How man-mind held back from the fashioning,
> Clung to its own deserting body, cried
>> For a breast of gold where no milk was.
> Listen, said a mountain of the world,
> Hear me, take the stern hand of your lover
> Whose face is covered from you, and go forward
> Surely over the sharp sand, to make
> A place where water comes laughing from the rock;
>> And being brought at last to a high place
> There is distance upon a distance to the utmost sea.

(*A moment of silence before the ABBESS speaks.*)

ABBESS: Do you have your answer, Father Prior? I have mine.

PRIOR: 'We hear the sound,' St John said, 'but cannot tell from where it comes or to where it goes.' It is evident that in some way the seal which kept his lips has been broken.

OVERMAN: Which no human endeavour could do, Father, that I can tell you.

ABBESS: Caedmon – it is your name?

CAEDMON: Yes, Reverend Mother.

ABBESS: Good Caedmon Stableman, the Prior has given us St John. I will give you St Matthew: 'No man lights a candle and hides it under a bowl. He puts it into a candlestick, and it gives light to everyone in the house.' We must think and talk more together. Thank you for sacrificing your hours of sleep to us.

CAEDMON: (*Giving a little bow.*) Thank you, Reverend Mother. Father Prior. (*He touches the OVERMAN's arm and moves away.*)

PRECENTOR: Caedmon – that's the name! Three years
 ago – the battle by the Vinwed river when the river was in
 flood after the great rains! You were there when the battle
 was over and the army of Penda's son Wulfhere had been
 defeated. – Caedmon, Stableman!
 (*CAEDMON seems deaf to his call and walks away, though the
 OVERMAN has tried to delay him.*)

ABBESS: Don't call him back. Don't make him carry any time
 except the present; it's enough for any man.

PRIOR: But what was this meeting with him that you
 remember? We should hear of it.

PRECENTOR: In the panic flight of Wulfhere's army away
 from the field, almost as many of his men were drowned in
 the flooded river as were killed in the fighting. I had come
 with some of the Brothers from St Stephen's nearby to
 tend the wounded – and I saw this man – I'll swear it's the
 same – instead of galloping off with the rest of Wulfhere's
 men, drew in his horse – his sword was sheathed – and
 he came back to the field, where many were ready to kill
 him, dismounted, cast his sword into the river, and came to
 help among the wounded, those he had fought beside and
 those he had fought against, into the night and on into the
 morning. As the first light came I went to fetch him back to
 the monastery to rest, but he and his horse had gone.

PRIOR: What sudden voice made him turn his horse, I wonder.
 There had been men of peace among the Mercians, Bishop
 Chadd for one.

ABBESS: Was it we, as he questioned in his song, who brought
 the Stableman to say that every true journey starts in a storm
 of pain?
 (*The light goes away from them and finds BEDE.*)

BEDE: The Abbess thought and prayed, and after a while
 embracing the grace of God in the man, she instructed him
 to leave his work in the stables and to take upon him the
 monastic life; which being done, she associated him to the
 rest of the brethren in her monastery – not without some

difficulty. The sins of his life, he said, would make him feel an interloper. And when the Abbess Hilda spoke of God's forgiveness, 'I believe that,' he said, 'with awe and with wonder. It is self-forgiveness that is harder to come by, self-sorrow that is harder to lose.' But by Hilda's persuasion he was brought into the Order; and now he no longer stood outside the walls hearing the music as the sun rose; he stood within the walls, himself a part of the music. His voice sang in antiphon with the voice of the novice nun who had been born in Rookhope beyond the Wear thirty years before; but of this Caedmon never spoke; it was all that was left of his silence, and all that there would be of it now until the time came for his life to end.

For sixteen years he lived in the peace of the monastery, making his verses, submitting to the discipline of the Order, until a morning when he seemed to be visited by a foreknowledge of his death. He asked the fellow-monk who attended him to prepare a place for him in the Infirmary, and when he was there asked that the Eucharist should be brought to him. 'What need is there of that?' the monk asked him. 'You talk so merrily, as though you were in perfect health. You are not likely to die, Brother.' 'In spite of that,' Caedmon said, 'bring it to me.' So when he had received the bread and the wine he lay on the bed prepared for him, as quietly as though he lay under the apple-trees of the orchard. But now it was night-time.

(*A pallet bed has been brought in by two MONKS, and CAEDMON has lain down on it. One of the MONKS remains and sits at his side.*)

CAEDMON: How many inches square is that small window above my head? A human hand could almost span it. The spread hand of a man could nearly touch its limits. And yet – look, Brother – in that segment of sky I can see distance without end. Even *my* rather unsatisfactory eyes can see at least five stars. There might even be seven. That would be comely. The seven words from the cross shining in that rectangle of darkness! The time that's left to me, earth time

I mean, measures less than the window, but there's eternity
in it, too, I believe so, like a passing thought which never
leaves the mind... I've been shown such a universe! These
not-so-many years, what vastness has filled them, though I
made so little of it. Before I am lost-and-found in God's love
I should like to make one thing more, a song or half-song or
no song, but one thing more in thanksgiving for having seen
and known and lived and died. – How near is the time when
this house will begin the night's Holy Office?

MONK: It's not far off.

CAEDMON: Well, I will keep you company until we hear their
voices.

(*He is silent for a moment or two, and then raises his voice a
little.*)

I am thinking now of my seven-year-old smallness
Going slowly backwards into the house
Unwilling to part from the company
Of those playfellows the dust and sunlight
To go to my bed, make ready for sleeping,
To be gathered up by the great shadow;
So unwilling, though there were stains on my face
Left by the daunting daytime; yet I was sad
To be parted even from the pain – as I am sad now, Master,
To go from an earth seared with your suffering,
For also your love lived there.
(*He laughs to himself.*) It was my dust and sunlight.
In the caves of the world where despair was
And the sound of the waves shifting their burden,
Light came, calling for me across the fields,
Your longing that all should be well. There would come
Days when the heavens rested from labour
And the sky looked on the land and saw that it was good.
I gave little enough praise, though each moment
Was eternal as it died to fulfil the year:
Summer's wide-open arms, the vineyard's blood,
Snow silence, and the Spring

Walking a road, away from an empty tomb.

So, Master, forgive me for this loitering.
 I am reaching towards you now.
My hands were full of dear discoveries
 But earthly time can have them...

(*The singing of Compline can be heard*: *of 'Te lucis ante terminum',*
or 'Christe qui lux es et dies'.)

CAEDMON: Listen. Where I break off, the music is filling my
 place.

(*The music takes over.*)

A RINGING OF BELLS

A Conversational Fantasy

Characters

RECEPTIONIST

ADAM

EVE

GEORGE

PAUL

ELIZABETH BUNYAN

The action of the play takes place in a small village hotel.

Time: Millennium Eve.

A RINGING OF BELLS

(The entrance hall of a hotel, Elstow. It is midnight.

The church bells are ringing with great certainty as the play begins,
but then intermittently as the wind takes them.

The RECEPTIONIST is at the desk, scarcely noticeable: he has
fallen asleep.

Through the door come a man and a woman: we will call them
ADAM and EVE.)

EVE: But where is it? Where have we come to? Why don't you tell me? You must know.

ADAM: Well, that's the trouble. I don't.

EVE: You must have known which way you were driving.

ADAM: Eve, you'd better sit down, I think.

EVE: Why, what is it?

ADAM: That's the question. When we set out, this was going to be a perfectly pleasant and sensible evening. We were going to celebrate –

EVE: New Year's Eve. Well, exactly. But somewhere where we knew where we were, I should have thought.

ADAM: Well, they're ringing the bells, whoever they are. There's nothing strange about that. It's what my watch says – just gone midnight. So there's nothing wrong with the time.

EVE: What do you mean, wrong with the time? Why should there be? For goodness sake, what are you trying to tell me?

ADAM: *(Taking the help of a chair.)* Just now – driving over – you didn't feel nervous?

EVE: No, why should I feel nervous? I've never felt nervous when you were driving. Only I wanted to know where we were going. That's why I kept asking you. Where were we making for? And you wouldn't say anything except 'Well'. You kept saying 'Well'. You wouldn't tell me.

ADAM: How could I, when I didn't know?

EVE: (*Sitting beside him.*) You must have known which road we were on. You must have known where you were making for.

ADAM: I've got to tell you. I wasn't driving.

EVE: Adam, stop teasing me. You know you were driving.

ADAM: I know I had my hands on the steering wheel, I know that. And I didn't feel we were out of control: not totally, anyway. But there was a kind of *persuasion* – a kind of calling almost – running through my hands.

EVE: Well, why didn't you say so? I should have told you to pull into a lay by until you felt all right again.

ADAM: But I didn't feel wrong, Eve. I felt in good hands – except that the hands were my own hands. You don't think I'm crazy?

EVE: Well, I do in a way, yes, I do. Or else the car is. I'll try to make some sense of it, given help. Only, I'd like to know where we have come to. And why the steering wheel was so keen on getting here. (*She gets up as though to look for someone.*) There must be somebody to ask, though this hotel, if it is a hotel, seems strangely deserted for a New Year's Eve – particularly this New Year. Oh, there *is* somebody, dead asleep by the look of him: that's not very receiving for a receptionist. Shall we wake him?

ADAM: Better *you* don't – he might wonder what he was waking up to. (*He goes across and rings the desk bell.*) Hallo there.
(*The RECEPTIONIST jerks into life.*)
I'm sorry to interrupt anything.

RECEPTIONIST: No, no, you mustn't mind that. It's been a particularly busy evening.

ADAM: (*Looking round the deserted room.*) Really?

RECEPTIONIST: For thoughts. They come swarming in, and don't really leave each other enough room to reach a conclusion.

ADAM: Perhaps I can help. My friend and I – we were wondering where we are.

RECEPTIONIST: Yes, of course – it's only natural.

ADAM: Well, will you tell us, please, so that we can get our bearings?

RECEPTIONIST: I expect you mean *exactly* where.

ADAM: Yes, of course exactly where.

RECEPTIONIST: You mean this building?

ADAM: All right – this building to start with.

RECEPTIONIST: And that depends, as you know, on whereabouts in time you are standing.

EVE: Adam, let's leave here – why can't he be civil?

ADAM: Look, we've already been a bit thrown out of kilter this evening – just be good enough to tell us –

RECEPTIONIST: I was meaning to be helpful. Time covers a great distance, you know. If you are meaning to concentrate on the particular hour which has just landed us onto the third millennium –

ADAM: For heaven's sake, yes, of course we do.

RECEPTIONIST: Then we can't call this place *The Star and Saracen,* which at another time we might have done. Or *The Catherine Wheel,* which was possible once. It could more reasonably be called *The Chequers* where you think you are now – 'the chequer board of nights and days', as the poet said – though *The Red Lion* across the Green could be equally suitable. John Newold did well for himself there, and the Newold family held it across a century or more – which is why I said New-old makes that pub a suitable resting place in the ocean of time if that doesn't sound fanciful –

(*EVE gives a little scream of exasperation.*)

Am I confusing your friend?

ADAM: Suppose you make things simpler for her by just telling us the name of the village.

RECEPTIONIST: Oh, yes, there's no difficulty there, whichever vantage point you're taking – not at least unless we go back fifteen hundred years or so –

ADAM: For God's sake, man, what *is* it?

RECEPTIONIST: Well, in the Old English it meant the place
of assembly, the holy place – belonging, it's thought, to
someone possibly called –

ADAM: The name, man, the name of the village!

RECEPTIONIST: Which I was just telling you. It's Elstow.

ADAM: Good grief. Is it really? (*To EVE.*) I was brought here
when I was a kid. On some special occasion, I think, though
I don't remember… How did my hands know that?

EVE: Adam, be sensible. Things don't happen like that.

ADAM: But someone brought me here before. And something
brought me here tonight. Someone brought me and helped
me to paint a picture of the church. Or rather, of the bell
tower. (*To the RECEPTIONIST.*) That's it, isn't it? The bell
tower stands on its own – like an individual standing for what
he believes. I mean, as though the bells spoke for themselves.

EVE: Well, to speak for myself I can see what might have
happened – your subconscious knew the road and so you just
followed it.

ADAM: But I was a small boy then, and someone brought
me – I don't know how we got here.

EVE: There must be some perfectly sensible answer. There are
always sensible answers if you keep your head and look for
them.

ADAM: What do we know about quantum mechanics?

EVE: Absolutely nothing, and rather glad of it.

ADAM: Suppose the voice of the bells – I mean the vibrations
– through the darkness without the daylight to interrupt
them – broke through some kind of floodgate which kept
time from interflowing – the way this chap seemed to be
describing.

EVE: If you're thinking of becoming a little boy painting
pictures, where does that leave *me*? Come on, Adam, let's try
to be sensible.

ADAM: After two thousand years, time must be wearing a bit
thin.

EVE: Well, don't lean on it, for heaven's sake.

ADAM: I wonder how old those bells are, how much of history they have been talking to.

(*A man, GEORGE, comes in through the door.*)

RECEPTIONIST: Here's somebody who should be able to tell you. Were you one of the bell-ringers tonight, George?

GEORGE: Yes, I was, along with Paul Cobb, but I'll tell you something: as well as us two –

RECEPTIONIST: This gentleman was asking how long the bells have hung there.

GEORGE: I could tell you – given time to remember – the sixteen hundreds all bar one – but I'll tell you this: while we was ringing – we'd been ringing five minutes or so, I should say – there was another chap had joined us – I hadn't noticed him coming up into the loft – nobody I could name, though there was something familiar about him. He just stood there listening – and now and then his arms would lift as though he was one with us. Hey, I thought, you know something about it, and I looked across at Paul and jerked my head towards this fellow, but old Paul didn't seem to notice him, and when we was done and I turned to speak to him he was gone, the fellow. He's not been in here, then – a foreigner, you've not seen him around?

RECEPTIONIST: A foreigner, no, I've seen no foreigner.

GEORGE: I don't mean a foreign foreigner, I mean foreign to these parts, like. And yet again he wasn't so foreign – like I said, there was something familiar. Maybe it was something about what he was wearing that seemed out of the way, though I couldn't get more than a look while I was ringing. A sizeable fellow, he seemed to be. You haven't seen him, then?

RECEPTIONIST: No, I haven't seen any sizeable fellow.

GEORGE: You wouldn't think one of his build would just vanish.

RECEPTIONIST: Well, whatever our build, it's a way we have in the end. But no, you wouldn't think so. Not if he was actually here.

EVE: (*To GEORGE.*) Had the night cleared up at all when you came in? It was so misty, a small rain almost, when we were driving here.

GEORGE: Yes, trying to make the beacon catch was quite a business, for the damp wood. But then it leapt up fine, and the heat of it seemed to break up the mist as well, and we've got the night sky back with us.

EVE: (*To ADAM.*) Because I would like to see where you have brought me to. And you would too, to find out how much you remember.

ADAM: (*To GEORGE.*) I was just telling her – I was brought here as a child – on a day trip I suppose it must have been. That's going back a bit. But it's all begun to ring a bell with me. It was the oldest of my aunts who brought me – goodness, yes – (*To the RECEPTIONIST.*) and talk about time covering a distance: she told me once that she had sat on the lap of a great-uncle who had been patted on the head by George the Fourth – so that when I held her hand we were making a bridge –

RECEPTIONIST: You could almost walk across.

EVE: Well, let's walk through the village, Adam – that's going to be easier.

ADAM: Yes, in a minute. Things are beginning to come together. I remember now why she brought me here. She had been reading *The Pilgrim's Progress* to me, and getting me to read some of it to her – nice big type, I remember – had been in the family for a century at least – well, I remember an inscription on the fly-leaf – beautiful writing – Christmas 1863 – and yet as immaculate as on the day it was published. I had to go and wash my hands before I turned the pages.

GEORGE: So you know, don't you, that this village –

ADAM: Yes, that's what I mean – it's John Bunyan's village – which is why she brought me here. He was born here, wasn't he?

GEORGE: Well, within a mile or two, yes. Lived and married here, and put us all into history.

(*PAUL COBB enters from within the hotel.*)

But here's the man to tell you about him – I'd lost track of you, Paul, after the ringing. I've just told this gentleman, you're the history bloke.

PAUL: Good evening. What's the question?

ADAM: No, I've just realised how I knew about this village – because of Bunyan.

PAUL: Ah, yes, the sturdy John. I've pretty well lived his life with him over the years. And tonight especially I thought of him. At one time of his life, as a lad, he would have had his head off his shoulders with joy at bell-ringing. The time when he would dance like a demon, swear like a tinker, play games on a Sunday like a champion. But when he saw these things as sins which were driving him into an eternity of Hell, why then, poor fellow, he thought the bells would fall on him and strike him dead.

ADAM: But tonight you think it would have made him glad to hear them ringing out so clear through the darkness?

PAUL: Yes. When he had lost his terrors he would have been eager to be up with us there, telling the night that the two thousand years of Christ had come. I could just see him there.

GEORGE: What do you mean, Paul, you could just see him?

PAUL: I can guess how he would have gone for it, singing out the old, and ringing in the new. And, as well as that, celebrating the three hundred and twenty-two anniversaries of his book. That would have put him in a glow, I don't doubt it.

GEORGE: That's all you meant, was it?

ADAM: I used to have a recurring dream – a nightmare – when I was very small. I would dream I was trying to escape from a town that was going to explode – or a city about to be bombed, perhaps it was. And it was desperately difficult to hurry because the path I was on was the keyboard of a piano. And what made it even more scary, more difficult, was that

I'd been told to keep to the black notes. It used to wake me up in a panic. I hadn't thought of it till now.

PAUL: How about that? Escaping from the City of Destruction.

EVE: Poor little Adam.

ADAM: Or I think more likely what I'd heard from my parents about the last War and the bombing of cities. Or, strangely enough, even more fearfully about the first Great War, from my grandfather. It's as if I had been a part of that time, as vivid as that. As though time was a tide coming back to where I played on the beach. Do you hear that, Mr Receptionist? Blow me down, if he hasn't gone to sleep again.

EVE: You wouldn't think there was enough dream-space to accommodate him!

PAUL: Perhaps we are the dream that he's having.

GEORGE: I keep thinking of that fellow who was watching us while we was bell-ringing. But you didn't see him, Paul, or did you?

ADAM: My God, things don't change much, do they, with the passing of time? In those kid nightmares I had all those years ago I was like a refugee from Bosnia or somewhere. That crazy division of human beings because of their labels! Do you think humans were more as they were meant to be in 1914? I'm thinking of that first Christmas, before the armies were thigh-deep in slaughter – when the Germans started singing: *Stille Nacht, Heilige Nacht* – and the British took it up – *Silent Night, Holy Night* – and they played football together. But then there were those four murderous years to follow. At least that wasn't the kind of destruction that John Bunyan was fearful of.

PAUL: Well, no. The Civil War caught him for a couple of years, of course. He was conscripted when he was sixteen, called up by one side or the other. I don't think he ever said which.

GEORGE: It would have been Cromwell's lot, surely?

PAUL: Maybe – or he might have got hauled in when the King was making a progress through the county. But no – it was later – it was the civil war in himself that so tore him apart.

ADAM: Yes, not being on good terms with himself, that was hard. (*To EVE.*) So: shall we go out into the night and see what we can find there?

EVE: No, I don't think we need to go just yet.

ADAM: Only I thought you were anxious to move on.

EVE: (*Laughing.*) Well, I don't have to be everything you think. There are things I'm interested to hear. (*To PAUL.*) Was there a wife? No, I see: he was only eighteen when he came out of the army. But then –

PAUL: He married at twenty, I think it was. And just travelled around, as his father had done, mending pots, the tinker's trade. But from what we know he had a great relish for life. He played a fiddle and a flute – maybe that helped the poet that was in him to take over when the time came – that and reading the chap-books that his grandfather peddled round the villages, and the Bible that brought him to think he was on the way to damnation. There was that shattering moment out here on the Green when he was playing tipcat on a Sunday. He was just taking a strike at the cat when, as he said, 'a voice did suddenly dart from Heaven into my soul, and it was as if I'd seen the Lord Jesus looking down, severely threatening me with punishment for all my ungodly practices'. That's the load he gave to Christian when he came to write his book.

ADAM: And that's when the joy even went out of the bell-ringing.

EVE: He couldn't have been exactly a little ray of sunshine to his wife.

PAUL: Well, he was as alive as a man could be, whether when he was wrong and guilt-ridden, or when, as he did later on, he came to see that humour was a great lifter of loads: when his God became not a breaker-in but a bringer-out.

EVE: God does seem to me to be a ridiculously small word for the size of creation. I imagine it was a pretty comfortably-sized universe in Bunyan's time. A kind of upstairs-downstairs job. But when you think of what infinities we're

beginning to reach out to now, always further, always the immeasurable power and the glory.

ADAM: The Big Bang, and all that came of it.

GEORGE: Or from what I hear they're saying now – Stephen Hawking or who is it – an almighty tiny bang – all space and time and evolution out of the compression of a germ you can't begin to imagine.

ADAM: Like one little sound suddenly becoming all the languages. In the beginning was the word, and the word was with God, and the word was God.

PAUL: And what I do know is, there couldn't be an energy strong enough to create, unless it was set off by purpose – the great, grinding, accomplishing of purpose – making, destroying, remaking, adjusting, persuading...

EVE: The beauty and the horror of it. Sun rising, moon setting, moon rising, sun setting, like the scales of justice.

ADAM: And the extravaganza of the inventiveness of life. Into every nook and cranny. I saw an insect yesterday, walking across the white piece of paper I was about to write on, honestly no bigger than a dot I could make with my pen, but with tentacles and feet, making its way within the millions of light-years. And the heavenly eccentricity of a peacock's tail. How on earth did a common sex-urge turn itself into such a pattern of eyes in a shimmer of feathers? Nobody's ever found a word, have they, for what produces such a conjuring of music out of a bird's egg? Well, yes, I know: the survival of the fittest, and all that. But what *does* it – the brain? The sex genes? The mind? What is 'the mind', anyway?

PAUL: I've asked myself the same question. 'Consciousness', the dictionary says; and 'intelligence'. No great help. A kind of creative discipleship, perhaps.

EVE: But the horror – I'm sorry to come back to that. The remorseless savagery that seems so to contradict the wonder. I could do without that.

PAUL: Well, what's in a victory that's unopposed? Tempering the metal with heat and cool and heat. The positive and

negative that makes things work. All that. As it took Bunyan's despair and terror to forge the power of his writing.

EVE: All I can say is, I think creation seriously overdid it.

PAUL: (*Laughing.*) Pretty seriously. Strange as it is, I suppose the darker the shadow, the brighter the light that casts it.

GEORGE: Well, he had the horrors all right, did old Bunyan, when he thought that the bell he was ringing would come down and crush him.

PAUL: He certainly went through it. And as soon as he came through on the sunny side, delighting the Meeting House with his preaching, the Bedford Meeting was closed down, and the local Justice issued a warrant for his arrest. Suddenly, instead of being, as he had been, the sinner in his own conscience, now – at peace with his God – he was thrown into jail a sinner in his country's politics. Even with the fear of transportation in his mind, and his family getting destitute.

ADAM: But they must at least have given him pen and paper.

PAUL: Later they did.

ADAM: And he wrote his book. He wouldn't have had the chance of it this century – if he had been prisoner of war on the Burma Railway, or brought down to skin and bone in a concentration camp.

EVE: Transportation? Would they really have done that to him, for not keeping to the rules?

PAUL: And worse. The statute said that if, after being transported, he returned to England, he would suffer death as a felon. In his imagination, he said, he was often on the ladder with the rope about his neck.

GEORGE: An odd thing about a lot of human beings. They can't bear it if anybody's different from themselves. Like they want to live in a world entirely populated by mirrors.

ADAM: Delight in difference – who said that? But as if disease, earthquakes, drought, flood weren't enough to contend with, you have to add civil war and ethnic cleansing to make life even more unbearable for yourself.

EVE: I sometimes think it's a pity that religion got any farther than 'Love your neighbour as yourself': there is no other commandment greater than this. And left it at that.

PAUL: It's preceded if you remember, by 'love God with all your heart and all your mind and all your strength'.

EVE: Well, I suppose in a way that *is* your neighbour. I don't know what I mean by that, but I think I think it. If those dogmatic bullies had loved this Bunyan a smitch and had a thought for his wife and family – was there a family?

PAUL: Yes, there was a family. His first wife had died, leaving him with four children, and the eldest of them, a girl, was blind.

EVE: Was blind?

PAUL: He said she lay nearer to his heart than all the rest. He was tortured by the suffering he was bringing to them – felt, he said, like a man pulling the house down on the heads of his wife and children.

EVE: His wife? He had married again, had he?

PAUL: Yes, he had married again: a girl of sixteen, called Elizabeth. The shock of his arrest sent her into premature labour and the baby died.

(The lights in the room flicker and dim.)

GEORGE: Hullo! Is there thunder around? It's as well to be prepared, to have a stock of candles when a storm is crouching ready to spring.

(The lights steady again.)

EVE: Perhaps something interfered with the power line. Suppose an owl had flown into it – could that be? Or the branch of a tree brushing against the wire.

ADAM: We take it so much for granted, the light we see by.

PAUL: And then something says it's not really like that; don't count on it.

(The lights flicker again.)

ADAM: It's the dark fighting to come back. It will win in the end, I expect.

(The RECEPTIONIST rouses.)

RECEPTIONIST: Eh? What's going on?

GEORGE: It's more like what's going off.

PAUL: How's the candle power in this place, Tim?

ADAM: Of course: *Tim.* The time-man. We might have guessed.

RECEPTIONIST: There were plenty where I was just now.

PAUL: You've been dreaming, old man, dreaming.

RECEPTIONIST: That's as maybe. There were plenty of candles there. In the *Swan,* I think it was.

(The lights go out. There is a little light from the night sky through a window.)

ADAM: Hey-ho! That's it. The owl has landed.

RECEPTIONIST: I'll call the High Sheriff. *(He lifts the phone receiver and dials.)*

GEORGE: The who?

RECEPTIONIST: *(Waving the receiver.)* It's dead.

GEORGE: So is he, I shouldn't wonder.

PAUL: It's a very strange thing, friends, Tim mentioning the *Swan.* I'll tell you why. What was I telling you before the lights got nervous?

EVE: About Elizabeth, the girl Bunyan married.

PAUL: That's right – and a gutsy girl she was. She travelled up to London for the first time in her life, to present a petition to the Earl of Bedford, asking for John's release. The case was postponed until the next Assizes at Bedford, and there she was, bless her, making a last bid, when the Judges were sitting at the *Swan* hotel. What have you been dreaming, Tim, to make you mention the *Swan?*

(ELIZABETH BUNYAN appears in the dark. Although a little light from the street reaches her, no-one on the stage sees her.)

RECEPTIONIST: Well, it's you who is saying I've been dreaming. And you feel quite sure that you're awake, I suppose?

ELIZABETH: It's false. It's very false.

315

RECEPTIONIST: There are things to be said for and against. The facts of the matter can be very misleading.

PAUL: You think so?

RECEPTIONIST: Everything is so very unlikely.

ELIZABETH: The indictment is false. I make bold to come to you again to know what will be done with my husband. They jailed him before there was any law forbidding the meetings. He only wishes to follow his calling and live in peace.

RECEPTIONIST: It's only a step, you see, between real and unreal. But how dreadfully reality gets punished for it.

ELIZABETH: I was with child when my husband was first apprehended – and the news of it so dismayed me I fell into labour – it lasted for eight days until the baby was born. And the baby died.

EVE: What am I hearing? Is there something going on in the street?

GEORGE: (*Looking out.*) Not a soul about. No lights in the houses.

RECEPTIONIST: There were plenty of candles alight in the *Swan*, but there was so much stir in the air they danced and guttered. It was the crowding together of human breath. The candlewax ran down like tears.

ELIZABETH: I have four small step-children: one is blind: we have nothing to live on except what comes from my husband's work.

EVE: (*To PAUL.*) I can't get that Elizabeth girl out of my mind! What can they have been living on while he was in prison? There couldn't have been much put by. He was a tinker, you said.

PAUL: Like his father before him.

ELIZABETH: And because he's a tinker and a poor man, he is despised and can't have justice.

RECEPTIONIST: There was a great puff of scorn from the Sheriff, and the candle flames bowed so low to him they threatened to leave us in darkness.

ADAM: (*To PAUL.*) And all because he was an unlicensed preacher.

PAUL: Preaching according to what he called the small measure of light that God had given him. That set the Judges snapping at his heels – for doing harm to his neighbours, they said.

ELIZABETH: No, my Lord, it is not so. God has owned him and done much good by him.

PAUL: They even said his preaching was the doctrine of the Devil.

ELIZABETH: My Lord, when the righteous judge shall appear it will be known that his words are not the doctrine of the Devil.

EVE: What a wild invention that is, making a Grimm's fairy-tale character out of the necessary dark.

GEORGE: The necessary dark?

EVE: Isn't that what you said? To make the creative power there must be the two: the contenders.

PAUL: Bunyan believed Satan was real – and gave us Apollyon.

ADAM: Well, as a metaphor, yes.

PAUL: And he got criticised at the time for dealing in metaphors. But they were metaphors for living truths. Despair was no less despair for appearing as a giant.

ELIZABETH: My Lord, it is another two years before the next Assize – what will become of us? And always the fearful thought in our hearts that he might be transported or put to death for knowing God as he feels he must. Always the fear of what will become of us. It's a hard thing to bear, my Lord – a hard thing to bear.

(*ELIZABETH's voice fades and she disappears into the dark.*)

RECEPTIONIST: And then all the candle flames gave up trying, and the dark was too heavy to go on sleeping – if that's the way you see it.

PAUL: And then the power failed and brought you back to us.

ADAM: But he got the better of the giant Despair – I seem to remember – or somehow escaped from his dungeon. But for Bunyan, I suppose, it wasn't so easy.

PAUL: For twelve years, more or less, they kept him in jail – and at last he came to the delectable mountains of having written a best-seller – sold for eighteen pence a copy – and there, like any mountain, it has stood secure, looking out over the human scene, for the past three hundred years.

(The electric power is restored, raising a cheer from all of them.)

There you are, Tim – you have the permission of the Electricity Board to go to sleep again.

ADAM: Wherever time will take you. When you're little, a week seems a terribly long time to wait for something. And even when you're much older, a century still speaks of history. But then, I imagine, time gets its skates on. An old chap once told me that when you get to eighty it's like having breakfast every half hour. At that rate even two thousand years becomes neighbourly.

GEORGE: Some trees can live that long, or not far off it.

EVE: That's true. A sequoia tree, I think it was. And yew trees and oak trees don't do so badly. When you were talking about the little big bang, Adam, I thought how the acorn does it. That sky-going eruption of branch and leaf.

PAUL: There's a wonderful passage by Mark Rutherford – his father had a shop in Bedford High Street – mid nineteenth century – Hale White his proper name – but Mark Rutherford when he took to the pen. I learnt it by heart once, the piece about the tree. I think I can still remember it. He said he was in a wood when something happened which was a transformation of himself and the world. It seemed to be no longer a tree away from him and apart from himself. The enclosing barriers of consciousness were removed and the text came into his mind, 'Thou in me and I in Thee'. The distinction of self and not-self, he said, was an illusion. He could feel the rising sap, and the fountain of life uprushing from the tree's roots; and the joy of the outbreak of the buds

318

right up to the summit was his own. Whatever kept him separate from the tree he felt was nothing.

ADAM: Well done, well remembered.

EVE: And thank you for remembering.

ADAM: Well, friends, I suppose we should be making our way.

GEORGE: It was a good coming-together.

EVE: (*To ADAM.*) How are your hands feeling?

ADAM: (*Closing and opening his hands.*) My own again, I think they are.

EVE: So this time, perhaps you'll be able to tell me where we're heading for.

ADAM: That could be. I'll take a chance on it.

(*Holding hands, ADAM and EVE begin to make their goodbyes, when GEORGE stops them.*)

GEORGE: Paul, are you hearing what I'm hearing? Listen!

(*The faint sound of the bells in the bell-tower ringing.*)

PAUL: The bells! Who in the world could be ringing the bells? Tim, do you know anything about this? Who on earth can be ringing the bells?

RECEPTIONIST: Well now, do I know? Who could be ringing the bells? The generations, it might be. It could be the generations ringing.

(*The others all turn towards the window to listen as the bells ring out bravely.*

The curtain falls.)